HOW TO READ A CHURCH

A Guide to Symbols and Images in Churches and Cathedrals

Richard Taylor

For Isobel and Mary, and Frank and Aurelia

Cover design by Trudi Gershenov

First published in 2003 by Rider,
an imprint of Ebury Press
Random House · 20 Vauxhall Bridge Road · London SW1V 2SA

Line illustrations by Rodney Paull

Library of Congress Cataloging-in-Publication Data

Taylor, Richard, 1967–
How to read a church: a guide to symbols and images
in churches and cathedrals / Richard Taylor.
p. cm.
Originally published: London: Rider, 2003.
Includes bibliographchial references and index.
ISBN 1-58768-030-0 (alk. paper)
1. Christian art and symbolism. 2. Church decoration and ornament. I. Title.
BV150.T39 2003
246—dc22
2004028484

Published in the United States in 2005 by
HiddenSpring

an imprint of Paulist Press
997 Macarthur Boulevard
Mahwah, New Jersey 07430

www.hiddenspringbooks.com

Printed and bound in the
United States of America

Contents

Acknowledgements

No one among the following is in any way to blame for any errors or omissions in this book, but it could not have been written without their generous and invaluable assistance, for which I am very grateful: Ms Isobel Bowler; Mrs Gillian Taylor; the Right Revd Richard Llewellin; Canon Ronald Diss; Prebendary Kenneth Bowler; Mrs Sarah Bowler; Sister Christopher; the Revd Paul Hunt; the Revd Jeremy Brooke; Mr Philip Feakin; Mr Conrad Arnander; Mr Denis Moriarty; and Dr Andrew Eburne.

Photo Credits

The Great Reredos—from Saint Thomas Church, Fifth Avenue, New York, by J. Robert Wright. Photo copyright © 2001 Saint Thomas Church, Fifth Avenue, New York. Used with permission.

Images of Sts Matthew, Mark, Luke and John—stained glass windows, St Joseph's Parish, Hamilton, Ontario. Photo copyright © Bill Wittman. Used with permission.

Image of Isaiah—detail of pulpit, Saint Bartholomew's Church, Park Avenue, New York. Photo copyright © Bob Johnson. Used with permission.

The Trinity—stained glass window, Sacred Heart Basilica, Syracuse, New York. Photo copyright © Bill Wittman. Used with permission.

The All-seeing Eye of God—stained glass window, St Joseph's Oratory, Montreal, Quebec. Photo copyright © Bill Wittman. Used with permission.

Image of St John the Baptist—detail of pulpit, Saint Bartholomew's Church, Park Avenue, New York. Photo copyright © Bob Johnson. Used with permission.

The Last Supper—detail of altar in the baptismal chapel, Saint Bartholomew's Church, Park Avenue, New York. Photo copyright © Bob Johnson. Used with permission.

The Ascension—stained glass window, Catholic Church of the Ascension, New York, New York. Used with permission.

Pentecost—stained glass window. Source unknown.

Author's Note

The ability to read a church – to interpret the images, signs, and symbols – is a skill now rare, even among regular churchgoers. At the same time, these sites remain focal points in communities, and visiting them is as popular as ever. The purpose of this book is to help visitors to churches, whether occasional sightseers or regular attenders, and of any faith or none, to understand the richness and depth of what they find around them. Christian theology, Church history, and Church architecture all have vital parts to play in the story of churches, and we will touch on these briefly in the next section and as we go along. This is not, though, a book about theology, history, or architecture. These fascinating subjects deserve more attention than we can afford them in these pages, and for readers who are interested there is a list of recommended reading in the bibliography at the end.

As we will see, language can be a troublesome medium, which symbols and images can be useful in transcending. To steer clear of this kind of trouble, I need to explain some of the language that I will be using.

Church/church As we will see, early Christians did not meet in buildings dedicated to worship, but in common meeting places or one another's homes. The word 'church' therefore referred to a body of Christian believers. Nowadays the word retains this meaning, as well as referring to the building that Christians worship in. To distinguish them, when referring to a body of Christians, I use a capital 'C', as in 'the Eastern Church'; when referring to the building itself, I use a small 'c'.

Jesus Christ The word 'Christ' is essentially the same as 'Messiah'. Christ comes from the Greek word *Khristos*, and Messiah comes from the Hebrew word *Mashiach*, both of which translate as 'anointed' or 'the anointed one'. Although the names Jesus and Christ are virtually interchangeable when writing or speaking about Jesus, writers tend to use

'Jesus' when they are talking in terms of his humanity, and 'Christ' when talking in terms of his divinity. For the sake of consistency, I have tended to stick to 'Jesus'.

The Virgin Mary 'The Blessed Virgin Mary' (or BVM for short) is the full title with which Catholics honour Jesus' mother. She can also be known simply as 'the Virgin'. Protestant Churches, which tend to place less emphasis on Mary's position, use these titles less often. To tread a middle path – and to save space – I refer to Mary simply as the Virgin Mary.

Catholic/Roman Catholic The word 'Catholic' denotes traditions or beliefs in the Western Church that originate in, or claim continuity with, the early Church. It therefore refers to practices that continue within many Churches, for example among Anglicans, and not only among Roman Catholics. For example, the form of service conducted in Roman Catholic churches and many Anglican churches is virtually indistinguishable, since both are based on traditions that originated in the early Church and which developed over the centuries. Those practices are 'Catholic'. I will be using the description 'Catholic' when referring to traditional teachings and customs in the Western Church, and the term 'Roman Catholic' to refer to the Church that is led by the Pope.

You will by no means see every image described in this book when you visit a church, and you may find many that are not. As fashions have changed over the centuries, churches have been built with varying degrees of decoration. Some are very plain, while others are highly ornate and the representations in them may extend to less common examples. Others emphasize local saints, or the particular spiritual or political concerns of the patron or builders. This book is an overview and explanation of the most common images.

READING A CHURCH: PRELIMINARIES

How do you go about 'reading' a church? In some ways, it is easy. There are many instances of specific Christian ideas and history that recur in the imagery and the way it is used, or which underlie the imagery. Understanding these gives a solid foundation for understanding many of the images themselves. In this section we look at the process of reading a church, some of the broad influences on church imagery, and some matters, such as numbers and colours, that we will encounter repeatedly.

Why Read a Church?

Churches and cathedrals are packed with meaning. Outside, the spire points heavenwards; carvings around the entrance announce the holiness of the space inside; the aisle that draws you to the altar, with its ranks of pews on either side, is the gangway of a ship carrying worshippers to God; the altar, the holy heart of the building, is contained in a separated and sacred space; all around, numbers, colours, the animals and plants in the stonework, and the scenes in the stained glass, point to aspects of Christian teachings

about God. In a number of senses, and to different degrees, churches were built to be read.

Churches can contain many images, but what is the point of them all? It is often said that images in older churches were meant for people who could not read, so that they could understand the Christian message as the educated did. This explanation of church imagery as 'the storybook of the illiterate' is good and democratic, and fits in well with the very principles that are its cause, but I am not sure it is true. There are few, or no, images that can be understood without already knowing the story that they represent. While at various points in history private Bible reading was important to many literate people, those stories would have first been heard in the nursery or from the preacher, not read. The literate and the illiterate would have been equally familiar with the basics, and I do not believe that these images would have been any more useful for the peasant than for the king. In fact, the 'picture-book' pleasure to be had from the images is as good for the educated as the not. It comes from the sense of sudden recognition, the satisfaction of the images sliding into place alongside the old, familiar stories, or the shared sense that whatever pictures were conjured when the stories were being told, here everyone is sharing a common mental shape. The power of the images to teach is even-handed. In the words of St Thomas Aquinas, 'man cannot understand without images'.

In any event, many symbols are rather less democratic. Roman or Greek words and letters carved in stone or painted on windows may have been understood only by the classically educated. These can suggest some hidden knowledge of God, exclusive to those who can interpret it, such as the clergy, or the well-to-do. But when the Roman Catholic Church banned the Latin Mass, precisely in order that the people could participate more fully in

what was going on, some were very upset at losing the rhythm and cadences with which they were familiar, and the mystery and power of rites spoken in an ancient language. The congregation might not have known another word of Latin, but they knew what *this* meant. And the use of Latin or Greek forms a direct link between the present-day and the ancient Church, especially where signs and symbols were created and handed down to us by the early Christians themselves, such as the IHC, or the Chi Rho.

A symbol is something that represents or stands for something else. There are three characteristics of symbols that make them as important today as they have ever been. Firstly, symbols can express concepts that language alone cannot. That is especially the case for mystical concepts, which, almost by definition, we can only approach and not completely grasp. But we *can* understand, and accept, a *symbol* of those concepts. In fact, given that a symbol may be trying to express the inexpressible, it could be as perfect an understanding of the concept as we can ever achieve. Secondly, symbols can help bridge gaps where language is simply too trouble-making. The Eastern and Western Churches became divided over the precise relationship between the Persons of the Trinity, which led to Creeds with very subtly different wording being adopted by each. In the world of symbols, no such problem, and no such division, need exist. Christians can all agree that a triangle expresses the Trinity. Thirdly, a symbol may have the power to touch us at a depth that a wordy exposition does not. We will see that this is an old language, some of it rooted in practices and ideas that predate Christianity. It can connect with us in a way we can barely understand.

The world of symbols is deep and rich and varied. Although their context may point to one interpretation over another, a single symbol can have multiple, even contradictory meanings.

These meanings can inform and colour one another. For example, the lion is a biblical symbol of evil, devouring and ravaging. It is also a symbol of Jesus, regal and powerful. The former symbol can inform the latter, for example, with Jesus as a king who has ruthlessly devoured evil.

It is also important to remember that the world of symbols is not fixed. The symbols recorded in this book have certain generally accepted meanings. But those meanings have developed over centuries or even millennia, and there is every reason to suppose that their meanings will continue to develop. Objects have different resonances for different people at different times, and readers should take their experiences with them when 'reading' symbols. Take the bulrush, for example. This is a symbol of God's sustaining and saving power, derived from the Book of Job. But for me, bulrushes are a reminder of the great Essex reed beds that had to be traversed to get to the beach when I was a child. The paths through the beds felt disorientating, dark, and long – until they opened up into the light and breeze of the sea. So, to me, they have a personal symbolism that could be read as the confusing passage of life with the promise of joy and light (and beach balls and sandcastles) in the end. Simply, viewers are often free to add parts of themselves to the symbols they see.

Turning to churches themselves, it is often said that we could, or even should, do without them. God is in the fields and in the woods, in the earth and in the wind, and is not contained within four walls. Many people feel closer to God on a walk in the park than in a building on a Sunday morning. This view is not only held by non-churchgoers. Early Christians often met to worship together at one another's homes. The rise of housechurches over the last few years shows the need felt by some Christians to worship together outside a traditional church environment. If you do not believe in God, then

church buildings can look like trying to win the argument with pomp and grandeur; if you do, they can still look that way, as if an established Church is trying to assert its monopoly over truth. But the men and women who made and decorated these churches will for the most part have done so with a purer purpose. They were built to be Houses of God, and are expressions of love and reverence. They are emblematic of heaven on earth, and so of all that we could hope for in a place. And while they can of course be used for personal meditation, they are places of *communal* worship, of coming together. They are also – usually – very beautiful.

Writers on churches tend to focus on their historical or architectural merits, and their aesthetic rather than their spiritual power (if these can be separated). In *England's Thousand Best Churches*, Simon Jenkins writes, 'I have lost count of the number of church guides which assert, "this building is not a museum, it is a place of worship". I disagree.' This remark is a pity in an otherwise excellent book. Yes, many churches present us with slices of history. Yes, they are often exquisitely beautiful works of art. But their spiritual power is their essence. Without it, they are turned into empty barns. Admiring a church for its beauty or history alone is like admiring a Monet for its frame.

Christian Theology in Imagery

Imagery was frequently put to use in illustrating or explaining points of Christian teaching, and we need to review some key points of belief that we will encounter.

A teaching that was hotly debated in the early centuries of Christianity concerns who exactly Jesus was, and what his 'nature' was. It was agreed that he was the Messiah, God's 'anointed one', but what did that mean? Was he a man, a prophet? Or was he God, descended to earth? The conclusion the Church reached was that

Jesus was both wholly human, and wholly God. Specifically, Jesus was the incarnation (from the Latin *incarnatio*, 'made flesh') of God the Son, the second person of the Trinity. We will find a number of references to this 'dual nature' in the imagery of churches.

The Trinity is a central dogma in the Eastern and Western Churches about the nature of God. God is at the same time one substance and three distinct, separate persons: God the Father, God the Son, and God the Holy Spirit. 'The Father is God, the Son is God, and the Holy Spirit is God, and yet there are not three Gods but one God' (the Athanasian Creed). As they are one God, the three do not have different 'roles' as such but, broadly speaking, the Father might be thought of as the creator and preserver of the world, the Son is the intellect and the Word of God manifested in Jesus, and the Spirit fills people, touching the disciples at Pentecost and still bringing spiritual gifts. The three stand equal, eternal, omnipotent – and one.

Christian teaching goes on to consider the relationship between God and man, and above all the sequence of sin, grace, and salvation. The Hebrew words signifying 'sin' in the Bible carry the notion of 'failure' or 'error', 'doing wrong' or 'revolt'. While sin exists in doing wrong, for example in failing to do to others what you would have them do to you, the idea carries a more complex significance than this. Sin does not belong in God's world. It is an intrusion, a violation, and contrary to the way that the world should be.

In Christian teaching, sin is brought into the world by humankind's moral and spiritual failure, and by disobedience to God. Adam and Eve, the first man and woman, were the first sinners, through disobeying God's command not to eat the fruit of the Tree of Knowledge of Good and Evil (see 'Adam and Eve' page 137). This 'Sin of Adam' led to the concept of 'Original Sin', which was most developed by the Christian teacher and

theologian St Augustine (354–430). In Augustine's thought, when Adam first sinned he created a hereditary stain that would be carried by all humankind. Original Sin is therefore a passive state of being, rather than an active state of doing. As a traditional teaching, the concept of Original Sin has had a strong influence in the development of church imagery, although it has been criticized by many Christian thinkers since Augustine's day.

Salvation from sin comes through God's grace, and above all, in Christian thought, through Jesus. The root of the word 'grace' is Hebrew, and means 'bend down to', like a parent bending down to his or her child. Grace is the self-giving love of God, which is given regardless of whether the love is deserved by its object. God's grace permeates the whole Bible, from the act of creation, to leading the Israelites out of Egypt, to His continuing forgiveness of sinful mankind. For Christians, God's grace is most present in the suffering and death of Jesus, for the sake of all things.

Just how Jesus' sacrifice led to salvation remains the subject of theological debate. In the context of St Augustine's teaching about Original Sin, Jesus is the 'New Adam' who washed away the hereditary stain that was the legacy of Adam's disobedience. Jesus sacrificed himself as a blood offering, like a sacrificial lamb, and thereby 'paid' for the sins of humankind, so saving it from hell. Some theologians, though, have argued that ideas of heaven and hell, of rewards and punishments, are difficult to reconcile with biblical teachings about God's all-embracing love. Some argue that the nature of Jesus' sacrifice is a mystery that cannot fully be understood, but is the ultimate manifestation of God's love for humankind.

The Eucharist

Another manifestation of God is in the Eucharist, also known as Holy Communion, the Mass, or the Lord's Supper. This is the

central act of worship in the Western and Eastern Churches, and is referred to frequently in church imagery. The ceremony invokes the acts and words of Jesus at the Last Supper. Jesus broke bread and gave it to his disciples with the words 'Take, eat, this is my body'; he then took a cup of wine and gave it to the disciples with the words 'This is my blood of the covenant, poured out for many for the forgiveness of sins.'

There are three aspects of the Eucharist that are significant in church symbolism: the bread and the wine as Christ's body and blood; the Eucharist as a sacrifice; and the Eucharist as a shared meal. As to the first of these, the Roman Catholic Church teaches that during the Eucharist, the 'substance' of the bread and wine becomes the actual body and blood of Jesus, such that he is physically present. Protestant Churches differ as to what happens (some teach that the ceremony is purely symbolic), but the key point is that Jesus' words give some correlation, however it is understood, between the bread and wine and his body and blood. The second element, of the Eucharist as sacrifice, is based on the very ancient understanding that there is some close relationship between Jesus' sacrifice on the cross and what takes place during the Eucharist. In some way, Jesus' sacrifice is perpetuated and reproduced in the ceremony. The final element is that the Eucharist is a meal in which everyone is invited to participate. We will see in the chapter on church fabric that this communion between the participants and God, and the breaking down of ancient barriers, is key in Christian belief.

Two Points of Church History

This is not a book about Church history, but history has of course had a great impact on the quantity and types of symbols and images found in individual Christian churches. Above all, this can

depend on denomination. A Church denomination is a group of Christians that have their own interpretation of aspects of Christian theology, and their own organization – Roman Catholic, Lutheran, Orthodox, and so on. These denominations, and their different approaches to imagery, stem from two great earthquakes in Church history: the schism between the Eastern and Western Churches, and the Reformation.

By 'Western' Church, we mean the Roman Catholic and Protestant Churches. The 'Eastern' (or 'Orthodox') Church is a group of autonomous Churches that recognizes the honorary leadership of the Patriarch of Constantinople. The division between the two came about to a large part through historical accident. In the fifth century, the Western part of the Roman Empire was overrun by barbarian hordes, and the Pope, the head of the Church in Rome, came to take on much of the vanquished Emperor's authority. But in the East the former Roman Empire, now often called the Byzantine Empire, continued for another thousand years. It had its capital in Constantinople and the Patriarch there emerged as head of the Byzantine Church. Minor differences in ritual and teaching led to tensions that culminated in 1054 with the Pope and Patriarch excommunicating one another. Mutual non-recognition continued for several hundred years.

The impact of the schism for our purposes is that the Church of the East and the Church of the West developed different traditions in imagery and symbolism. Just one example of this is that the Eastern Church does not generally identify saints by the instruments of their martyrdom, as the Western Church often does. Moreover, the Eastern Church developed the use and veneration of icons. Icons are formal paintings of Jesus, the Virgin Mary, and the saints, but they are more than just pictures: they are revered as demonstrating, in themselves, the revelation of Jesus as

God on earth. The thinking is that in the person of Jesus, God became man, fully visible and describable, just as he is visibly depicted in the icons. During the celebration of the Eucharist in the Eastern Church, a contrast is suggested between the visible revelation of Jesus in the icons, and his invisible presence in the Eucharist.

In part because of the veneration given to the icons themselves, the imagery of the Eastern Church has remained very consistent over time. An ancient work known as the 'Byzantine Guide to Painting', which gives detailed guidance as to how Christian subjects should be portrayed, has largely been adhered to.

We will also encounter a second earthquake in Church history: the Reformation. By the sixteenth century, the Western Church had become, in the eyes of its critics, spiritually bankrupt. Its officials were considered bloated and corrupt, concerned with their own wealth and power rather than the well-being of the people. Some practices attracted particular criticism, such as the sale of indulgences (spiritual dispensations for acts committed or not yet committed, in return for a fee), the veneration of relics, clergy who were absent from their churches, and nepotism in Church appointments. The Church had seen a number of movements towards reform – for example, that led by St Francis of Assisi – but this time the critics struck at the Church's teachings themselves. There were a number of different voices in what became the Protestant Churches, but broadly speaking they emphasized the importance of reconciliation with God through faith and God's grace, as opposed to actions such as doing good deeds or buying indulgences; the importance of the authority of scripture, rather than tradition; they had different views on the nature of the Eucharist, but did not accept that the bread and the

wine were transformed into the body and blood of Christ during the ceremony, as the Roman Catholic Church taught; and they objected to the degree of veneration that had been allowed to the saints, and the Virgin Mary in particular.

These objections led to the creation of the Protestant Churches, and a number of important denominations such as Lutheranism, Calvinism, and Presbyterianism soon sprang up. Although it was not a Protestant movement as such, in England Henry VIII rejected the authority of the Pope and established the Anglican Church. The Roman Catholic Church in the meantime engaged in what became known as the Counter-Reformation. Much-needed internal reform went hand in hand with an emphasis on the beliefs and devotional subjects that were under attack, such as the life of St Peter, or the real presence of Christ in the Eucharist. Spain and Italy became particular centres of Counter-Reformation activity.

The Reformation had equal and opposite effects in church art. In Protestant churches buildings tended to be plainer and less decorated. The imagery that was used tended to avoid traditions from sources outside the Bible. In some areas, iconoclasm raged, with Protestants smashing imagery in churches, particularly of the Virgin Mary and the saints. Conversely, in the Roman Catholic Church imagery and symbolism became even more emphasized and elaborate. It also emphasized Roman Catholic teachings that were different from the Protestants', for example St Gregory the Great's vision of Jesus while celebrating the Eucharist. Over time, these distinctions would blur in some places. For example, in the nineteenth century some in the Anglican Church championed the imagery and decoration of the medieval churches. A renaissance began in the use of images and symbols, complete with some references to extra-biblical sources.

Sources

The most common source of the images described in this book is, of course, the Bible. The Bible is a collection of texts that the Christian Church has acknowledged as being authoritative in their revelation of God. It comprises sixty-six books written over hundreds of years in an array of literary styles – historical narratives, folk tales, poetry, hymns, letters, and visions. The unifying thread is the story of God revealing himself to, and saving, the world. This passes from God's intimate relationship with the first man and woman in the Book of Genesis, through the story of the liberation of the Israelites from slavery in the Book of Exodus, messages from God in the books of the prophets, hymns to God in the Psalms, to the teachings, death, and resurrection of Jesus in the Gospels (which form the pinnacle of the revelation, from a Christian perspective), the teachings in the letters of St Paul and other early Christians, and concluding in a vision of the end of the world, in the final Book of Revelation.

But the Bible is not the only written source of imagery. Many images are derived from texts described as apocryphal, which means that they are in some way associated with, but not always accepted into, the official canon (I say 'not always' because there have been a few disagreements over where the Bible ends and apocryphal texts begin: the Roman Catholic Church, for example, accepts some Old Testament texts that Protestant Churches reject). Some of these are ancient Hebrew stories that did not make it into the Old Testament, others are post-resurrection stories. Apocryphal Gospels, such as the Protevangelium of James or the Gospel of Nicodemus, were written after the four biblical Gospels, and claimed to tell further stories of Jesus' life.

Over the centuries, the public also developed a passion for tales

of the disciples, and stories of the saints, many of which found their way into church imagery (the most famous collection of these tales is a medieval work called *The Golden Legend*). Moreover, as men and women built and decorated churches, they did not feel constrained to fit inside a textual tradition. We will see that they borrowed from the world around them, making analogies between nature and the Christian story, such as the low-growing violet becoming a symbol of humility; they co-opted legends and fairy stories into the Christian message, such as tales of the unicorn and the basilisk; and they were influenced by pre-Christian traditions, such as the cross as a symbol of life.

Numbers and Shapes

Numbers and shapes can be significant when incorporated into images, for example the triangle as a symbol of the Trinity, or twelve sheep being a reference to the disciples. They can also be important in church furniture, for example in octagonal fonts and pulpits, and even in the church fabric. It is undoubtedly true that the number of windows appearing in a facade will be dictated by the demands of the building, but a group of, say, three windows can also be a reference to the Trinity. It is therefore worth considering separately the symbolism of numbers and shapes.

The circle was considered by the ancient Greeks to be the perfect shape – eternal, without beginning or end, a perfectly balanced whole. A single circle is therefore a symbol of the divine, or eternity, while the number one expresses the unity of God.

The number two is used in reference to the human and divine natures of Jesus, or to the Old and the New Testaments. The number three is extensively used as a symbol of the Trinity, particularly in association with a triangle. The triangle in this meaning is always equilateral, in order to represent the equality of

the three persons of the Trinity. It can also represent the three days that Jesus spent in the tomb, before the Resurrection.

The number four can represent the Four Evangelists. It may also be the number of rivers that the book of Genesis said flowed from Eden (the Pishon, the Gihon, the Tigris, and the Euphrates; Genesis 2:10–14). At a stretch, it is also a warning reminder of the four horsemen of the apocalypse, described in the sixth chapter of the Book of Revelation. The four riders were unleashed with authority over a quarter of the earth, and have been interpreted as representing conquest (white horse, rider crowned and carrying a bow), war (red horse, rider carries a sword), famine (black horse, rider with scales), and death (green horse, rider usually skeletal). The form of a square or cube is a symbol for the earth. It is a solid, unmoving form, just as the earth is (or rather, as it was perceived to be). A square halo was used on images of holy people who were still alive (in this context, still on earth) at the time when the image was made. It forms a contrast with the 'divine' shape of the circle.

Five symbolizes the five wounds that Jesus suffered in the Crucifixion (the four nails in his hands and feet, and the spear in his side).

Seven is significant as a powerful mystical number that appears repeatedly through the Bible, and is associated with perfection. A few examples of this are: God resting on the seventh day after completing Creation; Jacob bowing seven times before his brother Esau, as a sign of perfect submission (Genesis 34:2–4); God ordering that the lampstand for the tabernacle during the Exodus should have seven branches (Exodus 25:37); and the seven angels blowing their trumpets in the apocalypse (Revelation 8–11).

The number eight, through the octagon, is a symbol of Jesus, unifying God and earth. An octagon is 'halfway' between a circle (God) and a square (earth). Just as Jesus was the incarnation of God

on Earth, so the octagon mediates between these two. This idea of heaven and earth coming into contact lies behind the octagonal shapes of some fonts and pulpits. At the baptism of a person, heaven and earth touch, while during a sermon the preacher is (hopefully) communicating the word of God.

Nine is the number of the angels, since there are nine choirs of them. Ten is the number of the Ten Commandments.

The number twelve in a church will refer to the twelve disciples, which in turn refers to the twelve tribes of Israel. Since in both instances it is the number of a group of people dedicated to God, it is sometimes used to represent the whole church. The number thirteen, on the other hand, is ominous, and indicates betrayal, since it was the number of people present around the table at the Last Supper (twelve disciples, plus Jesus).

Finally, although the number forty does not much come into play in church design or imagery, it is important in a number of Bible stories, associated with periods of trial or repentance (the word 'quarantine' comes from the Latin for forty, this being the number of days that penitents had to spend in isolation). Rather than denoting a precise sum, it can be taken to signify 'many'. For example, in the story of the Exodus the Israelites were in the desert for forty years; in the story of the Deluge it rained for forty days; in the story of the Temptation Jesus was in the wilderness for forty days. In all cases, it is acceptable to take these periods as shorthand for 'a long time'.

Colours

In traditional churches the year is colour-coded: the colour of the fabric used on the altar and the vestments of the priest will change according to the season. There are the 'liturgical colours', and the standard colours are green, purple, white, and red.

Green is the colour of new life. As a liturgical colour, it is a kind of 'default' setting, used whenever the other colours are not. Purple is the colour used for seasons of repentance. In the Western Church, the ecclesiastical year starts with the penitential season of Advent, which runs for four Sundays from the fourth Sunday before Christmas (so, from around 1 December). It is a period of preparation and anticipation (the name Advent comes from *Adventus Domini*, 'the coming of the Lord'), before the Christmas celebration of Jesus' birth and anticipation of his return. The second period of penance in which purple is used is Lent. Lent (the name has the same root as 'lengthen', and is a reference to the lengthening days of the time of year) is the forty-day period of repentance and preparation in the lead-up to the most important Christian festival, Easter.

White is the liturgical colour of both Christmas and Easter. The white of the church furnishings remains through the twelve days of Christmas, and through the festival and season of Epiphany, 6 January and the following four Sundays. Epiphany comes from the Greek *epiphanmeia*, 'to shine upon', 'show', or 'manifest', and is the celebration of God's manifestation of Himself. In the West it is most known for commemorating the visit of the Magi (when Jesus was first revealed to the Gentiles), and in the East it is the Baptism of Jesus (when the ministry of Jesus began), and also the wedding at Cana (when Jesus performed his first miracle). White is used again at the greatest Christian festival, Easter, in celebration of the Resurrection. On the seven Sundays after Easter, white is also used, until Ascension Day, forty days after Easter, when the Ascension is commemorated. The last day on which white is used is Trinity Sunday. The day honours all three persons of the Trinity, and summarizes the whole of God's revelation to humankind.

Red, the colour of fire, is the colour of Pentecost, also known as Whitsun (because it was the custom to baptize on that day, for which white clothes had to be worn). The red remembers the fire of Pentecost, when the Holy Spirit came to the Apostles, and the day is known as the birthday of the Church.

Colours can have symbolic meanings when used in wider church art, for example in the colour of clothes given to a particular saint. The traditional interpretations of colours in church art are as follow.

Black Sickness, death, and the devil, but also mourning. Black is sometimes used as a liturgical colour of mourning on Good Friday. Black and white together, though, can represent purity, for example on the habits of Dominican friars.

Blue Traditionally associated with the Virgin Mary, and also with Jesus, blue is the colour of the sky and represents heavenly love.

Brown The simple dress of the Franciscans is brown, in imitation of poor peasant dress. Brown came to represent renunciation of the world.

Gold Gold is the colour of light, and has the same symbolic meanings as white, with which it is often used.

Green Green is the colour of life, and in particular the triumph of life over death, just as green spring overcomes winter.

Grey The colour of ashes, grey symbolizes the death of the body, repentance, and humility. In paintings of the Last Judgement, Jesus is sometimes shown wearing grey.

Purple In addition to its liturgical function as the colour of penance, purple represents royalty, and was the colour of Imperial power. For this reason, God the Father is sometimes shown in a purple mantle.

Red As well as showing the fire of Pentecost, red is the colour of the passions. It can mean hate or love, although it is most often used for the latter. For example, Mary Magdalene is also often shown in red to show her love, and in images of the Sacred Heart, when the onlooker is invited to meditate on Jesus' spirit, Jesus is often dressed in a red cloak. As the colour of blood, red is also often used for the clothes of martyrs.

White The Bible contains several references to white as the colour of purity and innocence (for example, 'wash me, and I shall be whiter than snow', Psalm 51:37). It also shows spiritual transcendence: Jesus' clothes became dazzling white during the Transfiguration (Matthew 17:2), and the angels at the Resurrection were dressed in white (Matthew 28:3). When the risen Jesus is portrayed, he is usually shown dressed in white. Silver can be used instead of white.

Yellow Yellow can be used as a variant of white to represent light, and is a common colour for halos in stained glass. It can, though, also indicate an infernal light of treachery and deceit. Yellow was used in the Middle Ages to mark out plague areas, and so it came to suggest contagion and impurity. For this reason, Judas Iscariot is sometimes portrayed wearing yellow.

Halos

A halo, or 'nimbus', appears in most church art around the head of a person of particular spiritual power. Halos are extremely useful from an artistic point of view, since they frame and highlight the head, and they are far from exclusive to Christian art (they appear in images of gods or holy men through India and the East). Where an aura is portrayed around a whole figure it is known as an 'aureole' or 'mandorla'. The mandorla tends to be used for particular manifestations of God's power, such as the Transfiguration, Ascension, or Second Coming.

Halos in art expanded over time, and then contracted again. In the earliest Christian art they were not used at all, and when they first appeared it was as see-through auras of light. By the Middle Ages, many halos had become vast golden cartwheels, but by the Renaissance they had shrunk again to discreet little hoops of light. After that it became acceptable again to dispense with them altogether.

In the Eastern Church, a halo signifies power rather than holiness. Images of Satan might be haloed to show his supernatural power, while persons in authority, such as kings or bishops, could be awarded halos as well. In the Western Church, the halo was reserved for people of sanctity. The most sacred halo, which is applied only to images of God, is the cruciform halo, in which one vertical and two horizontal spokes appear within the circle of the halo to make the shape of the cross. Most commonly a cruciform halo appears around the head of Jesus (or in symbols for Jesus, such as the Lamb of God), although it can also be applied to God the Father and God the Holy Spirit. The Greek letters OWV, meaning 'I AM' (see the Burning Bush), or one of the Sacred Monograms, can appear within the cruciform halo. Identifying letters, for example the Monogram of the Blessed Virgin, or even

TYPES OF HALO

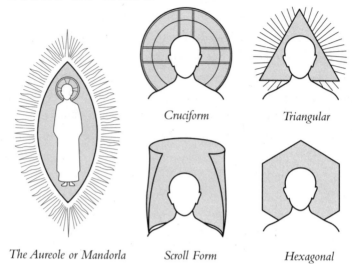

Cruciform

Triangular

The Aureole or Mandorla

Scroll Form

Hexagonal

full names, can also appear in the halos of saints.

There are also more esoteric halos. A triangular halo is sometimes added to images of God, to represent the Trinity. Particularly in Greek Orthodox churches, a six-pointed star, which is an ancient symbol of Creation, can be used for the halo of God the Father. A square halo (or square-like, for example in the shape of a scroll) shows that the person portrayed was alive when the image was made, since the earthly square was more appropriate for those still living (see Numbers and Shapes, page 14). A hexagonal halo is sometimes applied to personifications of abstract ideas, such as the Virtues.

That is the end of the groundwork. We will now look at the church itself.

CHURCH BUILDING AND FURNITURE

Bands of Sacredness

Places of worship are arranged into spaces with increasing degrees of holiness. At the time of Jesus, the Temple of Herod the Great in Jerusalem was arranged in just this way. The outermost part of the precincts was the Court of the Gentiles, open to Jew and non-Jew alike. A more sacred inner court, into which only Jews were allowed, led to two further courtyards, the Court of the Women and the Court of Israel. Nearer still to the Temple was the Court of Priests, into which only priests were allowed. The Temple itself was divided into the outer vestibule and the nave, the area where much of the Temple's ritual took place. Within this, separated by a curtain, stood the inner sanctuary, the 'holy of holies', the dwelling-place of God.

Churches too contain these degrees of sanctity, of spaces separated within spaces. The process starts at the wall of the churchyard. Medieval 'sanctuary', the area within which a criminal could not be arrested, started at the border of the church grounds. Next comes the church building itself. The building may be

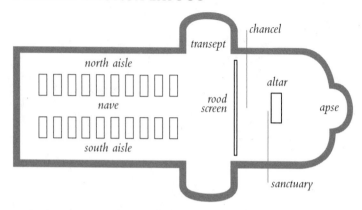

marked out as containing a holy space by the cross standing on its spire (when a church is put out of service, it is formally deconsecrated, and the cross is removed). The main body of the church, the nave, is the area where the congregation takes part in the service. Beyond this lies the chancel, usually separated from the nave by a step and/or arch, and often set up with choir stalls. Beyond the chancel is the sanctuary, again often separated from the chancel by a step and arch and altar rail, within which only the priests and their attendants are allowed. Within the sanctuary is the altar. In Catholic churches, standing on or behind the altar is a small space of even greater holiness, the tabernacle. It is the church's own holy of holies.

But an important difference in Christian thought between the divisions of church and temple is that whereas in the temple the holy of holies could only be approached by the high priest, in a church it is the resting place of a meal that can be shared by all believers, and can be approached (in the Western Church) by the whole of the congregation. This joining together of God and humankind is an important aspect of Christian teaching, illustrated in a striking way in Matthew's Gospel. Matthew says that when

Jesus died, the curtain that separated the holy of holies from the rest of the Temple was torn in two. One meaning of this story is that the death of Jesus destroyed the division between God and humankind.

Orientation

Before the destruction of Herod's Temple in AD 70, there were few 'dedicated' synagogue buildings. The Temple in Jerusalem was the focus of religious life, and meetings away from the Temple took place in private homes or public halls (the word synagogue means 'gathering together'). The early Church followed the same practice. But when building did begin, it soon developed a common pattern.

To begin with, almost universal customs developed as to direction. East and south are the honoured sides, north and west less favoured. Facing eastwards for worship, in the direction that the sun rises, is a practice that is probably pre-Christian, and there are a number of biblical references to God in the east (for example, 'the glory of the Lord was coming from the east', Ezekiel 43:2). The west may also have had a negative linguistic association, since the Latin *occidere*, 'to kill', was associated with the Occident, to the west. The longitudinal axis of most churches is therefore west–east, with the entrance on the west side and the altar on the east (I say 'most' because this is simply a common practice; there is no fixed rule). As the congregation worships it is usually facing eastwards, and images that express Christian hope are often deployed in the east window. The west side, on the other hand, was considered the best place for 'Doom' paintings of the Last Judgement. In much the same way, in the northern hemisphere the warm, light south was preferred to the dark north, and we shall see that the entrances to churches, and the more favoured burial sites, are on the southern side. As a final directional point, the

right-hand side was seen as good, while the left was bad (the Latin word for left, *sinister*, now means 'suggestive of evil').

If you approach a settlement you may well see the church first, standing on raised ground. For churches with the very oldest foundation, this may be because they were placed on a raised site with some religious, pre-Christian significance. It was Church policy to absorb, rather than destroy, the sites of pagan worship, so that coming to the site of the new religion was a natural continuation of past practices. In a few churchyards ancient stones stand, marked with a cross to signify their transformation from a pagan to a Christian point of worship, or they may have been incorporated into the churchyard cross, gateposts, or the fabric of the church. But raised ground may have a more prosaic explanation. One is that as graveyards filled with bodies, the ground increased in height. Another is that in lower-lying areas, churches were put on raised ground to stop them flooding.

Lychgate At the entrance to some English churchyards stands a lychgate, a small shelter over the entrance gate, often covering a central stone platform and perhaps seats on either side. The name comes from *lic*, an Old English word for corpse: its purpose was to act as a shelter for coffins and pallbearers before they came into the church for a funeral. The stone platform is the resting place for the coffin, the seats for the pallbearers.

The priest presiding over the funeral would come out of the church to meet the coffin. There was a legal reason for this, in that the cleric needed to receive the legal certificate for burial from the dead man's relatives outside the church. Over time, though, this came to be seen as a mark of respect for the deceased. The priest met the coffin at the entrance of the churchyard, before conducting it into the church.

The churchyard Churchyards are almost invariably used as graveyards. Graves should face east, and not only because this was the 'honourable' direction: Christians adopted the old Jewish custom of burying the dead with their feet towards the rising sun, as a sign of hope. There was also a belief that when Jesus returned to earth to rule over a new kingdom, the faithful would rise up bodily from their graves. It was believed that Jesus would return to Jerusalem, and therefore Christians living west of Israel wanted to face eastwards, so that they were facing the right way at the moment of his return. A similar belief in some Jewish thought is that the Messiah will enter Jerusalem through the Golden Gate, a now sealed gate that leads onto Temple Mount and the Dome of the Rock. This belief has caused the graveyard that looks towards the Golden Gate to be the most sought-after burial site in Israel.

Burials were preferred on the south side of the church (which therefore tends to be higher), and if there was ground on the north side, it was sometimes used for the burial of suicides, criminals, and infants who had not been baptized. Some rebelled against this arrangement, though: a gravestone at Epworth in Lincolnshire reads, 'That I might longer undisturbed abide/I choos'd to be laid on this Northern side'. The arrangement of the churchyard and the preference for the south meant that churches tend to be placed on the north end of the churchyard, with the entrance facing south. This gave more space for burials and a longer entrance-path, and had the added bonus of reminding visitors of the dead person, as they passed by their gravestone.

Some old churchyards contain a large churchyard cross. This marks the point where the priest would sometimes preach in the open air. In the days when tombstones were less common, the churchyard cross also served as a single memorial for all of the dead buried there.

Gargoyles The word gargoyle comes from the Latin *gurgulio*, meaning throat, a root shared with the word 'gargle'. In the days before pipe-drainage, rainwater was thrown clear of the church through a projecting spout. This spout could be decorated, and so came to be carved as the throats of monstrous beings, spewing the rainwater safely away. From these beginnings, any projections from the churches could be carved in a fantastic shape, or gargoyles could be installed for their own sake. There are symbolic interpretations of them, for example that gargoyles were intended to scare away the Devil, or that they make a symbolic contrast between the bedevilled world outside the walls of the church and the sanctuary within. But you have to be suspicious of symbolism in relation to gargoyles, since above all they gave opportunity for expression by local carvers, as their often fabulous work – terrifying, comic, bawdy, macabre, and rarely very 'holy' – attests.

Porch Church porches were an obvious place for secular business, and had important community functions. In England, they sometimes contained an altar at which legally binding contracts could be sworn. While few such altars survive, some remnant of them can sometimes be seen, such as a niche for a statue or irregular arrangement of the stone benches or doors. If the porch was large enough, it could be used for dispensing justice (in the churches of Alrewas and Yoxall in Staffordshire, courts were held until the nineteenth century), while in a room above the porch, schooling would take place. In the Middle Ages a couple to be married were met at the porch and asked if they would consent to be married, before they proceeded inside for their nuptial Mass.

Doors The door to the church has particular association with Jesus' words: 'I stand at the door and knock. If anyone hears my

voice and opens the door, I will come in and eat with him, and he with me' (Revelation 3:20), and 'Ask and it will be given to you; seek and you will find; knock and the door will be opened to you' (Luke 11:9). Most sculptures over or around church doorways are connected with Jesus: Jesus sitting in majesty, a Virgin and child, a Lamb of God, a Crucifixion.

The same type of decoration can be found on the doors themselves. One popular image on doors is Jesus' parable of the wise and foolish virgins (Matthew 25:1-13). Before a wedding feast, the wise virgins prepared by making sure their lamps were full of oil and trimmed. The foolish virgins did not, so that when the bridegroom suddenly arrived at the feast, they were unprepared and he shut the door on them. The foolish virgins may be holding their lamps upside down to show their emptiness.

Heavy and elaborate handles on the entrance door may derive from the use of churches as a place of sanctuary to fugitives. A fugitive was, in principle, safe from capture if he or she claimed sanctuary in a church. An unproved theory is that once a person had grasped the handle, he or she could not be removed without breaking sanctuary. The Constable of Arundel was compelled to do penance for having taken a thief who was holding on to the door handle of Arundel church.

Stoup of holy water In some, especially Roman Catholic, churches, there is a 'stoup' by the entrance, a recessed bowl of stone or metal containing holy (blessed) water. Entrants to the church dip their fingers in the water and cross themselves with it. The stoup is a descendant of Jewish customs of ritual washing of the hands, face, and sometimes feet. These customs were carried into the earliest churches, which placed a fountain at the entrance for washing; over time it was felt that size did not matter, since the

washing was purely symbolic, and so the fountain became the stoup. The stoup is therefore used to express the person's wish to be spiritually clean before entering the church building.

Font The font is used for baptism. St John the Baptist baptized those that heard his message, and baptized Jesus himself. Baptism is one of the seven Sacraments, and signifies a washing clean of the participants. It is also a presentation ceremony, a welcoming of the individual into the community.

The font is usually placed at the rear of the church, near the start of the central aisle. Since the central aisle represents the Christian's journey through life towards God, it was thought appropriate that the font should be placed at the symbolic start of the journey.

Fonts may be lidded, and the lids themselves range from simple covers to grand architectural confections (at Ullaford in Suffolk the cover is an eighteen-foot spire). Lids came to be used because the water was blessed on Easter day and then left there for later use (fonts therefore had to be impermeable in the long term as well as the short, which is why some are lined with lead). The holy water had to be protected from dirt and dust, and also from theft for use in charms and magical rituals. In England covers became compulsory from 1236, although nowadays water used in baptism is blessed on the day.

Nave The central area of a church, the main aisle flanked by rows of pews, is known as the nave. It is the space for the laity, the congregation. The word comes from the Latin *navis*, meaning ship, the root of the English word 'navigation'. The association of the church with a ship, and the congregation as passengers in the ship, indicates the priests and people travelling together towards God.

Pews are a fairly modern invention. Previously the congregation would stand (even mill about), although sometimes stone seats can be seen around the base of columns or against the walls, for use by the infirm (this was the origin of the expression 'the weakest to the wall'). Pews began to be installed in northern Europe after the Reformation, when an emphasis on the importance of sermons developed. These sermons were often very lengthy, and the congregation needed to rest its weary legs.

Columns The nave may be flanked by columns, which draw the eye forward towards the altar. Columns resonate with ancient pagan beliefs and practices. First, they are like trees. The first columns would have been made of wood, hewn out of single tree-trunks. The shape of the earliest known stone columns suggests mimicry by the carvers of these trunks, and the leafy decoration at the tops of some columns reinforces the connection. The central space of a church flanked with columns is therefore like the sacred groves in which our ancestors worshipped. Secondly, columns are akin to human figures, like ancient standing stones. Erect stones have long been used to represent people, and human names can be attached to them ('the Seven Maidens', 'the Long Man'). In a church the columns stand like these stones, their human shape

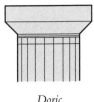

Doric

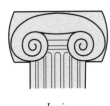

Ionic

Corinthian

TYPES OF COLUMNS

flanking the congregation. The tops of the columns may fly into buttresses, like arms raised in perpetual praise to God. Sites such as Stonehenge have been compared to cathedrals, but it may be that the analogy should be reversed: churches are our Stonehenge.

Different periods of architecture enjoy different styles of columns, but it is columns from the Greek and Roman traditions that have particular symbolic significance. Classical Greek architecture was organized into three 'orders': Doric, Ionic, and Corinthian. Each order had a different set of principles that determined the order of shapes and spatial relationships between the parts, and each had its own distinctive columns. Doric columns tend to be plain, with simple rounded heads, or capitals, and are shorter and thicker than the later versions. The capitals of Ionic columns, which are taller and more slender than Doric columns, look like opposing scrolls. Corinthian columns are topped with an arrangement of pointed acanthus leaves, which the Greeks viewed as having a special beauty. Roman architecture adopted these orders and added its own, including the Composite order, in which columns were topped with a fusion of the Ionic curls and the Corinthian leaves, to refer both to wisdom and to beauty.

Plain, sturdy Doric columns were associated with masculinity and strength, while graceful, slender Ionic columns were associated with the feminine, scholarship, and wisdom. Therefore, Doric columns tend to be used in churches dedicated to male saints, Ionic in churches for female saints. Corinthian columns, which were thought to be possessed of particular beauty, were used in honour of the Virgin Mary. Within a church building, different styles of columns can be used in different places, depending on the saints in the locality. For example, small Corinthian columns sometimes frame images of Mary.

Arches Arches have been interpreted symbolically as being like hands clasped in prayer, or arms thrown up in worship of God. A happy symbolic meaning relates to marriage. Couples are usually married under the chancel arch, which divides the chancel from the nave. Michelangelo defined an arch as two powerful forces that meet at their weakest point to make a stronger whole – a metaphor that seems good for marriage, too.

Some arches in much larger churches built in the classical tradition are 'triumphal', characterized by their great size and thickness, and by a rounded arch. Triumphal arches were originally freestanding, built by Roman Emperors to march beneath with their army, in celebration of an important victory. They were resurrected in more recent times, modern examples being the Arc de Triomphe in Paris and Marble Arch in London. When incorporated into church building, for example in the entrance, they symbolize the victory of Jesus. The priest and congregation as they pass beneath them are imitating the triumphant victory marches of the emperors.

The term 'triumphal arch' also refers to the wall above the arch that separates the nave from the chancel, and which is sometimes decorated with mosaics.

Ceilings and domes The church is a symbol of heaven, of the world as it should and could be. Some churches therefore refuse to see themselves as enclosed buildings – they are a world-within-a-world. The ceiling, particularly that of the chancel, or the sanctuary, can be painted to look like the heavens, as if the whole world is contained within the walls of the church. There may be clouds, or a night sky dotted with stars, or angels, or Jesus sitting in majesty in heaven. If there is not enough space to represent these images on the flat surfaces between the vaults, they are

sometimes carved on the roof bosses. Virtually the only images of the coronation of the Virgin left in English churches are those that appear on roof bosses. The images are high on the bosses because the coronation took place in heaven, and their inaccessibility saved them from the iconoclasts of the Reformation.

The meeting of a rounded dome with a square-walled building, which is a particularly common template of the buildings of the Eastern Church, has theological meaning as well. The dome, which represents heaven, atop a walled box, which represents earth (like a square or cube – see Numbers and Shapes, page 14), is meant to symbolize the descent of heaven to earth in the person of Jesus, and in the Eucharist. The chief model for church building in the Eastern Church is Hagia Sofia in Constantinople (modern-day Istanbul), in which a vast dome sits on an early Christian basilica.

Candles, the menorah, votives, pricket stand Candles have any number of symbolic meanings. They can represent the light of life itself; hope, like a single light flickering in the blackness; a person or message that illuminates the world around them; the easy passing of goodness from one to another, illustrated in some churches on Easter day (see below); burning love, even of a life that consumes itself with love; alertness and readiness, like the wise bridesmaids in Jesus' parable who kept their lamps lit to welcome the bridegroom (above, page 27); the fragility of life, and the ease with which it can be snuffed out; of standing up for what is right, and resisting wrong.

Many churches contain a pricket stand, an iron stand on which candles can be burned, accompanied by a prayer. The custom derives from 'votive' offerings, offerings made to God in return for a divine favour, such as a cure from illness. Votive offerings ranged

from candles to whole churches, depending on the size of the donor's wealth and level of gratitude. Where the candle is lit before an image the votive is being offered to the person of the image It is probably fair to say, though, that few people lighting these candles now think of them in this votive sense: rather, the candle stands as a vigil to the person's prayer.

A paschal candle is a single tall, thick candle that is lit on Easter day, and burns each Sunday through the Easter season. It stands as a symbol of the resurrection of Jesus (the light of hope). It is pierced with five knobs of incense, in a reference to the five wounds that Jesus suffered, is marked with the date, in a reference to the number of years since Jesus' death and resurrection, and may be imprinted with the Greek letters AΩ (see Letters and Words, page 216). In some church services on Easter day, candles held by the whole congregation are lit from the paschal candle, the candlelight sweeping through the church from that single source, in representation of the spread of the light of Christ. The paschal candle is often placed by the font, and is lit during baptisms. Its flame is used to light a candle that is presented to the newly baptized person.

During the season of Advent, which starts four Sundays before Christmas and is a period of spiritual preparation for the Christmas festival, candles can be used in an Advent wreath, a tradition that dates from around the ninth century. The Advent wreath is made up of four candles, joined together in a single candelabra or candleholder. On each of the four Sundays before Christmas, one of the candles is lit with a prayer. There is often a formula to the focus of the prayers said when each is lit – for example, Hope in the first week, then Peace, then Joy, and finally Love. The Advent wreath is usually decorated with a Christmassy evergreen such as holly or ivy, tinsel or baubles, and some churches

include a fifth candle for lighting on Christmas Eve or Christmas Day. To be strictly liturgically correct, the first three candles should be purple, the colour of penance (Advent is a penitential season), the fourth pink, and the last, if used, white.

A seven-branched candlestick is the menorah, which God commanded Moses to make and stand lit in the sanctuary during the Exodus (Exodus 25:31–40 & 37:17–24). It is used in imagery

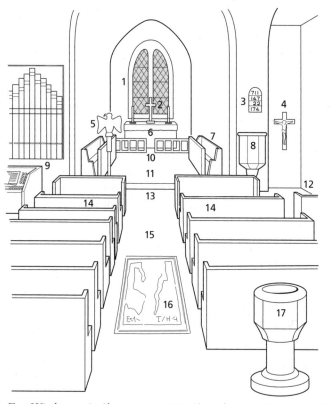

1	East Window	6	Altar	11	Chancel	16	Memorial brass
2	Cross	7	Choir pews	12	Lady chapel	17	Font
3	Hymn board	8	Pulpit	13	Chancel step		
4	Crucifix	9	Organ	14	Pews		
5	Lectern	10	Altar rails	15	Nave		

to represent Judaism, or the Temple in Jerusalem, and the word is now used to represent any seven-branched candlestick.

Lectern Placed near the division between the chancel and the nave is the lectern, on which the Bible rests for reading during services. The lectern is usually in the shape of an eagle, with the Bible resting on its outspread wings, although there are also instances of its being in the shape of a pelican. The eagle was thought to be able to look unflinchingly into the heart of the sun; in the same way, the words from the Bible are an unflinching revelation of God.

Pulpit Pulpits, from which sermons are delivered to the congregation, were introduced into Western churches in around the fourteenth century. Since they are the focus for teaching, images of the four Evangelists or the four Latin Doctors are sometimes found carved into them.

Screens In Eastern churches, a screen stands between the chancel and the nave. It is decorated with icons (the significance of which is discussed in Two Points of Church History, pages 9–10), and is pierced by three doors. The central, or royal, door leads to the altar; the prothesis, which leads to the area where the Eucharist is prepared, is on the left; and the diaconicaon, on the right, leads to the space where the sacred vessels are kept and cleaned, and books and vestments stored.

In some Western churches, particularly in some parts of England, a 'rood screen' can stand dividing the nave from the chancel. 'Rood' is an Anglo-Saxon word meaning 'cross', and the rood screen can be topped with a tall cross, often flanked by statues of the Virgin Mary and St John (both of whom were present at the Crucifixion).

Originally built to keep people (and animals) out of the chancel, the rood screen could be topped with a rood loft, a narrow gallery from which prayers could be said and hymns sung, especially at major feast-days. Most rood lofts were pulled down at the time of the Reformation, and in older churches a doorway at the entrance to the chancel, with steps leading to another doorway higher up (apparently leading nowhere), is where the rood loft was accessed. Many rood screens were destroyed at the same time, although some have survived, and in England some were installed during the Victorian fashion for church architecture in a medieval style.

Lady Chapel Many churches, particularly large churches dating from before the Reformation, include a small 'Lady chapel'. The chapel is dedicated to, and will contain images of, the Virgin Mary. Lady chapels tend to be used for services for smaller congregations (for example, mid-week services), and for the spillover of people when very large congregations are present.

Altar The altar is the holy heart of the church. It has two principal reference points. First, it is a sacrificial altar. At the time of Jesus' ministry, animal sacrifice as atonement for sin, performed on an altar, was normal Jewish ritual. Christian writers from St Paul onwards saw Jesus as having been like a sacrificial lamb in his crucifixion and death (a concept explored more closely in the section Lamb of God, page 52). The altar remembers, and in a sense repeats, that sacrifice. Secondly, it is a table for a communal meal, again remembering and repeating the Last Supper, when Jesus shared a meal with his disciples. These threads of sacrifice and a shared meal are joined in the Eucharist. Altars are made of stone (in Catholic churches) or of wood. A stone altar will tend to refer

more to the sacrifice, a wooden altar more to the meal.

In the last few decades, the altars in some churches have migrated. In the early 1960s, the Roman Catholic Church changed the practice of having the priest celebrate the Eucharist with his back to the congregation. The priest would instead, where possible, stand behind the altar and face the congregation. Therefore, instead of the priest appearing to lead the people, there would appear to be a dialogue and equality between the two. The approach has gone further in some churches. Rather than have the Eucharist celebrated in the distant area of the sanctuary, altars (often simple wooden tables) are placed at the chancel steps, or in the nave at the front or in the middle of the congregation. The purpose is to emphasize the sharing of the ceremony, and the equality of the participants before God.

A candle can hang before the altar. A white candle shows that 'reserved sacrament' (that is, bread and wine that was blessed but not consumed during the Eucharist, and is kept for future use, or use outside the church) is present in the tabernacle. Some churches keep a candle in a red lamp alight as a perpetual flame, to symbolize the continual presence of God. It remembers the menorah, the seven-branched lamp that God commanded the Israelites to burn before the altar during the Exodus.

Tabernacle Standing on or behind the altar in Catholic churches there may be a decorated box, known as a tabernacle. The name is the same as that used for the tent, in effect a portable temple, that the Israelites were commanded by God to construct and carry with them during the Exodus. Worship took place in the tabernacle, and the Ark of the Covenant, which contained the stones bearing the Ten Commandments, was placed there. The function of the church tabernacle is to store the bread for the

ceremony of the Eucharist. This bread is regarded, whether literally or metaphorically, as the body of Jesus. There is therefore a close analogy between the Israelite and the church tabernacles. The Israelite tabernacle was the holy place where God met with man, and where the symbol of the covenant between God and humankind was stored; the church tabernacle represents the meeting with God in church, and contains the new covenant, in the bread of the Eucharist. That shared meal becomes the heart of the church, physically as well as metaphorically.

CROSSES AND CRUCIFIXES

T he cross is Christianity's most important symbol, although its meaning in churches can be complex. Depending on how they are portrayed or displayed, crosses can evoke sacrifice and death, or love and hope.

The sign of the cross is a spiritual symbol that well predates Christianity. Two of the earliest forms with spiritual significance are the swastika in India and the Orient, and the ankh, or ansa, in ancient Egypt. The swastika represented sacred fire and fruitfulness, and was attributed to the goddess Maia, who personified productive powers. The ankh was held by the goddess Sekhet, who had the head of a lion and was goddess of vengeance and conquest, but it became a hieroglyphic sign for life, or the living. It is striking that both of these cross-shaped symbols, developed so far apart, were life-affirming.

The cross was not a symbol of the earliest Christians, who preferred the anchor, fish, or Chi Rho. The crucifixion was a problem for the early Church, since it had to convince unbelievers of what would have seemed a bizarre claim, that its God was a victim of this foul, and then still very current, form of punishment. Historically, crucifixion was not a punishment meted

out by the Jewish authorities, whose preferred method of execution was stoning: it was imported into Palestine by the Romans, and so was an instrument of imperialism and of subjugation. Two points illustrate this. First, it was forbidden for Roman citizens to be crucified. This was a punishment reserved for the lower orders. Secondly, it was used in particular on slaves found guilty of a crime. Therefore, it was a particular humiliation for Jesus the Jew to die like a slave on a Roman cross.

It was only over time that Christians began to think through the implications and meanings of the crucifixion, and to glorify the cross. It seems, though, that Jesus always understood the cross's positive significance. Jesus predicted his death by crucifixion, and compared himself to the bronze snake that Moses erected during the Exodus ('Just as Moses lifted up the snake in the desert, so the Son of Man must be lifted up, that everyone who believes in him may have eternal life', John 3:14–15). The purpose of the bronze snake was to cure people from poisoning. God had sent a plague of snakes to the Israelites but he provided a cure, which was effected by looking at the bronze snake. Poison is a Christian symbol for sin, and Jesus' words suggest a direct analogy between the power of the bronze snake to cure poisoning, and the power of Jesus to cure sin.

The empty cross The cross shown is the plain or 'empty' cross, a cross without the figure of Jesus hanging on it. The empty cross is an instrument of torture that has been defeated, from which the victim has walked away. In Christian teaching, Jesus died on the cross but he rose again, defying the cross's power – 'O death, where is thy sting!' (Hosea 13:14; quoted by St Paul, 1 Corinthians 15:55). The empty cross is therefore an image of

God's power, and of hope. It is hope that shines through the story of the crucifixion – the utter helplessness of Jesus on the cross, with the promise of his teachings and vision seeming to end in agonizing death, but in the end giving way to new life and glory.

The cross-anchor The message of hope is also symbolized by the cross-anchor – an anchor in which the upper beam forms the shape of a cross. Like the cross, the anchor was a symbol before the Christian period. Since they held ships safely in 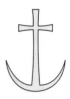 place, anchors were ancient symbols of safety, and so of hope. The symbol was adopted in the letter to the Hebrews ('We have this hope as an anchor for the soul, firm and secure', Hebrews 6:19), and it may have been adopted by the early Christians as a hidden symbol, which would not have been recognized by the authorities. In Christian terms, anchors are specifically a symbol of the hope of salvation and of eternal life, which is probably why they are found on many early Christian graves.

Crucifixes of Jesus' triumph Crucifixes are crosses to which the body of Jesus is fixed, or superimposed. On some, Jesus is shown with his arms outstretched, dressed in a long, seamless tunic (a colobium or alb) and wearing a halo and gold crown in kingly, or priestly dress. His hands may show him in the act of blessing the onlookers (with two fingers extended), or the palms may be open, in an attitude of openness and embrace (in the words of the Eucharistic prayer, used during the Eucharist, 'he opened wide his arms for us upon the cross'). This is Jesus triumphant, defeating the cross but also glorifying it. Historically, the image was most popular between the sixth and thirteenth centuries, when artists preferred not to strip Jesus of his clothes.

Crucifixes of Jesus' suffering From around the thirteenth century, crucifixes increasingly memorialized Jesus' suffering and death. Jesus is shown with his head to one side (the convention is for the head to hang to the 'good' right), and he is shown as having just died. He is wearing 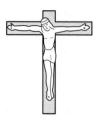 the crown of thorns, and is nailed through the palms of his hands and through his feet, usually with a single nail piercing his crossed feet, to give a devotional pose. A cut just below the ribs shows where Jesus was speared as he hung on the cross.

The reality of crucifixion is appalling. Scourging always preceded it, following which the condemned man had to carry his own, tremendously heavy, cross (or at least the cross-beam) to the place of execution. The victim was stripped naked. Long nails were then driven, not through the palms of the hands, but through the wrist bones. Without this arrangement, the victim's weight would have caused the nails to simply rip through his flesh. For the same reason, nails may have been driven just below and behind each ankle, one on each side of the central beam of the cross, rather than through the middle of the feet. Many crucifixes include a small footrest with this in mind, although in reality a small central prop, shaped like a rhino horn, often acted as a seat to give the victim support. The downward pull of the body would have caused a slow suffocation, and as he got weaker the victim would have had to endure the agony of pulling himself up against his nails to breathe. The lungs would gradually fill with fluid (some have speculated that the water that flowed out when a soldier pierced Jesus' side was the fluid that had built up in Jesus' lungs). Victims could hang in agony for days and nights. It was against Jewish law for a person to remain crucified over the Sabbath, and so on Friday afternoon if a victim was still alive his legs would be

broken, finally killing him with the shock, before he was taken down.

Crucifixes draw a veil over the worst of this suffering. It is also probably the case that by the time artists came to portray it, none had seen a crucifixion in life, and they had to rely on their imaginations to portray how it would have been.

The Stations of the Cross

Arrayed around the walls of some churches, particularly Catholic churches, are what are known as the 'Stations of the Cross' (also the *Via Crucis*, the 'Way of the Cross', and the *Via Dolorosa*, the 'Way of Sorrow'). These are tableaux, small reliefs, engravings, or paintings that show the key scenes in the condemnation and death of Jesus. They can be made of any material, most commonly wood, metal, marble, or plaster. Sometimes small crosses are placed over the tableaux. In accordance with a series of nineteenth-century papal directions, these should be made of wood, in memory of the wood of the cross.

The number of stations is now a fairly fixed canon, but there are and have been variations, with the number of scenes increasing to as many as thirty-one. The stations nowadays show:

1 Jesus condemned to be crucified;
2 Jesus taking up the cross;
3 Jesus falling under the weight of the cross (the first fall);
4 Jesus meeting the Virgin Mary;
5 Simon of Cyrene being forced to carry the cross, in place of Jesus;
6 St Veronica wiping the face of Jesus (leaving an image of his face on the cloth);
7 Jesus falling under the weight of the cross (the second fall);

8 Jesus encountering the women of Jerusalem;

9 Jesus falling under the weight of the cross (the third fall);

10 Jesus being stripped of his clothes;

11 The Crucifixion;

12 The Death;

13 The Deposition (Jesus' body being taken down from the cross);

14 The Entombment.

The series enables Christians to perform their own 'pilgrimage' in the footsteps of Jesus. Believers follow the stations in order, stopping at each to pray and meditate on the suffering of that stage ('stations', which has the same root as 'stationary', comes from the Latin for 'standing'). In this way, the Christian is trying to take literally Jesus' metaphorical command, that Christians must take up their cross and follow him (Matthew 16:24). In churches containing the stations, the whole congregation may follow them together in a service held on the day when the events are most remembered, Good Friday.

There is in fact a Via Dolorosa in Jerusalem (and that is its street name) along which Jesus is said to have walked to his death. The 'true' (or traditional) stations are set out along it. Papal indulgences (formal remissions from punishment for sin) used to be allowed to people who had undertaken a pilgrimage to these stations, and installing Stations of the Cross in churches became more popular as it became harder to make a pilgrimage to Jerusalem to visit the sites themselves. In the seventeenth and eighteenth centuries, the Popes declared that the same indulgences would be granted to anyone who visited the stations in a church as would be granted to pilgrims in Jerusalem.

Cross Shapes

There are a great number of crosses used with different shapes, many of them purely decorative. What follows are a few of the most common that have some symbolic association.

Celtic The Celtic or wheel-head cross incorporates a circle. The origin and symbolism of this is not known, although the wheel has been thought to represent a crown, a halo, rays of light, or the circle of eternity. Its popularity may simply derive from its additional strength.

 Easter The Easter cross is garlanded by flowers (especially the lily, although they are nowadays seen as often with spring-time daffodils), symbolizing new life.

Graded The graded cross has three steps leading up to it, symbolic (from the base) of faith, hope, and love.

Papal The Papal cross, which is carried before the Pope, has three bars, like the Pope's triple crown, or the inscription (INRI), crossbar, and foot-rest.

Passion A cross that has its ends coming to points is the Passion Cross, as the points represent the wounds of Jesus.

Patriarchal The Patriarchal cross of the Eastern Church has two bars, for the inscription and crossbar.

Swastika The swastika appears fairly frequently on old Christian monuments in Rome, but the appalling associations of the last century mean that it is now little seen elsewhere.

Tau In Western Europe the cross usually has the vertical extending above the cross-beam. Sometimes, though, the cross is shown shaped like the letter T, reflecting a debate in the early Church on the proper shape of the cross. A Y-shape is less common, but appears in some northern European churches.

Triumph A cross sitting on a globe (a globe is sometimes placed under the cross on a church spire) is the cross of triumph, and symbolizes victory over the whole world.

The Use of Particular Crosses

Altar crosses, crosses standing on the altars themselves, have swung in and out of fashion over the centuries. The rule between the ninth and eleventh centuries was that the altar should be left bare. In the thirteenth century, Pope Innocent III said that a cross should be placed on the altar at the beginning of Mass, and for several centuries it was the practice to leave the altar bare save for during the Mass. Protestant and Roman Catholic Churches diverged in their practices at the Reformation: reformers tended to be against ornamentation of any kind, and swept the altar bare again; conversely, Roman Catholics made the altar cross a permanent fixture and increasingly used crucifixes instead of the plain crosses of before. Nowadays, Roman Catholic churches keep a crucifix on the altar, guarded by at least two candlesticks. The practice in other churches is fairly diverse, and may depend on whether there is another prominent cross near the altar.

The processional cross stands on a pole, and is often kept by the altar or near it on its own stand. The cross is carried high at the front of processions, and if it is a crucifix then the image of Jesus is turned away from the procession, so that the procession is

'following' Jesus. The handle should be detachable, for a sad reason: in funerals for children the processional cross is meant to be carried without the handle, shrinking it to a size more suitable for a child.

Consecration crosses mark the points on the walls where a church was anointed when it was consecrated. The ritual of consecration is intended to sanctify the building and dedicate it to God. It therefore separates it from the 'ordinary' space outside, and differentiates it from other buildings (a ceremony of deconsecration reverses the process, and will have been performed on any church being turned into secular use). The consecrating bishop makes twelve signs of the cross, three on each wall. These spots are marked in a permanent way, in paint or with a stone or metal cross (perishable crosses, such as those made from wood, are not allowed in the Roman Catholic Church). Each is marked with holy oil and a candle placed under it. The crosses should never be removed, because they are proof that the space within the four walls has been consecrated. Some churches have the same spots on their outer walls.

GOD

'Thou shalt not make thee any graven image ... Thou shalt not bow down thyself unto them, nor serve them: for I the Lord thy God am a jealous God, visiting the iniquity of the fathers upon the children unto the third and fourth generation of them that hate me ... ' (Deuteronomy 5:8–9). So says the second of the Ten Commandments, creating a clear break between pagan worship, which was thought to be directed at specific idols, and the way the Jewish God would be worshipped: no idols necessary. As we will see, the commandment has inhibited direct portrayals of God the Father, although this has meant that this is an area in which symbolism has come into its own. We will be looking at ways in which the three persons of God – Father, Son, and Spirit – are represented in churches, and how they are used to illustrate specifically Christian teachings about God (the background theology is discussed in the section Christian Theology in Imagery, pages 5–7).

The Trinity

Unsurprisingly, symbols of the Trinity always involve the number three. An equilateral triangle is one of the oldest Christian symbols, the equality of the sides and the angles expressing the equality of the Persons of the Trinity. Two interwoven triangles

Equilateral Triangle *Two Triangles* *Triangle in Circle*

forming a six-pointed star can also be used. This image has a theological message, with a special reference to the Creation: a six-pointed star is an ancient symbol of creation, and using two interlacing triangles expresses the eternal nature of the Trinity, since it was present at the Creation.

Circles are a symbol of God (see the section Numbers and Shapes, page 13), and the equilateral triangle is often portrayed with a circle inside or outside it. Three interwoven circles represent the Trinity, as do the three-pointed symbols known as the trefoil and the triqueta. In fact, any three objects woven together are likely to symbolize the Trinity, most commonly three fish. This means that the image can take on a little local colour. For example, the church of St Mary's at Widdecombe-in-the-Moor in Devon was built

close to commercial rabbit warrens: in the church, the Trinity is expressed by three rabbits running in a circle, joined by shared ears.

A three-petalled flower such as the fleur-de-lys is often used to represent the Trinity, as is the clover or shamrock. The latter comes from a legend of St Patrick, a missionary to the Irish and now Ireland's patron saint. When challenged about the doctrine of the Trinity, Patrick plucked a shamrock from the ground and asked his listeners whether he held one leaf or three. Having stunned his

audience into silence, Patrick said that if they could not understand the shamrock, then how could they expect to understand the Trinity?

A heraldic shield (the 'Shield of the Blessed Trinity') is sometimes used, particularly in churches dedicated to the Holy Trinity. The Latin words *Pater* (Father), *Filius* (Son), and *Spiritus* (Spirit) stand in a triangle, with *Deus* (God) in the middle of them. The words *non est* (is not) runs between each of the words *Pater*, 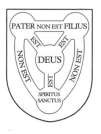 *Filius*, and *Spiritus*, to show that the Father 'is not' the Son, who in turn 'is not' the Spirit. The word *est* (is) runs between the word *Deus* and the other three words, to express the idea that, nevertheless, the Father is God, the Son is God, and the Spirit is God.

God the Father

It may seem surprising, but the cartoon image of God, as an ancient white-haired man sitting on a throne, does have biblical authority. The prophet Daniel had a vision of God like a man sitting on a throne, 'whose garment was white as snow, and the hair of his head like the pure wool: his throne was like the fiery flame, and his wheels as burning fire' (Daniel 7:9). However, there has traditionally been some reluctance to portray God in a representational way, because of the prohibition against creating

The Hand of God

God's Blessing

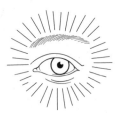

The All-seeing Eye

idols in the second of the Ten Commandments (see introduction to this chapter, page 48). This prohibition was sometimes interpreted as also forbidding the creation of an image of God.

God may, though, be represented symbolically. The most common symbol is a hand, known as the *Manus Dei* (Latin for Hand of God), which emerges from a cloud in a blaze of light, or is circled with a cruciform halo. It is always the right hand, after Psalm 139:10, 'If I rise on the wings of the dawn, if I settle on the far side of the sea, even there your hand will guide me, your right hand will hold me fast'.

Different shapes and directions of the hand show different intentions in the artist. If the hand is extending downwards towards humankind, then it expresses God's grace; two fingers extended indicates God's blessing; an open palm, God's assistance; and an arrangement with the first finger extended, the second and fourth curved, and the thumb and third finger crossed expresses Jesus, because it spells ICXC (see IHS and IHC, page 219). Sometimes the hand is shown holding a number of small figures, in which case God is holding the souls of the righteous, after the Book of Wisdom ('the Souls of the Righteous are in the hand of God').

Letters can be used, often within a circle, triangle, or blaze of glory. These may be the Hebrew letters for Yahweh, or, since the name of Yahweh was considered too holy to use, one or two yods (yods are the Hebrew letters that form part of Yahweh). Alternatively, the words *El Saddai* (the Almighty) or *Adonai* (Lord) are used.

Other symbolic representations of God the Father are an eye, to express God's omnipotence and all-seeing nature (this is the same eye that appears on dollar bills, within a triangle expressing the Trinity), a cloud, or an aureole standing alone.

God the Son

Needless to say, images of Jesus usually appear all about in churches. This section deals with individual symbols and representations, while the next chapter, 'Jesus', deals with episodes from his life. Other symbols that can refer to Jesus include the sun, the star, the branch, the fountain, the vine, the pelican, and the snake.

Fish The fish is an ancient Christian symbol, predating even the cross as a sign used by the early Christians. The Greek word for fish is *icthus*, which can be read as an acronym of the Greek phrase *Iesous Christos Theou Huios Soter* ('Jesus Christ, Son of God, Saviour'). It may be that the early Christians adopted this because it was a secret symbol, which would not draw attention to them at a time when the Church was suffering persecution.

Lamb of God (Agnus Dei) 'Lamb of God' is a description of Jesus first used by St John the Baptist. When John first saw Jesus he cried out, 'Behold the Lamb of God, who takes away the sin of the world!' (John 1:29). The image is taken up in Acts ('He was led like a sheep to the slaughter, and as a lamb before the shearer is silent, so he did not open his mouth', Acts 8:32 and Isaiah 53:7), by St Peter ('Christ, a lamb without blemish or defect', 1 Peter 1:20), by St Paul (Jesus is 'our Passover lamb', 1 Corinthians 5:7), and by St John the Divine ('Worthy is the Lamb, who was slain, to receive power and wealth and wisdom and strength and honour and glory and praise!', Revelation 5:12). A lamb that represents Jesus is identifiable by its cruciform halo.

The image is one of meekness and suffering (going quietly to

the slaughter), and of purity, through the whiteness of a lamb's fleece. Above all, the image is of Jesus as a sacrificial lamb, and specifically a lamb sacrificed at the Jewish ceremony of Passover. In the story of the Exodus, God planned to compel Pharaoh to release the people of Israel from slavery by killing the firstborn of each Egyptian household. He told the people of Israel to sacrifice lambs and use their blood to mark their doorposts, so that by that sign God would know to pass over their homes, and not take their firstborn. In John's Gospel, Jesus' death mirrors God's commands as to how to carry out this sacrifice: Jesus died at twilight on Passover, the time God told the Israelites that lambs should be sacrificed (John 19:4/Exodus 12:6); Jesus was offered wine from hyssop, a hairy plant that retained the liquid it was dipped in, just as God told the Israelites to dip hyssop in the blood of the sacrificed lambs (John 19:29/Exodus 12:22); and Jesus' bones were not broken, just as God told the Israelites not to break the bones of the sacrificial lambs (John 19:36/Exodus 12:46). On this reading, Jesus is the ultimate Passover sacrifice, causing God to pass over and spare humankind.

The lamb is often shown in a position of triumph, standing with its leg hooked around the pole of a flag made up of a red cross on a white background and topped with another cross (English public houses often have names which derive from religious imagery – the Lamb and Flag is just one example). The image is meant to convey the message that Jesus is the sacrifice that has triumphed. The lamb may also be shown bleeding into a cup, which is Jesus' blood becoming the wine of the Eucharist.

A lamb (or ram) also appears in Jewish writing about the apocalypse at the end of time, as the agent of God who would crush evil and save God's people. This is the starting-point for the use of a lamb in St John's vision in the Book of Revelation. John

saw a lamb, and a book with seven seals. When the lamb opened the seals, it ushered in the final apocalypse. If a lamb is positioned on or beside a book from which seven seals are hanging, it is a reference to this terrifying vision (Revelation 5).

The Sacred Heart A common image in Roman Catholic and some Anglican churches is that of the Sacred Heart. The heart may be rayed, or on fire, topped with a small cross or crown, pierced with a spear, or ringed by a crown of thorns. In some images, Jesus looks directly at the onlooker, holding open his cloak with one hand to reveal his heart beneath. He draws attention to his heart by pointing to it.

Some people now find these fleshy objects – the fleshiness is intended to emphasize Jesus' humanity – repulsive, and we need to look beyond the symbol to the intent behind it. This is a devotional image, meaning that it is intended for use by the onlooker as an object of meditation and as a channel for worship. Locating a person's spirit in his or her heart is an ancient tradition, and hearts are still a common symbol of love and of bravery. The intention in the image is to focus on Jesus' inner spirit, as opposed to, say, his words or his deeds. Above all, it is Jesus' love and his courage that are remembered in images of the Sacred Heart, with the rays or fire emphasizing the strength of his passion.

The biblical basis for the image is the wound that Jesus received in his side when a Roman soldier speared him as he hung on the cross. There was a steady increase in theological meditations on Jesus' wounds and his heart from around the twelfth century. The image received its greatest boost, though, through the visions of St Mary Margaret (1647–90). Mary Margaret was a nun at the Visitation Convent at Paray-le-Monial in France. She was an

ascetic (as a child her self-mortification was so severe that she was paralysed for four years) who had received visions of Jesus from an early age. These visions began gradually to focus on the Sacred Heart. Jesus told Mary Margaret that he wanted to be honoured through the image of a heart, and in June 1675 Jesus appeared to her with the words 'Behold the Heart that has so loved men'. Mary Margaret overcame suspicion and opposition from her own order and was persuaded to write an account of her visions, which quickly became popular.

Similar images of the heart are also attributed to the Virgin Mary, when they are known as the Immaculate Heart of Mary. They can be distinguished from the Sacred Heart of Jesus, because whereas the heart of Jesus is pierced with a spear, the heart of Mary is pierced with a sword. The image derives from Mary's meeting with Simeon at the Presentation. Taking the baby Jesus in his arms, Simeon turned to Mary and said, 'This child is destined to cause the falling and rising of many in Israel, and to be a sign that will be spoken against, so that the thoughts of many hearts will be revealed. And a sword will pierce your own soul too' (Luke 2:25–35).

God the Holy Spirit/Holy Ghost

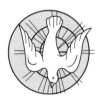

The most common way of representing the Holy Spirit is in the form of a dove. The reference comes from the Baptism of Jesus: 'When all the people were being baptized, Jesus was baptized too. And as he was praying, heaven was opened and the Holy Spirit descended on him in bodily form like a dove. And a voice came from heaven: "You are my Son, whom I love; with you I am well pleased" ' (Luke 3:21–22). The dove is often seen descending and haloed (frequently with a cruciform halo), particularly high up on a church's main stained-glass window.

The Holy Spirit can also be represented by fire, in particular a fire with seven or nine or twelve tongues of flame, or by seven or nine hanging lamps, or an equal number of doves. The reference to fire is to Pentecost. The disciples were sitting in a room together, when there was suddenly a sound like a violent wind, and tongues of fire appeared and touched each of them. The disciples were filled with the Holy Spirit and began to speak in other languages (Acts 2:1–4). The reference to the hanging lamps is to the gifts of the Holy Spirit, and this is also the origin of the different numberings. If there are seven lamps, tongues of fire, or doves, then they represent the seven 'sanctifying' gifts of the Holy Spirit: wisdom (*sapientia*), understanding (*intellectus*), counsel (*consilium*), spiritual strength (*fortitudo*), knowledge (*scientia*), godliness (*pietas*), and fear of God (*timor*) (derived from Isaiah 11:2–3). If there are nine, then they represent the nine 'charismatic' gifts: speaking with wisdom, speaking with knowledge, faith, the power of healing, the power to perform miracles, the power to prophesy, the gift of discerning spirits, speaking in tongues, and the gift of interpreting (derived from 1 Corinthians 12:8–10). There may be twelve tongues of fire, because at Pentecost the fire of the Holy Spirit touched each of the twelve disciples.

The Seven-fold Flame

The Seven Lamps

JESUS

There are few churches that do not contain many images of Jesus, in stained glass, on the walls, in paintings, statues, or on crucifixes. The way he is portrayed has developed over time. The earliest representations portrayed him as a young man, clean-shaven and with long curling hair. The now-familiar image of Jesus, bearded and in his early thirties, derives from an apocryphal description that was supposedly sent to the Roman Senate by Publius Lentulus, Proconsul of Judaea, after a meeting with Jesus. Lentulus described Jesus as having hair that was straight from his crown to his ears before descending in curls to his shoulders and then down his back, where it was divided into two portions. He said that Jesus had an abundant forked beard, and that his hair was the colour of wine (a description that is not terribly helpful, given the variety of wine's colours). Whether Lentulus' description was true, or is a fiction created from a desire to know more about Jesus' appearance, it was in circulation among the early Christians, and from the fourth century the Emperor Constantine caused images of Jesus to be made on the basis of it.

Apologies to bearded readers for what follows. Images of Jesus with a beard may also have developed through a wish to symbolize ugliness. There was some debate in the early Church as to whether Jesus was in appearance the most handsome, or the most repulsive,

of men. One view was that since God is supremely beautiful, and Jesus was God on earth, so Jesus too must have been supremely beautiful. The opposing view was that God the Son took on himself all human misery when he entered the world, and so had a horrible, diseased appearance. This 'ugly' view claimed support from the Prophet Isaiah: 'he had ... nothing in his appearance that we should desire him. He was despised and rejected by others ... surely he has borne our infirmities and carried our diseases' (Isaiah 53:2–4). Bearded and unbearded images of Jesus appeared concurrently until around the eleventh century. The theory runs that during this period, if an artist wanted to emphasize Jesus' divinity then he would take the 'beauty' side of the debate, and symbolize this by having Jesus beardless, whereas he would portray him as bearded if he wanted to emphasize Jesus' humanity and supposed ugliness. From around the eleventh century, images of Jesus with a beard took the ascendance.

We now turn to representations of some scenes from the life of Jesus. There is a tendency in church imagery to portray events that are marked by a Church festival, which in turn tend to mark events in the early and later stages of his life. Therefore what follows has an emphasis on those events, rather than aspects of Jesus' ministry and teaching. Jesus is the focal point of every scene in which he appears, and is often identifiable by his cruciform halo.

The Nativity

The Bible states that Jesus was born in a stable in Bethlehem. The key figures in any Nativity scene are the baby Jesus, who lies or sits on a bed of straw or in a manger (the feeding stall from which the animals ate); his mother the Virgin Mary, dressed in blue; his foster father, St Joseph, bearded and usually in brown; and an ox and an ass.

The ox and the ass do not appear in the Gospels, but derive from

HOW TO READ A CHURCH

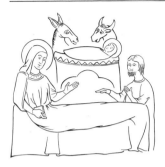

the opening chapter of Isaiah: 'The ox knows his master, the donkey his owner's manger, but Israel does not know, my people do not understand' (Isaiah 1:3). Apocryphal Gospels later recorded their presence as fact. Some Christian commentators tried to explain how the ox and the ass came to be there: the ox, they said, was brought to Bethlehem by Joseph to sell, while the ass was transport for Mary.

To be biblically correct, Jesus should appear wrapped tightly in cloth (which was, and still is, a comfort for newborn babies). However, many artists felt that it would make a more affecting scene to portray Jesus out of these constraints. In 1370 the mystic St Brigid of Sweden had a famous vision of the Nativity, which also influenced portrayals. Brigid saw an 'instantaneous' birth in which Jesus was born radiant in glory and free of constraints, while Mary fell on her knees before him in welcome and worship. An alternative account of the birth came from another fourteenth-century work, *Meditations on the Life of Christ*. In this account, Mary gave birth standing up and leaning on a column, which is why a column can appear (sometimes quite incongruously) in the middle of the stable.

The stable is often portrayed as a tumble-down building. This may be a symbol of the dilapidation of the old covenant with God, which was now to be replaced by a new covenant through Jesus, or it may be another tradition from the *Meditations*, that the family rested in a shelter that Joseph had built. The stable has also been portrayed as a cave, after certain of the apocryphal Gospels. The tradition may have some truth in it, since in first-century Palestine animals were often stabled in caves.

The Holy Family may be joined by a group of shepherds, and one or more of their sheep. Angels appeared to a group of shepherds outside Jerusalem to announce that the Messiah had been born that night in Bethlehem, and they went to visit the new king. There is an old tradition that the shepherds were playing music when the angels interrupted them, and so they are sometimes portrayed carrying their instruments. The sheep also function as a reminder of Jesus as the Lamb of God.

The Presentation in the Temple and the Purification

Mary and Joseph then went to the Temple in Jerusalem, for the purification of Mary and the presentation of Jesus, in accordance with Jewish law. Scenes will usually include a pair of turtledoves or pigeons, which was the prescribed sacrifice. They may also include candles, because the Church's feast commemorating the Purification, known as Candlemas, came to involve a procession of candles.

It had been revealed to a devout man called Simeon that he would not die before he had seen the Messiah. When he saw the baby Jesus in the Temple, he took him in his arms, blessed God, and said the words 'Lord, now lettest thou thy servant depart in peace' (*Nunc dimittis, Domine*). There was also an elderly prophetess in the Temple called Anna. When she saw Jesus, she too gave thanks to God, and spoke of Jesus to all those who had come to Jerusalem looking for redemption. Anna is sometimes portrayed in a gesture of prophecy, with her right arm raised and finger pointing.

The Magi

Matthew's Gospel records that the Holy Family was visited by the Magi, who had observed a star in the east and come looking for the King of the Jews. In the Bible the Magi are wise men or astrologers, although they are usually portrayed as kings, a portrayal

that derives from the idea that their visit fulfilled prophecies in the Psalms that 'all kings shall fall down before him' (72:11), and in Isaiah that 'Nations shall come to your light, and kings to the brightness of your dawn' (60:3–6). One significance of the visit in Christian teaching is that the Magi were the first non-Jews to recognize Jesus. In addition, the fact that the Magi bowed down before Jesus was often cited by the Church as proof of the submission of earthly powers to its heavenly power.

The Magi did not arrive until after the Presentation. Matthew's Gospel refers to them visiting the Holy Family in a house, rather than in the stable (2:11), and they may have visited up to two years after the Nativity. Jesus is therefore often older in scenes including the Magi than he is in scenes of the Nativity. The Magi brought with them symbolic gifts of gold, frankincense, and myrrh. Gold was later interpreted as representing Jesus' kingship, frankincense (an incense used in worship) his divinity or priestliness, and myrrh (an embalmer for the dead) his death. There is no record in the Bible of how many Magi there were, but the number of gifts led to three being portrayed. Their traditional names in the West are Gaspar (or Caspar, who is the oldest, and bearded), Melchior, and Balthasar. From the fourteenth century the Magi were sometimes portrayed as being of different races, with Balthasar, carrier of myrrh, portrayed as having been black. This came from the idea that all the races of the earth – European, Asian, and African – had come to worship the new King (Matthew 2:1–12).

The Massacre of the Innocents and the Flight to Egypt

On their way to Bethlehem, the Magi had told Herod that they were looking for the King of the Jews, who was to be born in Bethlehem. Disturbed by this apparent threat to his power, Herod

asked the Magi to tell him once they had found this King. However, after the Magi had visited Jesus, they were warned in a dream to return home by a different route. Incensed, Herod gave an order that every boy in Bethlehem and its vicinity under the age of two should be put to death (Matthew 2:13–15). These 'Holy Innocents' have been considered the first Christian martyrs, dying in place of Jesus. A medieval convention portrayed them being killed before the throne of Herod.

Jesus was saved because an angel appeared to Joseph and told him to escape with his family to Egypt. An image of Joseph leading an ass on which Mary is carrying the infant Jesus, possibly guarded by one or more angels, is a representation of the Flight into Egypt. Interesting traditions grew up around the Flight. Pursued by Herod's soldiers, the Family was said to have passed a man sowing corn. Mary asked him to tell the soldiers chasing them that the family had passed by before the man's corn had grown. The corn miraculously grew and ripened overnight, and Herod's soldiers gave up the chase when the sower told them – quite truthfully – that the family had passed over the field before the corn had grown. A cornfield in the background, or sowers or reapers, is an allusion to the story. A broken or tottering building in images of the Flight comes from the story that the pagan idols of the Temple of Sotinen in Egypt fell to the ground when Mary and Jesus arrived and entered it. The tradition is derived from a prophecy of Isaiah, 'See, the Lord is riding on a swift cloud and comes to Egypt, the idols of Egypt will tremble at his presence' (Isaiah 19:1). Another story, from the apocryphal Gospel of pseudo-Matthew, is that on the journey Mary wished to eat the fruit of a tall tree beneath which the family was resting. On Jesus' command the tree bent down to give its fruit into Mary's hand. The story is sometimes alluded to with a background of a bending tree.

The Return from Egypt

After the death of King Herod, an angel told Joseph that the land was now safe. Joseph therefore returned with his family to Nazareth, in fulfilment of a prophecy that the Messiah would come from Nazareth (Matthew 2:19–23). The return from Egypt was also significant because of its reflection of the Exodus. Images of the return from Egypt differ from those of the Flight to Egypt, because Jesus is portrayed as a young boy.

Christ among the Doctors/Dispute in the Temple

Each year Mary and Joseph went to the Temple in Jerusalem for the Feast of the Passover. Returning from the feast when Jesus was twelve, they accidentally left him behind. They returned to Jerusalem, and after three days found Jesus in the Temple, deep in discussion with the teachers (rabbis). The scene is significant in Christian terms for a number of reasons. It shows Jesus' precocious abilities; it is the first instance of Jesus teaching; and it is the first time that Jesus indicated his position as the Son of God, through his rebuke to his worried mother ('Why were you searching for me? Didn't you know I had to be in my Father's house?' Luke 2:49).

The teachers can be portrayed in exotic Eastern dress and turbans, although the scene is sometimes given a contemporary spin by putting them in modern scholarly dress. Sometimes Jesus is portrayed holding a book, while one of the teachers is holding a scroll – an arrangement that is intended to contrast the New and Old Testaments.

The Baptism of Jesus

St John the Baptist was preaching repentance in the Judaean desert, and baptizing those that came to him. Jesus came to be baptized. As John baptized him 'heaven was opened, and he saw

the Spirit of God descending like a dove and lighting on him. And a voice from heaven said, "This is my Son, whom I love; with him I am well pleased."' This point is considered to be the start of Jesus' ministry.

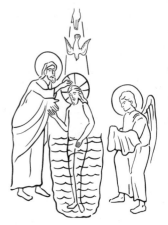

Representations of the baptism usually have Jesus wearing a loincloth and standing in the River Jordan. John pours water over his head, as light streams from the heavens or God the Father appears (for example, represented by a hand) and God the Holy Spirit descends in the form of a dove. If there are fish in the water, these represent Christian souls: the water of baptism gives them 'new life', just as water is life to the fish. Angels sometimes appear on the bank of the river, holding Jesus' clothes. Either Jesus or John may be kneeling before the other. If John is kneeling, it is an allusion to his humbling himself before Jesus, with the words 'I need to be baptized by you, and do you come to me?' (Matthew 3:14). If Jesus is kneeling, it is meant to indicate his humility in accepting a ritual of purification that was unnecessary, since Jesus was without sin.

The Wedding at Cana

Jesus' first miracle took place at a wedding banquet in the town of Cana near Galilee, which he was attending with his mother and the disciples. As the party ran out of wine, Mary tried to prompt Jesus to do something about it. Jesus responded, 'Dear woman, why do you involve me? My time has not yet come.' Mary, though, persisted, and told the servants to do whatever Jesus told them. Badgered by his mother, Jesus had the servants take six vast stone jars, which were used for ceremonial washing, and fill them

with water to the brim, which he then turned into wine (about 150 gallons of it; this was quite a party) (John 2:1–11). The wine tasted even better than the 'good' wine that the host had served his guests first, a comparison that was taken to be a metaphor for the glories of the new world that Jesus was ushering in, compared to the old world of the prophets.

The moment most often depicted is that when the astonished master of ceremonies tastes the new wine. The groom is sometimes shown with a halo, which alludes to a tradition that he was St John, or alternatively St Simon the Zealot.

The Raising of Lazarus

Lazarus, the brother of Mary (possibly St Mary Magdalene) and Martha, fell sick and died. By the time Jesus arrived at the tomb, Lazarus had been dead for four days. Jesus comforted Martha with words that are used in the funeral service, and may appear on representations of the scene: 'I am the resurrection and the life. He who believes in me will live, even though he dies; and whoever lives and believes in me will never die' (John 11:25-26).

Mary then fell weeping at Jesus' feet, and 'Jesus wept' (words famous as the shortest verse in the Bible: John 11:35). Jesus then ordered that the stone be removed from the entrance to Lazarus' tomb, in spite of Martha's protest, 'Lord, by this time he stinketh' (Mary and Martha are sometimes shown holding their noses). Jesus then called in a loud voice, 'Lazarus, come out!' The dead man came out, his hands and feet wrapped with strips of linen, and a cloth around his face (John 11:1–44).

The Transfiguration

Jesus went with St Peter, St John, and St James onto a mountain (traditionally Mt Tabor in Galilee) to pray. As he prayed, the

appearance of his face changed, and his clothes became bright as a flash of lightning. Moses and Elijah then appeared, talking with Jesus. The three disciples, who had been sleeping, woke up, and Peter offered to build three shelters for them. While he was speaking, they were enveloped by a cloud from which a voice came, saying, 'This is my Son, whom I have chosen; listen to him.' After the voice had spoken, they found that Jesus was alone (Luke 9:28–36). The scene is important as a manifestation of Jesus' future glory, rather like the trailer to a film.

Expulsion of the Moneychangers/ Cleansing of the Temple

Strictly speaking, the Expulsion of the Moneychangers took place after Jesus had entered Jerusalem (see next page). However, since it does not form part of the Passion cycle, it is usually treated separately.

Jesus entered the Temple area, and with a scourge of small cords began furiously driving out those who were buying and selling there, overturning the tables of the moneychangers (who converted Roman coins, which could not be used in the Temple, into kosher money, which could) and the benches of those selling oxen, sheep, and doves for sacrifice. Jesus gave the reason for his uncharacteristic behaviour: 'Is it not written: "My house will be called a house of prayer for all nations" [a quotation from Isaiah 53:7]? But you have made it a den of robbers' (Mark 11:15–17; John 2:13). Jesus is shown brandishing his scourge, in the middle of a chaos of spilt coins, escaping animals, and cowering people.

The Passion

The events of the last week of Jesus' life are known as the Passion. Two of the events, the Last Supper and the Crucifixion, are the

scenes most often portrayed in church art. The events start with
Jesus' triumphal entry into Jerusalem.

The Entry into Jerusalem

After preaching through Judaea, Jesus came to Jerusalem. He
entered Jerusalem riding on a young ass that the disciples had
collected for him. Jesus' fame preceded him, and many spread their
cloaks on the road, or palms or branches cut in the field (if palms
are not shown, the branches are usually olives, in reference to the
Mount of Olives, where Jesus was to be betrayed). John's Gospel
explains that the entry on a donkey was a fulfilment of the words
of the Prophet Zechariah: 'Do not be afraid, daughter of Zion.
Look, your king is coming, sitting on a donkey's colt!' (Zechariah
9:9; John 12:15). Jesus is usually shown entering the city gates,
from (bad) left to (good) right. Riding side-saddle is a normal way
in Palestine to travel on a donkey, and in the Eastern Church this
is how Jesus is shown riding.

The crowds shouted words that may appear near the
representations of the scene: 'Hosanna! Blessed is he who comes
in the name of the Lord!' Sometimes a large number of children
are included in the crowd. This may come from a passage in the
apocryphal Gospel of Nicodemus, that at the coming of Jesus 'the
children of the Hebrews held branches in their hands'; it may also
be a reference to the choirboys who might greet or lead the
congregation as it processed into church, carrying their palms, on
Palm Sunday.

Often appearing in the scene is the little figure of Zacchaeus
up a tree, although strictly speaking his story took place in Jericho,
and not in Jerusalem. Zacchaeus was a wealthy tax collector. A
short man, he could not see Jesus over the crowds, and so he
climbed a sycamore tree besides which Jesus was to walk. Jesus saw

him, told him to come down, and said that he was coming to stay at his house (Mark 11:1–11; Luke 19:1–10 & 28–40).

The Last Supper

Jesus' words and deeds during his Last Supper with his disciples before his betrayal and death are the basis of the Eucharist, the Church's central act of worship. Images of the Last Supper are therefore extremely common in churches, particularly behind or above the altar, where the Eucharist is celebrated.

The meal of the Last Supper was held in celebration of the Passover, the festival that commemorates the liberation of Israel in the Exodus. Jesus and the disciples ate together in a large upstairs room. During the meal, Jesus said that one of the disciples would betray him. St John was reclining beside Jesus, and leaned back against him to ask who he meant (John 13:23–27). Jesus revealed to Judas Iscariot (although not to the other disciples) that he knew that it would be him, by dipping a sop of bread in wine and handing it to him (John's Gospel), or alternatively by dipping his bread into a bowl at the same time as Judas (Mark's and Matthew's Gospels). Although the group would have been eating lamb (since it was Passover), sometimes the table is shown laid with fish. The fish is a symbol of Jesus himself, and was also associated with miraculous feeding because of its use in the feeding of the five thousand, which some Christian writers thought anticipated the Eucharist.

While they were eating, Jesus performed the ceremony that remains central to the Eucharist. He took bread, gave thanks and broke it, and gave it to his disciples, saying, 'Take and eat; this is my body.' Then

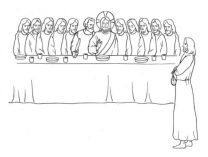

he took the cup, gave thanks, and offered it to them, saying, 'Drink from it, all of you. This is my blood of the covenant, which is poured out for many for the forgiveness of sins.' (Matthew 26:17–30; Mark 14:12–26; Luke 22:7–22.) These words may be inscribed near the scene.

Representations of the Last Supper usually include the twelve disciples seated around the table, with Jesus in a central position. This is probably not historically accurate. When God commanded the Israelites to commemorate the Passover, he said that they were to eat standing up, as if they were about to leave, in memory of the rushed last meal before the Exodus. However, by Roman times, reclining during meals was the mark of a free man, and so was considered more appropriate for a festival that celebrated freedom. The very earliest representations of the scene have Jesus and the apostles in reclining positions, with Jesus at the right of the table, the Roman position of honour.

Jesus may be taking the bread to break it, or blessing the cup of wine, or dipping into a bowl with Judas. Sitting next to Jesus is St John, beardless and with his head resting on Jesus' chest (some artists misinterpreted John's reclining position and portray him fast asleep!). Often no real attempt is made to distinguish the other disciples, but some or all of the following features can be used. Peter may sit near Jesus, in reference to his seniority. He has short curly grey hair and a beard, and is sometimes holding a knife, perhaps in a reference to his cutting off the ear of the slave of the High Priest, during the Betrayal; Andrew is usually more elderly, with flowing grey hair and a forked beard; James the Great and James the Less were said to be brothers of Jesus, so can be portrayed with similar features and hairstyle to that worn by Jesus (James the Great will be sitting closer to Jesus, since he was the closer companion of the two); Philip and Thomas are the youngest

of the group, and may be clean-shaven; Simon and Jude were traditionally brothers, and are older and sitting together; Bartholomew and Matthew may both have dark hair and beards.

The treacherous Judas Iscariot often sits slightly apart from the group, or else is already up and leaving the room to betray Jesus. Since he was the money-holder for the group, he is usually carrying or wearing a purse, a device that also alludes to the thirty pieces of silver he took to betray Jesus. Unlike the other apostles, he may have been denied a halo – or been given one that is black. Judas may also have his back to the viewer, or be shown side-on. In Byzantine artistic tradition, evil persons could not be portrayed looking outwards, because if an onlooker caught their gaze it might corrupt them. The tradition seems to have been followed in Western art.

Jesus Washes the Feet of the Disciples

During the Last Supper, Jesus got up from the meal, took off his outer clothing, and wrapped a towel around his waist. He poured water into a basin and began to wash his disciples' feet, drying them with the towel that was wrapped around him. When he came to wash St Peter's feet, Peter resisted. Jesus explained that he was setting an example that they should do as he had done. No servant, he said, was greater than his master, nor is a messenger greater than the one who sent him (John 13:1–17). It is always Peter's feet – with Peter looking rather uncomfortable, or with a hand raised in protest – that Jesus is shown washing.

The Agony in the Garden

The word 'Agony' in 'the Agony in the Garden' can be thought of in terms of its root in the Greek word *agon*, a contest. It is a reference to the turmoil of mind that Jesus went through before giving himself up to betrayal and crucifixion, the contest between

his wish to avoid the suffering to come and his obedience to God, or a conflict between his human and divine natures.

After the Last Supper, Jesus went with his disciples to the Garden of Gethsemane. He took St Peter, St John, and St James the Great with him as he went to pray. Going further into the garden, he fell forward, and prayed: 'My Father, if it is possible, may this cup be taken from me. Yet not as I will, but as you will.' The three disciples, meanwhile, had fallen asleep. Jesus woke them (saying to Peter, 'The spirit is willing, but the body is weak'), and twice more returned to prayer, only to find them asleep again. In one version of Luke's account, an angel appeared to strengthen Jesus (page 177), and he prayed so earnestly that 'his sweat became like great drops of blood falling down on the ground' (Luke 22:43–44). These lines are missing from some ancient versions of Luke's Gospel, but the vivid images of the strengthening angel and the sweat like blood are often reproduced.

The night-time scene includes Jesus praying, often kneeling on a rocky outcrop, with the three sleeping disciples below. Jesus is looking to the angel, or to an image of the cup that he had asked to be taken from him.

The Betrayal

Judas then arrived at the garden with a detachment of soldiers and officials, carrying torches, swords, and clubs. He identified Jesus to the soldiers by kissing him, and this 'Judas kiss' can form the focus of the scene. John's Gospel does not mention the kiss, but says that when Jesus identified himself the soldiers fell to the ground. These two elements – the kiss and the collapsing soldiers – are sometimes combined into the one scene.

Peter drew his sword and struck off the right ear of Malchus, the slave of the High Priest. Jesus told Peter to put his sword back in its

sheath, and he touched and healed Malchus' ear, showing compassion and forgiveness, even at this heightened moment (Luke 22:39–53 and John 18:1–11). The disciples took to their heels, and are sometimes shown running away. An odd detail from Mark's Gospel may also be included. A young man was following the disciples dressed only in a linen cloth. The soldiers tried to grab him, but he slipped out of the cloth and ran away naked (Mark 14:51–52). The young man has traditionally been identified as Mark himself.

The Trials of Jesus

The Gospels have various accounts of the trials of Jesus, including before Caiphas (the Jewish High Priest; Matthew 26:57–68), Annas (Caiphas' father-in-law; John 18:12–23), Herod (tetrarch of Galilee, representing the civil authorities; Luke 23:8–12), and Pontius Pilate (the Roman governor; Luke 23:13–25).

Jesus was accused of blasphemy and condemned by Caiphas/Annas and the Jewish authorities. However, they needed the approval of the authorities before he could be executed, and so Jesus was taken before Pontius Pilate. Pilate said that he could find no basis for any accusation against him, and sent him to Herod. Getting nothing but silence from Jesus, Herod sent him back again.

Pilate's wife had sent him a message that he should have nothing to do with the condemnation of Jesus, and scenes can show her messenger speaking in Pilate's ear. It was the custom at the feast of Passover to release a prisoner, and Pilate went before the crowd to offer them the choice of releasing Jesus or Barabbas, a man who had been condemned for insurrection and murder. The crowd cried out for Jesus to be crucified, in spite of Pilate continuing to protest his innocence. Pilate then washed his hands before the crowd, saying that he would be innocent of this man's blood, before he allowed the execution to proceed.

The Flagellation

As was the usual practice before crucifixion, Jesus was flogged (Matthew 27:26). Although the flagellation is only mentioned in passing in the Gospels, harrowing medieval accounts of visions of the event made representations popular. The mystic Margery Kempe had a vision of sixteen men with sixteen lead-tipped scourges agreeing to give Jesus forty blows each, while St Brigid of Sweden counted five thousand strokes (Jewish law would have stopped at forty). The scene is sometimes set in Pilate's house, and shows Jesus tied to a narrow post or pillar while he is beaten.

The Crowning with Thorns

After the flagellation, a whole cohort of soldiers gathered around Jesus in Pilate's headquarters. They stripped him, put a scarlet (or purple) robe around his shoulders, a twisted crown of thorns on his head, and a reed in his hand (in imitation of a sceptre), then knelt before him saying, 'Hail, King of the Jews!' They spat on him and beat him, before dressing him in his own clothes and leading him away to be crucified (Matthew 27:27–31). The scene can include elements from the earlier Mocking of Jesus (Matthew 26:67), which took place before his trial, when he was blindfolded and beaten with fists. The two scenes can be distinguished because the Crowning was undertaken by soldiers, whereas the Mocking was by the people.

The Road to Calvary

Jesus was forced to carry his own cross, or at least the cross-beam, to the execution site. On the way, a man called Simon of Cyrene was forced to carry the cross for part of the way. Jesus also spoke to the women of Jerusalem, who were crying for him. He urged them not to cry for him but for themselves (this has been taken to

be a prophecy of the brutal sacking of Jerusalem by Rome, which was to take place a few decades later). These scenes are set out more fully in the section Stations of the Cross (page 43).

The Crucifixion

Jesus was crucified outside the walls of Jerusalem at a site called Golgotha (in Greek, Calvary), which means 'Place of the Skull'. In reference to the name, images often include a skull or skulls around the base of the cross. The site's name may be a reference to its function as an execution-ground, or there may have been something skull-like about it: one of the sites in present-day Jerusalem that is claimed to be Golgotha lies beside a rocky outcrop that resembles a skull.

In images of the crucifixion, the skull can also be a reference to the grave of Adam. As we have seen (page 7), theologians came to see Jesus as the 'New Adam', whose crucifixion bridged the division between humankind and God that Adam had caused (see The Fall/Adam and Eve, page 136). In theological terms, the skull in this context was Jesus laying to rest the sin of Adam, but in addition, legends developed that explicitly connected Jesus and Adam. One of these was that Golgotha lay on the site of Adam's grave – so it is Adam's skull that is represented.

Jesus was stripped of his clothes and nailed to the Cross. Above him, Pilate had fixed the sign 'Jesus of Nazareth, King of the Jews' (see INRI, page 220). His garment was 'without seam, woven in one piece' (see alb and pallium, pages 225 and 231), and so rather than cut it the Roman soldiers gambled for it (pictures have them throwing dice, and sometimes fighting among themselves). The crowds below mocked Jesus, telling him to save himself if he was God's chosen one.

Two criminals were crucified at the same time on either side

of Jesus. Matthew and Mark record that they cursed Jesus with the crowd, but Luke records that one of them rebuked the other and asked Jesus to remember him, to which Jesus replied, 'I tell you the truth, today you will be with me in paradise.' The thieves became known as Dismas and Gestas. Dismas the good is on Jesus' right-hand (good) side. He is sometimes the younger of the two, and may have a serene expression, looking towards Jesus as his soul is carried away by angels; Gestas is older, twisted with hate and pain, and as he looks away from Jesus his soul may be being dragged downwards by demons. Two further points. First, the crosses of the criminals are usually smaller than Jesus', in accordance with the artistic convention that greater size meant greater honour. Secondly, in Western art they are sometimes tied, not nailed, to their crosses.

St John is named as having been present at the Crucifixion, as were the Virgin Mary and St Mary Magdalene, and they are usually shown at the base of the Cross. From the Cross, Jesus gave his mother and John into one another's care. Darkness then came across the land. In reference to this, in some medieval and early Renaissance pictures the sun and the moon appear, with the sun on Jesus' right and the moon on his left, occasionally with human faces and veiled with cross-hatching, or part-covered by a cloud. They also show the two natures of Jesus, the sun representing his divinity and the moon his humanity, or the New and Old Testaments, since the Old Testament (the moon) was thought by St Augustine to be simply a reflection of the light shed by the New Testament (the sun).

Jesus cried out in Aramaic, '*Eloi, Eloi, lema sabachthani?*' meaning 'My God, my God, why have you forsaken me?' One of those present (traditionally named Stephanon) dipped hyssop in vinegar (or sour wine, the alcohol being intended to ease the

agony), placed it on a reed, and raised it for Jesus to drink. With a final cry, Jesus died.

A soldier pierced his side with a spear, and a mixture of blood and water flowed out. This outpouring was interpreted as symbolizing two of the sacraments, Baptism (water) and the Eucharist (blood), and with this in mind sometimes an angel is portrayed catching the flow of blood from Jesus' side in a communion chalice. The soldier has been given the name Longinus, which means 'lance'. In one story he was blind until Jesus' blood fell into his eyes and cured him, and so sometimes he is pointing to his eyes, or else someone is shown guiding his hand with the lance. He has been honoured, and later achieved sainthood, for having become a Christian and suffered martyrdom (Matthew 27:32–54; Mark 15:21–39; Luke 23:26–47; John 19:16–28).

Additional allegorical details can include a pelican at the top of the Cross, and, in the Middle Ages, figures representing the Church and the Synagogue. The different ways of representing Jesus on the cross, from standing clothed in glory to hanging in suffering, are dealt with in the chapter Crosses and Crucifixes (pages 41–42).

The Descent from the Cross, the Pietà, and the Entombment

In the Descent from the Cross, or 'the Deposition', Jesus' blood-streaked body is brought down from the Cross, as St John, the Virgin Mary, and St Mary Magdalene look on. Joseph of Arimathea, a Jewish council member, and a lawyer called Nicodemus (who had appeared previously in the Gospels, asking Jesus questions and defending him to the Pharisees, John 3:1–21 & 7:50–52) may also be present: in the apocryphal Gospel of Nicodemus, Joseph was said to have supported Jesus' body while

Nicodemus drew out the nails. Joseph and Nicodemus appear together in the Gospels in the Entombment. Joseph asked to be given the body of Jesus. Together, he and Nicodemus wrapped Jesus' body in a clean linen cloth with spices, then placed it in Joseph's own tomb, hewn out of the rock. A stone was rolled over the entrance to seal the tomb (Matthew 27:57–61; Mark 15:42–47; Luke 23:50–56; John 19:38–42).

The image of the dead Jesus lying across the knees of his mother is known as the pietà. It is a hugely powerful image, with its direct reflection of the happier pictures of the Madonna and child, Mary with her infant son on her knee.

The Harrowing of Hell/Descent into Limbo

The Gospels do not state what happened in the period between Jesus' death and his resurrection. The Church considered the question of where Jesus was in this period, together with the question of what had happened to the people who had died before Jesus' redeeming death, and gave the teaching of the Harrowing of Hell, or *Anastasis* in the Eastern Church. Images of the Anastasis are most common in Eastern Churches, which prefer them to images of the Resurrection.

According to this doctrine, the souls of the righteous who had died before Jesus was crucified could not have gone to heaven, since Jesus had not yet died to save them, and they therefore waited in hell. Later the Church took the view that the righteous would not have been sent to hell but to a limbo on the border of hell (limbo comes from the Latin *limbus*, hem). The doctrine went on, that on his death Jesus descended to hell, or limbo, to liberate these souls. The doctrine was considered to be supported by the letter of Peter: '[Jesus] was put to death in the flesh, but made alive in the spirit, in which also he went and made a proclamation to the spirits

in prison who in former times did not obey'; (1 Peter 3:17).

An account of the Harrowing that is often reflected in imagery is set out in the apocryphal Gospel of Nicodemus. Hell is usually cavernous. Jesus enters in radiant clothes, smashing the gates of hell, after Psalm 24:7 ('Lift up your heads, O you gates; be lifted up, you ancient doors, that the king of glory may come in'). Satan lies in chains, or cowering before him, while his demons flee. A crowd of righteous souls crowds towards Jesus, including Adam and Eve, Kings David and Solomon, St John the Baptist, Dismas (the redeemed criminal who was crucified with Jesus), and any number of Old Testament figures.

The Resurrection

The moment of Resurrection is not recorded in the Gospels, but is widely portrayed in the art of the Western Church. Jesus emerges in glory from the tomb. He is dressed in white or gold and may be holding the banner of the Resurrection, a pole bearing a pendant with a red cross on a white background. Jesus' wounds are visible, to confirm that he is the Jesus who died, and to glorify the suffering that he endured.

The type of tomb portrayed varied over time. Often Jesus was portrayed stepping out of the sort of modern box-tomb that would have been familiar to the artist and viewers. From the second half of the sixteenth century Jesus tends to stand before a closed tomb, after the Roman Catholic Church condemned the scriptural inaccuracy of portraying him emerging from it.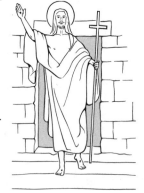

The Gospel accounts of the discovery of the Resurrection differ slightly.

According to Matthew, Mark and Luke, in the early morning, Mary Magdalene and other women came to the tomb with spices to anoint Jesus' body. They found that the stone had been rolled away from the entrance. A man or two men dressed in bright white clothes (presumably angels) told them that Jesus had risen. According to Matthew, Jesus himself then appeared to the women, and told them to tell the other disciples what they had seen. In John's account, Mary Magdalene found the tomb empty. She told Peter and John, who came running to find the linen wrappings lying alone in the tomb. They returned home, while Mary Magdalene remained, where she encountered the two angels and then the risen Jesus in person.

Roman soldiers are often shown slumped around the tomb. Matthew's Gospel records that the Pharisees were worried that the disciples would steal Jesus' body and then claim that he had risen from the dead. Pilate therefore gave permission to station a guard of soldiers at the tomb. When an angel appeared and rolled back the stone, the guards 'shook and became like dead things'. Over time, the guards came to be portrayed sleeping (Matthew 28:1–10; Mark 16:1–8; Luke 24:1–12; John 20:1–18).

The Incredulity of Thomas

Jesus appeared to the disciples, but Thomas was not present at the time. When the disciples told him that Jesus had returned, he declared that he would not believe it unless he put his fingers in the nail-marks in Jesus' hands, and his hand in the wound in Jesus' side. A week later, Jesus appeared to them in a locked room, and invited Thomas to touch his hands and side. Thomas responded, 'My Lord and my God!' (John 20:24–29).

On one view of John's account, Thomas' flood of belief came after he was invited to touch the wounds, but it is not recorded that he actually touched them. Nevertheless, in art he is often

shown in contact with the wounds. The scene is sometimes represented in a stylized way, with a hand reaching into the crack of a broken heart.

The Ascension

Forty days after the Resurrection, Jesus led the disciples to Bethany. He raised his hands, blessed them, and then was lifted up until a cloud took him out of their sight. As the disciples were gazing upwards, two angels appeared with them, dressed in white. They said that Jesus would return to them in the same way as they had seen him leave (Luke 24:50 and Acts 1:9–11).

In the Church of the Ascension on the Mount of Olives there is an indentation in the rock that is meant to be Jesus' last footprint on earth. This hole in the rock is sometimes included in images of the Ascension. Eleven apostles look on (they had not yet replaced Judas), often accompanied by the Virgin Mary.

In the earliest portrayals of the Ascension, Jesus steps up to reach the hand of God, or rises upwards supported by angels. In Eastern art, Jesus had to be portrayed in full frontal; in the West, it is more usual to see him in profile, as if climbing to heaven, or disappearing into a cloud, with his feet and the hem of his clothes visible. The image may derive from the practice on the feast of the Ascension of drawing up an image of Jesus into the church vaulting, where it disappeared into a ring of curtains.

Pentecost

Pentecost, when the Holy Spirit filled the disciples, followed the Ascension. It is considered to be the birth of the Church, and is one of its major feasts.

The disciples were all together in a house, when it was filled with a sound like a rushing wind. Tongues of fire appeared and touched each one of them, and they began to speak in other languages. A crowd gathered at the noise: some were amazed, while other sneered and accused the disciples of being drunk. St Peter responded that they could not be drunk since it was only nine o'clock in the morning, and started preaching about Jesus (Acts 2).

The Holy Spirit is represented by the tongues of fire themselves, and also as a dove hovering above the scene. The biblical account of Pentecost does not state that the Virgin Mary was present, but it does say that she and the disciples were constantly at prayer together, and she is usually included and even placed at the centre of the scene: at the birth of the Church, she represents the Church itself. The words *Effundam de Spiritu meo super omnem carnem* (Latin: 'I will pour out my spirit on all flesh') can appear near the scene. These were words that Peter spoke to the gathering crowd, and are a quotation from the Prophet Joel (2:28).

In Eastern and some Renaissance art, a man appears with twelve scrolls, or twelve figures appear in various form of dress. The scrolls represent the languages of the world that the disciples were speaking, and the people are the people of the world to whom they were speaking.

The Last Judgement (Doom)

In Matthew's Gospel, Jesus said that he would sit in judgement on the world, separating the people like a shepherd separates sheep from goats. The righteous, who had fed the hungry and given the thirsty something to drink, welcomed strangers, clothed the naked, cared for the sick, and visited prisoners, would inherit the kingdom of God; the damned, who had not done these things, would go to eternal fire (Matthew 25:31–46).

This has become known as the Last Judgement, or the Doom. Jesus sits in glory with his wounds visible and may be portrayed with a sword emerging from his mouth, a golden sash across his chest, and seven stars in his right hand, following the description of him in St John's vision in Revelation (1:16). The dead rise up from their graves. On Jesus' right, the saved enter heaven; on his left, the damned are dragged by demons into hell.

Heaven can appear as a fortified city, or a garden, and St Peter may be welcoming the souls of the saved. Heaven can also be symbolized by a looped cloth held by an old man. The old man is Abraham, and the image comes from one of the parables of Jesus, in which Dives, a rich man, ignored Lazarus, a poor man who was starving at his gate. Lazarus went to heaven and Dives to hell, from where he could see Lazarus 'in Abraham's bosom'. 'Bosom' (*sinus*) could also be translated as the fold at the neck of a toga, used as a pocket – hence the looped cloth (Luke 16:19–31). Hell is sometimes the mouth of a monster, in a reference to Leviathan.

Doom paintings are often loaded with symbolism. A pair of scales held by an angel (it is the Archangel Michael) is the weighing of souls, righteous souls generally being the heavier (the devil or a demon may be trying to skew the balance by tipping one side of the scales towards damnation, while the Virgin Mary tips the other side towards mercy); an angel (traditionally the Archangel Gabriel) or angels may be blowing trumpets, from the account of the seven angels ushering the Second Coming of the Messiah in the Book of Revelation (8:7 – 11:19), and Jesus' words, that in the last days 'he will send out his angels with a loud trumpet call' (Matthew 24:31); a tree entwined with a snake is the Tree of the Knowledge of Good and Evil; a ladder symbolizes the cross, by which man can ascend to heaven. Specific sins can also be represented, for example a miser with his money bags.

THE VIRGIN MARY

Christians revere the Virgin Mary because she is the Mother of Jesus, and therefore the Mother of God. She is honoured as a model of obedience and faithfulness, while her sufferings as a mother add to the empathy that many feel with her. In her hymn of praise and joy after the Annunciation (Luke 1:46–55; see page 87) she says that 'from henceforth all generations shall call me blessed'. This has led to the title that honours her before all other saints – the Blessed Virgin Mary.

Mary has been the subject of sharp theological divisions between Roman Catholic and Protestant Churches, and when iconoclasts destroyed images in churches they fell on images of Mary with particular fury. Protestants objected to the level of veneration accorded to her, which they felt seemed at times to be as great as that given to Jesus. They also objected to some of the doctrines that the Roman Catholic Church allowed to Mary: that she was without sin, that she remained a virgin throughout her life, and that she was physically assumed into heaven at her death. These teachings seemed to Protestants to be without biblical authority, and to elevate Mary to a position that was more than mortal. In more recent times, though, it is probably fair to say that there has been a softening of approach and appreciation of Mary among many Protestant Churches.

The Lily *The Fleur-de-Lys* *The Rose*

Mary is almost always portrayed dressed in blue. The colour blue was at one time the most expensive in an artist's repertoire, and so was used sparingly and only on the most precious objects. Mary's chief attribute of a white lily expresses her purity and virginity, and may have originated from representations of the Annunciation, which traditionally took place in the flower-filled springtime. The lily is sometimes expressed heraldically as a fleur-de-lys (also a symbol of the Trinity). She is also represented by a rose, the most beautiful of flowers. Again, the rose is often portrayed in a stylized, heraldic form.

The Pierced Heart

Other ways of representing Mary symbolically include a heart pierced with a sword, often with wings (see Sacred Heart, page 54); and the letter M, alone or as part of a sacred monogram (see Letters and Words, page 221).

A common image of Mary is standing alone on a crescent moon, shining in glory and with an array of twelve stars around her head. This comes from the Book of Revelation, which talks of 'a woman clothed with the sun', commonly identified as Mary. The passage is mystical, mysterious, and terrifying: 'A great and wondrous sign appeared in heaven: a woman

Sacred Monogram

clothed with the sun, with the moon under her feet and a crown of twelve stars on her head. She was pregnant and cried out in pain as she was about to give birth. Then another sign appeared in heaven: an enormous red dragon with seven heads and ten horns and seven crowns on his heads. His tail swept a third of the stars out of the sky and flung them to the earth. The dragon stood in front of the woman who was about to give birth, so that he might devour her child the moment it was born. She gave birth to a son, a male child, who will rule all the nations with an iron sceptre. And her child was snatched up to God and to his throne' (Revelation 12:1–5).

Scenes from the Life of the Virgin Mary

Joachim and Anne/Anna

Mary's parents were called Joachim and Anne, or Anna. No mention is made of them in the Bible, but stories about them were told in the apocryphal Gospel of James, which dates from the second century.

The couple had been childless for many years. Joachim was humiliated when he brought a lamb to the Temple, which the High Priests refused to allow him to sacrifice because he had not fathered a child. Ashamed, he did not return home, but instead went to stay with shepherds in the desert. There, the Angel Gabriel appeared to him and foretold that Anne would conceive, and that he should go to meet her by the Golden Gate in Jerusalem (images of the appearance have the angel and Joachim with sheep or shepherds nearby). Anne, who had received the same angelic message, was waiting under a laurel tree by the Golden Gate. She looked up at a nest of sparrows in the tree, and lamented that, unlike her, even the birds of the air were fruitful. Joachim met her

and kissed her, and it was the convention that at that moment she became pregnant. The Golden Gate, which faces onto the Temple Mount in Jerusalem, is walled shut. It appears in the tender scene of the reuniting of Joachim and Anne in gold or topped with gold, while its closed arch represents Mary's virginity.

The Nativity of Mary

Representations of the birth of Mary are within a well-appointed house (Joachim was a wealthy man), or sometimes in a church, since Mary would be brought up in the Temple. Anne may be reclining on a bed with midwives, the elderly Joachim may be nearby, and neighbours may be arriving with gifts.

The Presentation of Mary/The Childhood of Mary

Anne had prayed that if she could be blessed with a child, she would dedicate it to God's service. Therefore, when Mary was three, her parents took her to be presented at the Temple. She climbed the fifteen steps to the Temple as if she was older than her years, and then danced before the altar. She was left in the Temple with the other virgins, where she spun wool and embroidered clothes for the priests.

The Marriage

When Mary was fourteen, an angel visited the High Priest to tell him to arrange a husband for her. The angel said that men of marriageable age should be assembled, with their staffs. Among the assembled men was Joseph, a carpenter from Nazareth. He was shown to be the husband chosen by God when his staff blossomed (see also Almonds, pages 201–202); an alternative legend has a dove landing on his staff. The flowering rod was thought to represent Mary, since it flowered without being fertilized. In the

marriage scene, Mary and Joseph are shown before the High Priest, Joseph holding his sprouting or dove-topped staff, and placing a ring on Mary's finger. Scenes may contain some slapstick from the unworthy suitors, angrily breaking their staffs over their knees or trying to hit Joseph.

The Annunciation

The first event in Mary's life told in the Bible is St Luke's account of the Annunciation. The Annunciation is a simple and very common scene, due to the importance of the Church's teaching on the conception of Jesus, and the many religious and lay groups that took the event as their patronage.

The Angel Gabriel appeared to Mary in Nazareth, with the words 'Greetings, favoured one, the Lord is with you' (which may be written *Ave, gratia plena, Dominus tecum*, or simply *Ave Maria*). He told her that she would conceive through the power of the Holy Spirit, and bear a son to be called Jesus, who would be a mighty ruler. In the face of this alarming announcement, Mary responded faithfully and obediently: 'Behold the handmaiden of the Lord, let it be to me according to your will' (*Ecce ancilla Domini, fiat mihi secundum verbum tuum*; Luke 1:26–38). The conception and incarnation of Jesus is believed to have taken place

at this moment of submission, and is the moment portrayed. The festival of the Annunciation is held on 25 March, exactly nine months before the birth of Jesus is celebrated.

The key elements in the scene are Mary, the Angel Gabriel (carrying a sceptre or lily), and the Holy Spirit descending on Mary in

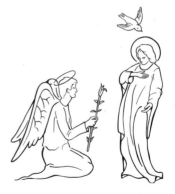

the form of a dove. As the Annunciation was held to have taken place in springtime, it is often in or beside a flowering garden, or else flowers (usually lilies) are shown in a vase. Mary may be reading a book, on which are written the prophetic words of Isaiah, *Ecce virgo concipiet et pariet filium* ('Behold, the Virgin will conceive and will give birth to a son'; Isaiah 7:14). Close to Mary may be wool or fabrics, in a reference to her work on the High Priest's clothes when she lived in the Temple.

Joseph's Dream

Joseph was very disturbed when he discovered that Mary was pregnant, and he planned to end their engagement quietly. However, an angel appeared to him in a dream and explained that the child was from the Holy Spirit, and would fulfil Isaiah's prophecy (Matthew 1:18–25). Joseph may be portrayed slumbering at his carpenter's bench, surrounded by his tools, as the Angel Gabriel appears overhead.

The Visitation

After the Annunciation, Mary went to visit her relative Elizabeth, who was pregnant with St John the Baptist. When Mary approached, Elizabeth cried out: 'Blessed are you among women and blessed is the fruit of your womb!' (*Benedicta tu inter mulieres et benedictus fructus ventris tui*). John leaped for joy in the womb of his mother (Luke 1:39–56).

Elizabeth was barren and elderly (by the standards of the time) when she conceived John, and was six months pregnant at the Visitation, and so there should be a contrast between her older appearance and heavier pregnancy and Mary's youth and smaller bump. The women's husbands may hover in the background, Joseph in his worker's clothes and Zechariah in priestly robes.

The Nativity

See Scenes from the Life of Jesus, page 58.

The Purification (The Presentation at the Temple)

See Scenes from the Life of Jesus, page 60.

The Escape to Egypt/Return from Egypt

See Scenes from the Life of Jesus, pages 61–63.

The Wedding at Cana

See Scenes from the Life of Jesus, page 64.

The Crucifixion

See Scenes from the Life of Jesus, page 74.

Pentecost

See Scenes from the Life of Jesus, page 80.

The Death (Dormition) and Assumption of the Virgin

In the teaching of the Roman Catholic and Eastern Churches, after her death both Mary's soul and body were assumed into heaven. The Death and Assumption of Mary forms a small cycle of its own. Again, the stories do not appear in the Bible, but are derived from apocrypha and traditional stories.

The Annunciation of Mary's Death

From the cross, Jesus had given Mary and St John to one another as mother and son, and so Mary joined John's household (John 19:26–27). After the Gospel accounts, Mary may have travelled to

Ephesus in Ancient Greece (now Turkey), although in another tradition she died in Jerusalem.

Desperately lonely, Mary would visit the sites of events in her son's life (including the Stations of the Cross in Jerusalem), but longed to be with him again. An angel appeared to her and foretold that in three days' time she would die and be reunited with her son in Paradise. The angel gave her a palm branch, which she gave to St John to carry before her at burial. Portrayals of the scene are similar to the Annunciation, except that Mary is portrayed as an older woman and the angel carries a palm instead of a sceptre or lily.

The Death of Mary

Mary had asked the angel that all of the apostles should be present at her death, and they therefore all appear grouped around her bed (one legend has it that they were swept up in clouds from the places where they were evangelizing, and deposited at Mary's door). St Peter is usually at the head of the bed, conducting the service, while St John is at the foot, holding the palm that Mary had given him. St Thomas may be just coming in through the door, late because he has had to come all the way from evangelizing in India. Suddenly, the room was filled with light, and Jesus appeared to take his mother's soul to heaven. In a touching reversal of the familiar image of the Madonna and child, Jesus is sometimes shown cradling the soul of his mother. In one tradition, Mary did not die before the Assumption, and so the event is sometimes called the Dormition (Falling Asleep).

The Funeral Procession and Entombment

Occasionally, the funeral procession and entombment of Mary are shown. In one legend, the High Priest tried to stop the funeral by

pushing at the bier. His hands stuck and he found himself dangling from the bier and carried along with the procession. He was released only when he agreed that Jesus was the Messiah.

The Assumption

Three days after her death, Mary's soul was reunited with her body, and both were assumed into heaven. Scenes have Mary rising from her tomb, attended by angels, while the disciples look on. Knowing St Thomas' reputation for scepticism, she may be dropping her girdle (belt) to him, as proof of her passing.

The Coronation of the Virgin

The Coronation of Mary may form the final part of the Dormition cycle, or it may stand alone. Richly robed and surrounded by angels, Mary is crowned Queen of Heaven by her son, often sitting at his right hand. Alternatively, all three persons of the Trinity crown her, God the Father and God the Son holding the crown while the Holy Spirit hovers above in the form of a dove. There is sometimes quite a crowd looking on: angels, patriarchs, prophets, saints, and, of course, donors (patrons who had commissioned the work from the artist).

SAINTS

There are two Hebrew words in the Bible that translate as the English 'saint'. One simply refers to pious, godly people (for example, Psalm 30:4); the other indicates people who are holy, and separated to God (for example, Psalm 16:3). The latter is the meaning used in the New Testament, where for the most part it is used to describe the Christian faithful (for example, Romans 1:7). In this meaning, everyone who confesses to the Christian faith is a saint.

In the context of church imagery, saints are particularly holy men and women, recognized as such by the Church. The power to 'declare' sainthood derives from Jesus' commission to St Peter: 'I will give you the keys of the kingdom of heaven; whatever you bind on earth will be bound in heaven, and whatever you loose on earth will be loosed in heaven' (Matthew 16:18). Over the centuries, the choice of person to be sainted has been influenced in varying parts by genuine devotion, fashion, and politics, to produce a mixed bag of saints, from the largely made-up to the truly inspirational.

Saints have an ancient role as 'intercessors' between God and man. Since God could seem too awesome to be approachable, the prayerful could ask the saints in heaven to intercede for them with God. They are therefore not, as such, prayed *to*, they are simply

asked to pray to God on behalf of the praying person. Children's names were often taken from saints, originally in the hope that the namesake saint would then watch over the child and include him or her in their prayers.

Church names were also taken from saints, a tradition that began when the church would be named after the saint whose relics it held. The saint in question will have a particular association with the church named, and the church will most likely have a higher than usual number of references to that saint within its walls. The saint is meant to watch over that church, and the church generally returns the compliment by holding a special celebration on the saint's feast day.

There are a multitude of saints, and a multitude of books about them. The most common are those that appear in the Bible, and in this section we deal with those and a few of the most popular post-biblical saints.

St John the Baptist

Ragged hair and beard, emaciated, dressed in animal skins (or the skin of a whole camel) and belt; holding a tall, very narrow cross; a head on a dish; the Lamb of God; reeds at feet, and/or axe at the root of a tree.

John the Baptist is easily recognizable by his wild dress and hair: he was a wild, ascetic holy man, preaching repentance in the Judaean desert, dressed in clothes of camel's hair (some representations have him wearing the whole skin of a camel) and a leather belt, and living on a diet of locusts and wild honey. John's ferocity is apparent from his fiery warnings to the crowds: 'You brood of vipers!

Who warned you to flee from the coming wrath? ... The axe is already at the root of the trees, and every tree that does not produce good fruit will be cut down and thrown into the fire' (Luke 3:7–9). John baptized in the River Jordan those who heard his message and turned back to God.

John and Jesus were related, as their mothers Elizabeth and Mary are described by Luke as kinsfolk. Elizabeth had no children and was getting on in years, as was her husband, a priest called Zechariah. The Angel Gabriel appeared to Zechariah and told him that he was to have a son called John, who would be a great holy man – a forerunner of the Annunciation. Zechariah did not believe the angel, and so was struck dumb until after John was born. When he made it clear that his son would be called John, he regained his speech. Mary and Elizabeth met in the Visitation (see the Virgin Mary, page 88), when they were both pregnant. This meeting gave artists licence to sometimes include John with Jesus as infants at play together.

John's significance in Christian belief is as a forward messenger for Jesus, as foretold by the Prophets Isaiah and Malachi. John was the 'one calling in the desert, "Prepare the way for the Lord, make straight paths for him" ' (Isaiah 40:3; John is sometimes portrayed carrying a scroll with Isaiah's words in Latin, *Vox clamantis in deserto: partae viam domini*). He was also the messenger referred to in Malachi's prophecy 'I will send my messenger ahead of you, who will prepare your way before you' (Malachi 3:1). John said the same thing: 'After me will come one who is more powerful than I, whose sandals I am not fit to carry. He will baptize you with the Holy Spirit and with fire.' John baptized Jesus, at the start of Jesus' ministry (see the Baptism of Jesus, page 63).

John died at the hands of King Herod. John's uncompromising beliefs led him to publicly rebuke Herod for having married

Herodias, the wife of his brother (John 14:1–12). As a result Herod had John imprisoned, although the king showed no sign of wanting John dead, and used to visit him in prison to hear him talk. At a banquet, Herodias' daughter Salome danced for his guests and Herod was so impressed that he unwisely promised to give her anything she chose. Prompted by her mother, who was looking for revenge for John's rebuke, Salome asked that she be brought the head of John the Baptist on a platter. Images of this scene, in which the beautiful Salome is contrasted with John's gory head, were extremely popular.

Through the manner of his death, John may be indicated by a head on a platter. He may also be indicated through his standing beside a lamb, because he was the first to describe Jesus as the 'Lamb of God' (see God the Son, page 52). Two other elements are sometimes included in images of John. First, a reed, or reeds, may be growing at his feet. This is a reference to Jesus' statement of John: 'What did you go out into the desert to see? A reed swayed by the wind? … no … A prophet? Yes, I tell you, and more than a prophet' (Luke 7:24–26). Secondly, there may be an axe at the root of a tree, recalling John's angry warning to the crowds (above). Finally, the long thin cross that he holds refers to the cross on a long staff that was a symbol for a preacher or missionary.

St Joseph

Appearing with Mary and Jesus as a baby or child; elderly; lily; carpenter's tools.

Joseph was husband of the Virgin Mary, foster-father of Jesus, and protector of the Holy Family. Centuries of mockery and rough treatment of Joseph in popular art have given way to honour for his strength of character, devotion, and kindness. He was, as Matthew says, 'a just man' (Matthew 1:19). He was even given socialist

respectability through the timing of his feast day, 'Joseph the Worker', on 1 May (International Workers' Day; Joseph was a carpenter).

Joseph's story is told more fully in the chapters Scenes from the Life of Jesus and Scenes from the Life of the Virgin Mary (the Marriage of the Virgin Mary, the Nativity, the Presentation, the Flight into Egypt, and the Return from Egypt). His strength of character is apparent in his first appearance in the Gospels. Matthew records that when Mary became pregnant, she was engaged to Joseph. Becoming engaged was treated at the time as marriage for the purpose of sexual relations, so that Mary's pregnancy would not have been a surprise to anyone – except to Joseph. Matthew says that, nevertheless, Joseph did not want to exercise his right to expose Mary to public disgrace, but instead planned to end the engagement quietly. Before he could do so, an angel appeared to Joseph in a dream and told him that the unborn child was from the Holy Spirit.

Joseph is often depicted as being an old man. He is not mentioned as having been present at Jesus' crucifixion, and is therefore supposed to have died before Jesus started his public life. In addition, apocryphal sources claim that he was an elderly widower when he married Mary (his children from his previous marriage being the brothers of Jesus referred to in the Gospels). Joseph was imagined as having died with Mary and Jesus at his bedside, and he is therefore the patron saint of those who want a 'good' death. A popular fifth-century tale, 'The History of Joseph the Carpenter', portrays Joseph on his deathbed as afraid, but comforted by the words of Mary and Jesus, who promise protection to all who do good in Joseph's name. This has led to many hospitals, hospices, and churches being named after him.

Joseph sometimes has the attribute of a lily. Traditionally, his staff sprouted to show that he was God's choice of a husband for

Mary (see the Marriage of the Virgin Mary, page 86). The blossoming staff became the lily, as a reflection of the Virgin Mary's attribute of a lily, and as a symbol of Joseph's purity.

The fact of his fiancée falling pregnant, his supposed age, and the Catholic teaching that Mary remained a virgin throughout her life, caused Joseph to be an object of some derision, particularly in the Middle Ages. Being cuckolded by God was not a good way to appeal to medieval man. In paintings of the Nativity, Joseph was sometimes given an 'embarrassing' role, such as washing nappies in the background, and he was used for comic relief in medieval plays. It was believed that he could be coerced into assisting prayers to be fulfilled, for example by burying his statue upside down and refusing to dig it up, or by taking the baby Jesus from his statue and refusing to give it back, until the prayer was granted.

But Joseph has been rehabilitated since these bawdier times through his qualities as a foster-father, husband, and man: strength in difficulty, kindness to Mary, and care in protecting Jesus.

St Mary Magdalene

Long hair, red dress; a pot or jar (of perfume).

Mary Magdalene was a disciple of Jesus, and is one of the most vivid and appealing women in the Bible. With a troubled past, she was sensual, emotional, and completely devoted to Jesus, her devotion making her the subject of criticism from others. In images of her she is always beautiful, with long, often blonde or reddish hair, which can be worn loose or bound up in the style of a courtesan. The name Magdalene may be a reference to Mary's home town of Magdala, or to an expression in the Talmud (a collection of Jewish religious and legal standards) that means 'curling women's hair'.

The Gospels contain a number of stories around disciples

called Mary who may or may not have been the same person as Mary Magdalene. For the purposes of church imagery, the Marys are generally united in the person of the Magdalene.

Traditionally, Mary was a reformed prostitute. She is usually dressed in red to emphasize her love for Jesus, but also as a nod to her past as a 'scarlet woman'. In the Gospel accounts, she was possessed by seven demons, from which Jesus saved her (Luke 8:1). She followed Jesus from Galilee, stood at the foot of the cross, and is often present in scenes of the crucifixion (Matthew 27:56). Above all, Christians honour Mary as the first person to whom Jesus revealed himself after the Resurrection. John's Gospel has a touching account of Mary meeting the risen Jesus. She was standing outside the empty tomb, crying because Jesus' body had disappeared, when a man appeared and asked her why she was crying. Thinking that the man was the gardener, she begged him to tell her where the body had been taken. The man said her name, 'Mary', and she suddenly recognized him as Jesus, with the word '*Raboni!*' ('Teacher'). Mary may have tried to embrace Jesus, as he had to tell her not to hold onto him (see *Noli Me Tangere*, page 222). She was told to go and tell the other disciples that he was alive (John 20:10–18).

Mary Magdalene's attribute is a jar or pot of perfume. Shortly before Jesus entered Jerusalem, a dinner was held in his honour at Mary's house. While her sister Martha served the guests, she took a jar of expensive perfume, poured it on Jesus' feet and wiped them with her hair (this is probably the reason why she is portrayed with long hair). Judas Iscariot rebuked her, on the grounds that the money for the perfume could better have been spent on the poor, but Jesus said that she was doing the proper thing, and was in fact preparing his body for death (John 12:1–8). Possibly on the same occasion, Mary also found herself in trouble

with her sister Martha. Martha complained to Jesus that Mary was spending her time listening to him, when she should have been helping her in the house. Again, Jesus said that Mary was doing the proper thing (Luke 10:38–42).

There are different traditions about Mary's life after the Gospel accounts. In the tradition of the Western Church, she went to France with her sister Martha and brother Lazarus, evangelized in Provence, became a hermit in the Maritime Alps (where angels lifted her up for glimpses of heaven), and died at Saint Maxime-La-Sainte-Baume. In the tradition of the Eastern Church, she went to Ephesus in Greece (now Turkey) with the Virgin Mary and St John, where she died and was buried. There is a late tradition that Mary had been engaged to St John, before he renounced all worldly things to follow Jesus.

Two inscriptions are particularly associated with Mary, both of them to do with her being an example to others: *Ne desperetis vos qui peccare soletis, exemploque meo vos reparate Deo* ('Do not despair, you who have fallen into the way of sin; restore yourself through my example and through God'); and *Optimam partem elegit* ('The part she has chosen is best', from Jesus' words when she was rebuked by Martha, Luke 10:42).

St Paul

Sword; pointed beard and receding hairline; book.

St Paul is called the Apostle to the Gentiles (whereas St Peter was the Apostle to the Jews; together they are known as the 'Princes of the Apostles'), and is regarded as the founder of the Church. He was not a disciple of Jesus, and in fact led violent persecutions of the early Christians. His conversion to become one of the Church's founding fathers is one of the most famous in history, and his personality – opinionated, difficult, and passionate –

emerges strongly through his letters in the New Testament.

Paul was originally called Saul, and was born in the city of Tarsus in around AD 10. He was a Pharisee and a zealous persecutor of the early Church, hunting out Christians and 'breathing threats and murder against the disciples of the Lord' (Acts 9:1). He was present at the stoning to death of the first Christian martyr, St Stephen, where he looked after the cloaks of the men doing the stoning (Acts 7:58). But on the way to hunt out more Christians in the city of Damascus, Paul experienced a startling vision of Jesus. A great light flashed around him and he fell to the ground, from where he (and his attendants) heard Jesus say: 'Saul, Saul, why do you persecute me?' Paul was struck blind, and Jesus told him to continue to Damascus. Jesus then appeared to a Christian in Damascus called Ananias, and told him to visit Paul and lay his hands on his eyes. Knowing Paul's reputation as a persecutor of Christians, Ananias was reluctant to go near him, but nevertheless obeyed Jesus' command. When Ananias laid his hands on him Paul regained his sight, and was baptized (Acts 9:1–19).

Paul's preaching generated such hostility in Damascus that he had to escape through being lowered from the city walls in a basket. He travelled to Jerusalem and, after some resistance, was accepted by the Christian community there. He later worked at Antioch, where he had a famous dispute with St Peter, over the inconsistent treatment of Gentile converts. He embarked on three great missionary journeys, to Cyprus, to Asia Minor and eastern Greece, and to Macedonia and Achaea, before returning to Jerusalem. In Jerusalem, charges were brought against him, but he appealed to the Roman Emperor (as was his right, since he was a Roman citizen through his father). On the way to Rome, he was shipwrecked at Malta before travelling on. The account of his travels in Acts ends in Rome, but Paul may have escaped

condemnation since he seems to have revisited Ephesus and even gone to Spain. Traditionally, Paul was executed in Rome during the persecutions of the Emperor Nero, on 29 June, the same day as St Peter (which is why they share this as their feast

St Peter and St Paul

day). Whereas Peter was crucified, Paul was entitled as a Roman citizen to be executed by beheading with a sword, the sword becoming his major attribute.

Early accounts described Paul as short, bald, and bandy-legged, with a long nose and joined-up eyebrows. In any event, representations of his appearance have been fairly fixed down the ages, with dark, receding hair and a pointed beard. He is sometimes shown in Roman armour, in reference to his position as a Roman citizen. He may be holding a scroll or a book, in reference to his letters.

The Four Evangelists

St Matthew, St Mark, St Luke, and St John, each a writer of one of the four Gospels, are known as the Four Evangelists. Their symbols are, respectively, a man (or angel), a lion (often with wings), a bull or ox (likewise), and an eagle. The Four Evangelists, and these four symbols, are almost always found grouped together, for example at the four points of a cross, or in series on a panel. The symbols can be found either next to figures representing each of the Evangelists (so indicating which is which), or freestanding.

There are two sources for the symbols, both of them visionary. In the Old Testament, the Prophet Ezekiel describes a vision of a divine chariot, ridden or driven by Cherubim (angels):

'I looked, and I saw beside the cherubim four wheels, one beside each of the cherubim ... each was like a wheel intersecting a wheel. As they moved, they would go in any one of the four directions the cherubim faced ... Each of the cherubim had four faces: one face was that of a cherub, the second the face of a man, the third the face of a lion, and the fourth the face of an eagle' (Ezekiel 1 & 10). In the New Testament, St John had a similar vision, recorded in the Book of Revelation: 'In the centre, around the throne [of God], were four living creatures, and they were covered with eyes, in front and in back. The first living creature was like a lion, the second was like an ox, the third had a face like a man, the fourth was like a flying eagle ... Day and night they never stop saying: "Holy, holy, holy is the Lord God Almighty, who was, and is, and is to come"' (Revelation 4:7–8). These visions were interpreted by Christian writers as representing the four Gospels, interconnected and moving together like the wheels in Ezekiel's vision, or together glorifying God like the creature in St John's vision.

Which of the four creatures was ascribed to which Evangelist depended on the nature of their Gospel. St Matthew was given the man/angel because his Gospel emphasizes Jesus' humanity, and opens with a description of Jesus' human ancestry. St Mark's Gospel was thought to emphasize Jesus' kingship, and so he was ascribed the lion, king of the beasts. His gospel also opens with St John's voice 'crying in the wilderness', like the roar of a lion. St Luke's bull is sacrificial, as he was thought to deal with the sacrificial aspects of Jesus' life, but also because his gospel begins with Zechariah, father of St John the Baptist, making an offering to God. St John was ascribed the eagle because his Gospel is the most soaring and revelatory, and the eagle in mythology is the only bird able to look directly into the light of the sun. But the

theme is one that attracts different interpretations. One commentator claimed that the four creatures appear around the cross because they are associated with the kingship of Jesus in the centre: man as king of creation, the lion as king of wild animals, the ox as king of tame animals, and the eagle as king of the birds.

The Twelve Apostles

The Gospels name twelve disciples of Jesus. 'The Twelve' were picked by Jesus to be his companions and learn from him, but they also stood in an elevated position. They were given the power to exorcize demons, cure disease and infirmity, and ultimately to assist Jesus in judgement over humanity (Matthew 10:1 & 19:28, Luke 9:1 & 22:30).

But why only twelve? Jesus attracted thousands to hear him preach, and away from the crowds there were people who followed him continually but were not included among the twelve (for example, St Matthias). The reason lies in the symbolism of the number. When God made his first covenant with Israel, Israel was divided into twelve tribes, although the system had become redundant by the time of Jesus. Now that a new covenant was being made through Jesus, the twelve disciples stood in place of these tribes.

In a church, the twelve can appear together, for example ranged in a tableau on either side of Jesus above the altar, each identifiable by the symbol he holds, or (as for St Peter and St John) by their physical appearance. They may be represented in a heraldic way, with their symbols set in shields, for example over the nave or in stained glass. They will appear in key scenes without their symbols, for example in the Last Supper, or as witnesses to a miracle, when it is often not possible to distinguish between them.

In a literary sense, the disciples as a group acts as a chorus in

the Gospels, asking the questions that elicit vital answers from Jesus, or standing dazed and baffled by Jesus' message or miracles. As individuals, some personalities – Peter, John, and James – emerge strongly, while others – Jude, Bartholomew – remain permanently in the background. Similarly, while we have a reasonable idea of what happened to some of the apostles after the Gospel accounts of their lives, for others there remain only vague and unreliable traditions. They are, though, a hugely diverse and enjoyable group. Jesus put together a band of men that included the mystical and the sceptical, the boisterous and the timid, revolutionaries and traitors.

St Peter

Square face, rounded beard and bald or tonsured; most common symbols are keys, and/or an inverted cross; occasional symbols include a rock, church, fish, ship, or cockerel; he may be dressed in bishop's robes or have a papal triple crown.

Peter is a hugely popular saint, in part because of the strong, and very human, personality that emerges from the Gospels. He is impulsive and headstrong, at times almost comic. In lists of the disciples, Peter is always first, and he may have been their leader. He is considered to have been the first Pope.

Originally called Simon, Peter was a fisherman and the brother of St Andrew. The brothers were fishing together when Jesus called them from the shore to follow him. We know that he was married, because Jesus healed his mother-in-law. When Jesus asked his disciples the key question, 'Who do you say I am?' it was Peter who said that he was the Messiah. Jesus replied effusively, and renamed him: 'Blessed are you, Simon son of Jonah, for this was not revealed to you by man, but by my Father in heaven. And I tell

you that you are Peter, and on this rock I will build my church'
(Matthew 16:18; Peter is the Greek word for rock; the Aramaic
word, used in John's Gospel, is Cephas).

The accounts of Peter in the Gospels range from the absurd to
the sublime, and from comedy to tragedy. When Jesus walked on
water, Peter asked if he could do so too, only to start sinking
(Matthew 14:22–32); when honoured by being allowed to be
present at the Transfiguration, Peter clumsily blurted out that he
could build shelters for Jesus, Moses, and Elijah (Matthew 17);
when Jesus predicted his own death and Peter took him to one
side to protest that this would never happen, he got the sharp end
of Jesus' tongue for diverting him from his mission ('Get behind
me, Satan!', Matthew 16: 21–23); when Jesus was arrested, Peter
took a sword and struck off the ear of the high priest's servant.

Most famously, shortly before Jesus' arrest, when Peter said that
he would never desert Jesus, Jesus predicted to Peter that that day
he would deny knowing him three times before the cock crowed
at daybreak. During the night after Jesus' arrest, when asked by
bystanders if he was one of Jesus' followers, Peter did indeed deny
it three times, even going so far as to swear that he didn't know
Jesus. When the cock crowed, and Peter realized what he had
done, he wept bitterly (Matthew 26:31–35 & 69–75). After Jesus'
resurrection, Peter was the first apostle to whom he appeared. In
a reversal of the three denials, the risen Jesus asked Peter three
times if he loved him, and when Peter answered that he did,
charged him to 'tend my sheep', meaning his people (John 21:15).

After the Ascension, Peter took a lead in guiding and building
the Church. According to the Acts of the Apostles, he preached at
Pentecost and to the Jewish authorities. He performed miracles, the
most notable being healing the sick by the touch of his shadow and
raising a woman (Dorcas) from the dead. He was imprisoned by

Herod, but freed from his chains by an angel. He had a vision in which he saw a sheet descending from heaven, filled with animals, birds, and reptiles that would have been impure or unclean under Old Testament laws. In the vision he was told that nothing that God had made could be called unclean, which he took as a cue to admit Gentiles into the Church (although he also had disagreements with St Paul about the extent of Jewish–Gentile interaction; Acts 10). He probably wrote the first epistle of Peter, although the second epistle of Peter is almost certainly not his.

The story of Peter's death is a tradition not recorded in the Bible, but set out in the apocryphal 'Acts of Peter'. Peter had gone to preach in Rome. In around 64, during the persecutions of Christians under the Emperor Nero, he tried to escape. On the road, he met (or had a vision of) Jesus coming in the other direction, carrying his cross towards Rome. Peter said to Jesus, 'Lord, where are you going?' (*Quo vadis? Domine, quo vadis?*), to which Jesus replied, 'To Rome, to be crucified again.' Ashamed of his attempt to flee but strengthened, Peter returned to Rome, where he was condemned to death by crucifixion. Peter asked to be crucified upside down, on an inverted cross, because he was not worthy to die in the same way as Jesus had died. St Peter's in Rome is reputed to be built over his tomb.

The depiction of Peter has been consistent down the ages: a square face and curly round or square beard, with either short curly hair or bald/tonsured. His most common attributes are keys, being the keys of heaven that Jesus promised him, and an inverted cross, after the manner of his death. Other symbols associated with him include a fish (on account of his profession, and Jesus' statement that he would be a fisher of men, Matthew 4:19), a rock, sometimes with a church standing on it (on account of Jesus' statement that he would be the rock on which he built his Church), and a cockerel (on account of his denial of Jesus). He is

regarded in the Catholic tradition as being the first Pope – symbolically, the rock on which the Church is built – and so is sometimes dressed in bishop's or papal robes, with a papal crown.

St John

Youthful and without facial hair; eagle; book; chalice with serpent or dragon.

John was Jesus' favourite, his 'beloved disciple' (John 21:20). John is attributed with the authorship of the Fourth Gospel, three epistles, and the Book of Revelation, although there is some question as to whether the same John wrote all of these. In churches, the beardless John is usually identifiable in two key events, the Last Supper and the Crucifixion. He is leaning against Jesus in the Last Supper, and standing at the foot of the cross during the Crucifixion.

John was another fisherman, brother of St James the Great. John and James were passionate about Jesus' message and mission, and Jesus gave them the nickname Boanerges, 'sons of thunder' (Mark 3:17). When Jesus called them they were mending their fishing nets with their father Zebedee; they followed immediately, leaving their father with just the hired hands. They offered to call down fire from heaven when a village refused to welcome Jesus (for which they were rebuked by Jesus). They incurred the indignation of the other disciples by asking Jesus if they could sit one to his left and one to his right in glory (Jesus replied that it was not for him to say where they would sit in glory; Mark 10:35–45). The brothers are described in the Gospels as witnesses to the Transfiguration and the Agony in the Garden.

After the Resurrection and Ascension, John worked with St Peter, to whom he was subordinate, and was imprisoned with him.

Tradition has it that John was persecuted under the Emperor Domitian (including a miraculous escape from a cauldron of boiling oil), but lived to an old age in Ephesus, where he exhausted (this may be a euphemism for bored) his followers with his repeated exhortations to love one another. He is the only disciple not to have a tradition of martyrdom.

The common image of John holding a chalice over which hangs a serpent (or a dragon) comes from a legend that he was challenged by a high priest of the goddess Diana at Ephesus to drink a cup of poison (an alternative tradition has it that he was tricked into drinking from the cup). He drank; not only was he unharmed, but he restored to life two men who had drunk from the cup before him.

Although it is now thought unlikely that John the Apostle is the same as the John who wrote the Book of Revelation, it was long assumed that the two were the same. The vision of the events at the end of time contained in the Book of Revelation was given to John in a cave on the island of Patmos in Greece. In representations of the scene he is usually white-haired and white-bearded.

St Matthew

A man or angel, with a book (when portrayed as an evangelist); money bags, spear, or sword (when portrayed as a disciple).

St Matthew – called Levi in Mark and Luke's Gospels – was a tax collector. His fellow Jews would therefore have regarded him as a traitor, gathering their money to fill the coffers of the invading Roman force. Tax collectors were outside Jewish law and, from the point of view of Jewish purity rules, unclean. His traitorous profession had probably made him a wealthy man: Luke's Gospel relates that he held a great banquet for Jesus (5:27–32).

Jesus called Matthew to be a disciple when he passed him sitting in the tax collector's booth near Capernaum on the Sea of Galilee. When Jesus had dinner in Matthew's house in the company of other tax collectors and sinners, he was criticized by the Pharisees for eating in such company. But he rebuked the Pharisees for the attitude that would have excluded the likes of Matthew: 'It is not the healthy who need a doctor, but the sick … I have not come to call the righteous, but sinners' (Matthew 9:9–12).

The course of Matthew's life after the Gospel accounts is unclear, one tradition having him preaching and martyred in Ethiopia, another in Persia. The tradition is also unclear on the manner of his death, with martyrdom either by a sword or by a spear, and he may be pictured with one of these (although another tradition has him dying of old age). More commonly, he is represented by the money bags, or a slotted money box, of his profession. He may even be pictured wearing spectacles – presumably on account of his closely written ledgers. Matthew is also patron saint of bankers.

St Matthew is traditionally the writer of Matthew's Gospel. If he is being portrayed as one of the four evangelists, rather than one of the twelve apostles, then he is pictured next to an angel or a man, and with a book or an inkwell.

St James the Great

Scallop shell, pilgrim's staff, pilgrim's hat.
James' story in the Gospels is closely linked with that of his brother St John, the other son of Zebedee, which is set out above (page 107).

James was the first of the apostles to suffer martyrdom. King Herod Agrippa (grandson of King Herod the Great, who was in power at the time of Jesus' birth) saw

persecution of the Church as a way of increasing his popularity among the Jews, and James was put to death by the sword in the course of Herod's persecution, around 44 (Acts 12:1–3).

For all that James' death by the sword is one of the most reliable records of an apostle's martyrdom, his most common symbols are the pilgrim's staff, hat, and scallop shell (pilgrims carried scallop shells to scoop drinking water from the streams and brooks that they passed). Over time, James has become firmly associated with Spain, where is meant to have preached (and of which he is the patron saint), and with pilgrimage, because the Church of Santiago de Compostela in northern Spain claims to house his relics. In fact, for a number of reasons (including his early martyrdom), it is very unlikely that James ever visited Spain at all. Nevertheless, over time Compostela became the third most important site of Christian pilgrimage (after Jerusalem and Rome). The old pilgrimage routes, lined with monasteries, are still well used by Christian pilgrims and serious hikers alike.

St James the Less

Saw, club.

St James is called 'the Less' to distinguish him from St James the Great, brother of St John. James has over time tended to be portrayed as a short man, although this is probably a result of his name, rather than his name being a result of his height.

The Gospels mention a number of individuals called James, so that it is difficult to clearly identify him. He is usually identified as the James whose mother stood by Jesus on the Cross, with James one of the brothers of Jesus, and with the writer of the Epistle of James.

Sources outside the Bible suggest that James the Less was the first Bishop of Jerusalem. In the middle of the first century

Hegesippus, a Jewish Christian, wrote that James was called the 'Just', that he did not drink wine or eat animal food, that no razor touched his head, and that he did not anoint himself or use the bath (this was meant as a compliment).

There are two traditions of the martyrdom of James the Less. One is that he was sentenced to death by the Jewish Sanhedrin, thrown from the Temple in Jerusalem, stoned, and sawn in two. Another is that he was beaten to death with clubs. James can be portrayed with either a saw or a club.

St Bartholomew/Nathanael

Flaying knives.

Bartholomew appears in lists of the apostles in Matthew, Mark, and Luke, but in John is called Nathanael. An exchange between him and St Philip shows the rivalry that existed between Palestinian towns. Philip had just become a disciple of Jesus when he came across Nathanael under a fig tree. Philip excitedly reported that he had met the man who had been foretold by the prophets, and that he was from Nazareth. 'Nazareth! Can anything good come from there?' replied Nathanael. For all his scepticism, he went with Philip to meet Jesus. Jesus called him 'a true Israelite, in whom there is nothing false', and Nathanael declared Jesus the Son of God and King of Israel (John 1:43–50).

There are no reliable stories of Bartholomew's life after Pentecost, although traditionally he undertook missionary activities in India and Armenia. The stories attached to his death and relics are unremittingly gruesome. Tradition has him flayed alive, and/or beheaded, and/or crucified upside down, at Derbend on the Caspian Sea. It was the first of these that captured artists' imaginations, and his symbol is a set of flaying knives (although

some images, including Michelangelo's *Last Judgement*, go so far as to have him holding his own skin, draped over his hand in a seamless whole). Whether he appreciates the irony, Bartholomew became the patron saint of tanners and leather workers. A number of British churches are named after him, his popularity rising after one of his arms was donated to Canterbury in the eleventh century.

St Thomas

Carpenter's square; spear.

'Doubting' Thomas was also known as Dydimus, 'the twin'. Although courageous (he encouraged the disciples to follow Jesus even though it would mean death to them, John 11:16), he also seems to have had a tendency to miss the point. Jesus taught the disciples about life after death, and promised to go ahead of them to prepare a room in God's house. The baffled Thomas responded, 'Lord, we don't know where you are going, so how can we know the way?' This prompted Jesus' famous reply, 'I am the way and the truth and the life' (John 14:1–6). Above all, Thomas is remembered for doubting the resurrection of Jesus, and he is most often portrayed in images of the Incredulity of Thomas (page 79).

Thomas was a popular saint, and a great deal of later literature grew up around him with fantastic tales of his adventures. There is a persistent tradition that Thomas conducted his missionary work in India, perhaps with St Bartholomew. There he was said to have built a palace for an Indian king, and one of his symbols became a T- or L-shaped carpenter's square. His other symbol, a spear, relates to the supposed instrument of his martyrdom. One tradition has him martyred as deep into India as Mylapore, near Madras. Another has it that Thomas made it as far as America – although it is more likely that this tradition was prompted by an

overly literal reading of Jesus' last words to his apostles, that they would carry his message to the ends of the earth (Acts 1:8).

In Christian literature, Thomas has been both praised for the scepticism that prompted Jesus to prove himself, and condemned for his lack of faith and spiritual blindness. For that reason, he became the patron saint of poor eyesight.

St Jude

Ship, club, letter or book.

Also known as Thaddeus (in Mark) and Lebbaeus (in Matthew), Jude was the brother of James and one of the brothers of Jesus (Matthew 13:55 and Mark 6:3).

Tradition has it that after Pentecost Jude conducted missionary work with St Simon the Zealot in Persia, where he was martyred by being clubbed to death. If a church is named after him, it tends to be with St Simon, in commemoration of their work together. Jude is also symbolized by a ship. The ship, which is also a symbol of the Church itself, was attributed to him either as a reference to Jude's sailing on his missionary journeys, or to a belief that he was a fisherman (although this is not mentioned in the Gospels) – in which case Simon is identified in the same vein, holding a fish.

Jude is traditionally the writer of the Epistle of Jude, the penultimate book of the New Testament, although the author of the epistle might have been using the name as a pseudonym. The epistle is characterized by its sharp rebuke of immorality. The association with the epistle has meant that St Jude is often portrayed with a book or sheaf of paper.

Jude's name is so similar to that of the despised Judas Iscariot that he was invoked as a saint only in the most extreme circumstances. He therefore became the patron saint of lost causes.

St Simon (the Zealot)

Fish or boat, book, saw or falchion or lance.

Simon appears in the Gospels in lists of the apostles, but not elsewhere. He was known as 'the Canaanite' (Mark 3:18; Matthew 10:4) or 'the Zealot' (Luke 6:15, Acts 1:13). The latter name may mean that he was part of a Jewish sect called the Zealots (fierce patriots in the vanguard of the rebellion against Rome), or simply that he was zealous in keeping the Jewish law. One Greek tradition claims that Simon was the bridegroom at the wedding at Cana. Another tradition holds that he was one of the shepherds to whom the angels announced the birth of Jesus.

After Pentecost Simon may have preached in Egypt, and then joined St Jude to travel to Persia. There are a number of symbols of his martyrdom, the most common being a saw; others include a falchion (a short curved sword) or a lance. He is also sometimes seen with a fish (where St Jude carries a boat), or less commonly, a ship.

St Philip

Loaves of bread; cross.

Philip, like St Andrew and St Peter, was from the town of Bethsaida by Lake Genesareth, and was probably a fisherman. He comes across in the Gospels as shy (when some foreigners asked him to introduce them to Jesus, he asked Andrew first, John 12:22–23), innocently enthusiastic (as when he was telling the cynical St Bartholomew about Jesus, John 1:43–50), and sincere. When Jesus was teaching the disciples, Philip said, 'Lord, show us the Father and that will be enough for us.' Jesus replied, 'Don't you know me, Philip, even after I have been among you such a long time? Anyone who has seen me has seen the Father.'

Philip is most prominent in the story of the feeding of the five thousand. Jesus and the disciples were on a grassy mountainside

near the Sea of Galilee. On seeing a crowd approaching, Jesus turned to Philip and asked how they were going to feed them. Philip replied that eight months' wages, or two hundred pennyworth, would not buy enough to feed the crowd. Jesus solved the problem by miraculously multiplying five loaves of bread and two fishes that a young boy in the group had brought with him (John 6:1–15). For his part in the miracle, Philip's symbol is loaves of bread, either five or two in number. In heraldic representations simple circles represent the loaves.

Little is known of Philip's later work and death, although he may have preached in Phrygia, and traditionally was crucified, which gives his other symbol, the cross. In one tradition he was crucified on a saltire cross, like St Andrew, and the two are distinguished by the background colour: St Andrew is blue, while St Philip is red. A second-century document suggests that Philip had three or four daughters who became famous prophetesses or holy women.

St Andrew

'X' cross; fishing net; bushy, messy grey hair.
Andrew was the brother of St Peter, and the two shared a house in Capernaum, on the Sea of Galilee. Andrew was a follower of John the Baptist before he became one of the twelve. In Mark's Gospel, Andrew and Peter were called together when Jesus saw them casting their nets on the Sea of Galilee, this being the source of Andrew's minor symbol of a fishing net (Mark 1:16–17); in John's Gospel, Andrew was the first disciple to be called, and introduced Peter to Jesus (John 1:40–42). Andrew is particularly mentioned in the Gospels for taking part in the feeding of the five thousand (it was Andrew who said: 'There is a boy here who has

five barley loaves and two fishes: but what are these among so many?'; John 6:8–9) and was the person St Philip went to when a group of foreigners asked him to introduce them to Jesus (John 12:20–22). An ancient tradition has Andrew with grey hair, like his brother, but bushier and more unruly.

After Pentecost, Andrew's preaching was either wide-ranging, or the records are bad, with different sources claiming that he preached in Scythia, Epirus, and Hellas (all in Greece). It is generally agreed, though, that he was condemned to death by the Roman Governor Aegeas at Patras in south-west Greece. He was crucified on an 'X'-shaped cross known as a saltire, or St Andrew's cross, which became his major symbol. To prolong his suffering he was bound, rather than nailed, to the saltire – although this simply gave him more time to preach the Gospel to the crowds around him.

Andrew is the patron saint of Scotland, his saltire being displayed on the flag of Scotland and so in the Union flag of the United Kingdom. Andrew's association with Scotland came about because part of his relics were supposed to have been transferred there in the fourth century by St Rule, an otherwise fairly obscure saint. An angel appeared to Rule in a dream and told him to take part of Andrew's relics from where they lay in Patras and then to head north-west to an undisclosed destination. When Rule finally reached what is now the town of St Andrews he was told to stop, and he built a church to house the relics.

St Matthias

Halberd or axe.

St Matthias is the 'thirteenth' apostle, chosen to replace the dead Judas Iscariot. The disciples needed to complete their number to the symbolic twelve (see section introduction, page 103). To

qualify, candidates had to have been with the group continuously from the date of Jesus' baptism until his ascension. There were two candidates, and Matthias won after lots were cast to choose between them (Acts 1:15–27).

Matthias was with the other disciples at Pentecost. Afterwards, he traditionally preached in Judaea, then around the Caspian Sea ('Andrew and Matthias in the City of the Cannibals' is one splendidly named tale about him). He was martyred by being stoned and beheaded with a halberd or a battle-axe.

Judas Iscariot

Rope; thirty pieces of silver.

No saint, but a key figure in the Gospels, Judas Iscariot is the great villain of the Gospel story. He was the betrayer of Jesus, and his name is still a term of abuse – a 'Judas' is a traitor.

Judas was one of the twelve disciples and was their money-keeper. 'Iscariot' has been interpreted as meaning 'man of Kerioth', Kerioth being a town near Hebron. If that is right, then Judas was the only disciple who was not a Galilean, which would make him the outsider of the group from the start.

John's Gospel records Judas objecting when Mary Magdalene spent money on fine perfume to anoint Jesus, on the grounds that the money could have been better spent on the poor. This does not seem an unreasonable argument, but John goes on to say, perhaps with the anger that he still felt at later events, that Judas said this because he was a thief, and used to help himself to the contents of the group's money bag (John 12:4–6). After this, Judas approached the High Priests to negotiate his betrayal of Jesus, for which they offered him thirty pieces of silver, which became one of his emblems. The key events in his betrayal of Jesus are shown

in depictions of the Last Supper and the Betrayal.

The New Testament contains two dark accounts of Judas' death, and in both Judas is linked with a site near Jerusalem called the Field of Blood. Matthew has Judas filled with remorse after Jesus' arrest. He tried to return the thirty pieces of silver to the chief priests. When they refused to take it, he threw the money into the Temple, went away, and hanged himself. The chief priests could not keep this tainted money, and so used it to buy land called the Potters Field. The field was to be used for the burial of foreigners, and was renamed the Field of Blood (Matthew 27:1–10). Acts, which is a continuation of Luke's Gospel, has Judas using his silver to buy a piece of land. On the land he fell headlong and his body burst open – which caused it to be named the Field of Blood (Acts 1:18–19). In his suicide, Judas is sometimes portrayed as a detail in a larger picture, or juxtaposed with Jesus on the Cross. He may be hanging from a tree with the thirty pieces of silver at his feet. Pots on the ground may indicate the original name of the Field of Blood.

The Gospels are in no doubt of Judas' villainy, calling him wicked and a devil. However, it is not clear why Judas did what he did. Luke and John's Gospels deal with the question by having Judas filled with the devil. A different view is that Judas was a frustrated revolutionary, and the betrayal was in fact an attempt to prompt Jesus into starting a revolution and bring in the new kingdom that he had spoken of so often; another is that Judas had foreseen disaster for the group when Jesus attacked the moneychangers in the Temple, and was trying to get out while he could. Whatever the reason, it is also worth mentioning an unorthodox view that is more sympathetic to Judas. This view sees him as an instrument in the Divine plan that led to Jesus' death, and so to the eventual salvation of the world.

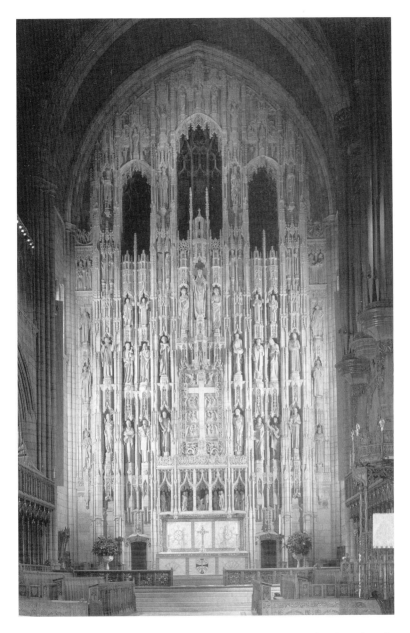

The Great Reredos: The chancel steps lead up to an altar bearing the legend "O God My Heart Is Ready", while saints and prophets look down. Taken from Saint Thomas Church, Fifth Avenue, New York.

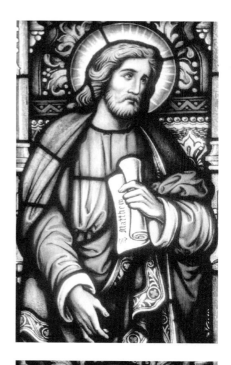

St Matthew: Holding a scroll to represent his gospel. St Matthew is traditionally the author of the first gospel that appears in the Bible. He was a tax-collector, and would have been regarded as in league with the Roman invaders when he became a disciple of Jesus. From St Joseph's Parish, Hamilton, Ontario.

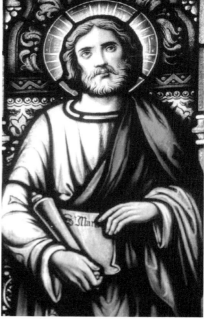

St Mark: Holding a scroll to represent his gospel. From St Joseph's Parish, Hamilton, Ontario.

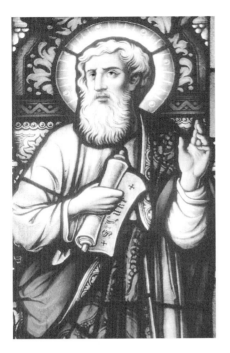

St Luke: Holding a scroll to represent his gospel. From St Joseph's Parish, Hamilton, Ontario.

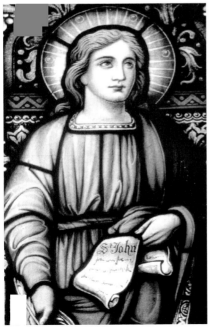

St John: Here St John is unshaven, as he is always represented as a disciple, and is holding a quill pen and parchment, in reference to the tradition that he is author of the fourth gospel. From St Joseph's Parish, Hamilton, Ontario.

Isaiah: The figure of Isaiah with a staff in his hand and the cedars of Lebanon to his left. Above in the spandrels are a lily, referring to Isaiah's prophecy of the Virgin, and the nails and thorns, which signify Isaiah's prophecy of the Suffering Servant. From *St. Bartholomew's Church in the City of New York: An Architectural Tour,* by Percy Preston Jr., © 1998 by Saint Bartholomew's Church in the City of New York. Used with permission.

The Trinity: Stained glass window showing God the Father (Right hand of God descending with two fingers extended in a gesture of blessing), God the Son (the Lamb of God holding the pennant of victory) and God the Holy Spirit (the Dove). All three have a cruciform halo in reference to the crucifixion, which indicates that although they are three people, they are also one person. From Sacred Heart Basilica, Syracuse, New York.

The All-seeing Eye of God, within a triangle representing the Trinity. From St Joseph's Oratory, Montreal, Quebec.

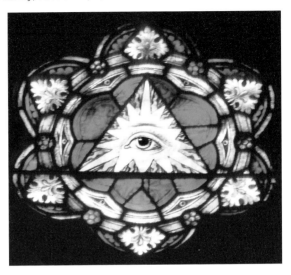

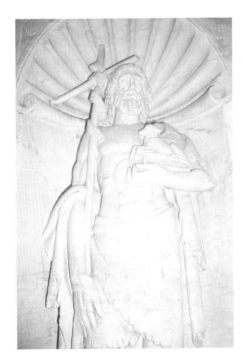

St John the Baptist: John has wild hair and rough, camel-skin clothes. He is holding a thin cross on a staff, wrapped with the script "Ecce Agnus Dei", "Behold the Lamb of God", his words to his disciples on seeing Jesus. He is carrying a lamb sitting on a sealed book, which is a reference to St John's vision in the Book of Revelation. John saw a lamb and a book with seven seals. When the lamb opened the seals, it ushered in the final apocalypse. From St Bartholomew's Church, New York.

The Last Supper: The words at the foot, "This Do in Remembrance of Me", are Jesus' words to his disciples, after he had told them to eat the bread and drink the wine of the Last Supper. From St Bartholomew's Church, New York.

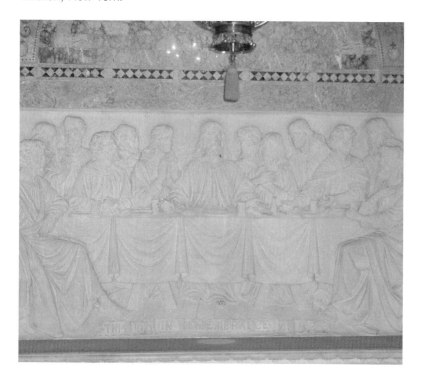

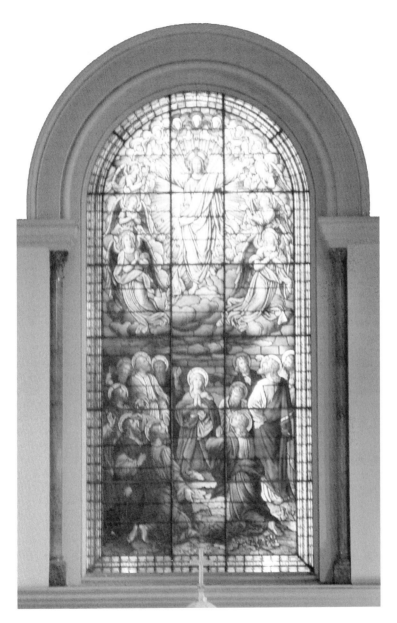

The Ascension: Stained glass window above the altar at the Catholic Church of the Ascension, New York, showing Christ in glory, with cruciform halo, crown, orb, pierced hands and feet. Used with permission.

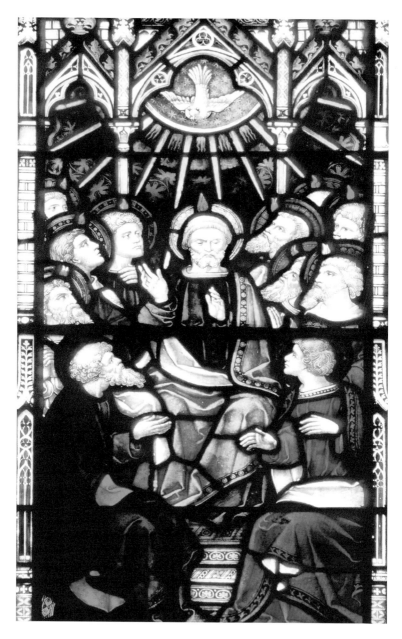

Pentecost: The twelve apostles seated in the upper room with the tongues of fire resting above their heads, as the Holy Spirit descends symbolized as a dove. The dove is wearing a cruciform halo, which connects it with Jesus, as two persons of the Trinity.

St Stephen

Young man, unshaven; stones.

St Stephen is the first Christian martyr, and the story of his death is recorded in the Book of Acts. Stephen was one of seven deacons chosen by the disciples to deal with charity for the poor. He was accused of blasphemy, and taken before the Jewish authorities in Jerusalem. Acts records his long speech in his defence, in which he reviews Jewish religious history and then condemns those present for having failed to listen to Jesus ('You stiff-necked people, with uncircumcised hearts and ears!'). Finally, he looked to the sky and was touched with a vision of Jesus, crying out, 'Look, I see heaven open and the Son of Man standing at the right hand of God!' This was enough for those present, who dragged Stephen outside the city walls and stoned him to death. Stephen's last words were: 'Lord, do not hold this sin against them.' Before stoning him, Stephen's executioners laid their cloaks at the feet of a young man named Saul – later to become St Paul. In representations of the martyrdom, Saul can often be seen standing to one side, cloaks at his feet (Acts 6–7).

Later Saints

St Agnes

A lamb.

The lamb is the identifying attribute of St Agnes through a play on her name, which is similar to the Latin *agnus*, 'lamb'. The association is more than just word play, though, since the story of her martyrdom is one of innocence and sacrifice. Agnes was a young Christian girl in Rome, aged around twelve or thirteen when she died in 305. According to ancient stories of the martyrs, she was ordered to marry a Roman pagan. Having dedicated her

life to Jesus, she refused, and as a punishment was dispatched to a brothel. When she was stripped, her hair grew long to cover her, but not before a man had seen her naked and was struck blind. She was then executed by being beheaded with a sword, in a symbolic violation of her virginity.

It seems likely that within the fantastic elements of Agnes' story there are a number of powerful truths. Early Christians in Rome suffered a series of violent persecutions; punishing women by forcing them into brothels did happen; and execution by the sword was common. It is the youth of Agnes that makes her story particularly moving, and which moved her contemporaries. Agnes is known to have been honoured as a Christian martyr from only a few years after her death.

St Anthony of Egypt (or, of the Desert)

Elderly, with wild appearance; pig; bell; Tau cross.

St Anthony of Egypt is regarded as the father of Christian monasticism. Born around 251, Anthony renounced his inherited wealth in order to practise a life of extreme austerity, first in a tomb near his home village, and then in an abandoned fort at Pishir (now Der el-Memum) in Egypt. He stayed within the walls of the fort in complete solitude for twenty years, subsisting on food thrown over the walls by pilgrims. In 305, devotees who had gathered around the fort persuaded him to emerge, and he spent five or six years instructing and ordering the group. In the final forty-five years of his life, Anthony returned to the life of a hermit in the Egyptian desert, although he received visitors and made occasional journeys to Alexandria. Austerity makes for longevity: Anthony died in 356, aged 105.

The episode in Anthony's life that is most often portrayed is the story of his torment and temptation by demons at the tomb

outside his home village, which gave artists an opportunity to let their imaginations run wild in depicting the monstrous gang. Anthony's attributes of a bell and/or a pig are derived not from his life, but from the practice of an order of hospitallers that was founded in his name in La Motte, in around 1100. Pigs belonging to the order were allowed to roam free in the town, and members of the order rang small bells to collect alms. The bells were then hung around the necks of animals, to protect them from disease.

St Anthony of Padua

Fat, in brown habit of a Franciscan monk; lily; child; fishes.

Born into the Portuguese nobility in 1194 or 1195, St Anthony of Padua entered the Order of Austin Canons, before being inspired to join the newly formed Franciscan order by an encounter with a group of Franciscan friars. He was determined to undertake the risky venture of missionary work in Morocco, where a number of Franciscans had been killed, but fell ill and had to return almost as soon as he had arrived. Although an unknown, the young Anthony was asked to preach at the General Chapter of the Franciscans in 1221 (at which St Francis of Assisi was present), and he is said to have astonished the assembly with his eloquence and learning. Anthony is remembered as an outstanding travelling preacher, with huge crowds gathering to hear him speak, and it was said that the fish in the River Brenta near Padua poked their heads out of the water to hear him. His key messages included the Franciscan themes of care for the poor, condemnation of tyranny, and love.

Anthony is particularly associated with children, and he is often portrayed holding a baby or infant. On one occasion, he was seen praying in a state of ecstasy, with his arms held as if he were cradling a baby; on another, he was seen sitting in front of an open

book on which a child stood. Both times, it was clear that the child was Jesus.

In addition to his preaching, Anthony was known as a miracle worker. One incident that is sometimes depicted is of a young man called Leonardo, who confessed to Anthony that he had kicked his mother in a fit of temper. Anthony told him that the foot of the man who kicked his mother deserved to be cut off (words that will have done little to diminish his popularity, at least among mothers). Taking these words a little too literally, Leonardo returned home to do just that, prompting Anthony to step in and reconnect the severed foot. Another story is that one day a novice friar borrowed Anthony's book of psalms without asking permission. An apparition appeared which scared the young man so much that he dashed to return the book. This incident has given Anthony a reputation for helping people who ask for his help to find lost or mislaid objects.

According to legend, Anthony was a fat man, and this is how he is usually portrayed. As it turns out, this is rather unfair. Anthony's body was exhumed and examined in 1981: he had a long, thin face, and his bones were found to show some malnutrition, possibly as a result of his frequent fasts and long journeys by foot to preach. He died in 1231 aged just thirty-six.

St Catherine of Alexandria

Wheel set with knives.

St Catherine of Alexandria lived in the fourth century. A young noblewoman of fine intellect, she was said to have upbraided the Emperor Maximinus for his cruelty to Christians. He set her to debate the truth of Christianity with fifty philosophers, and she emerged from the debate so successful that several of them

converted. This episode has led to her being adopted as patron saint of philosophers, and she is particularly popular among students and academics (both Oxford and Cambridge Universities have a college named after her). Catherine was thrown into prison, where her standing with the Emperor was further diminished when the Empress visited her and was converted as well.

The Emperor tried to execute Catherine by breaking her on a wheel set with knives, but it was the wheel that broke, injuring the jeering onlookers. She was then beheaded (she was named as patron saint of nursemaids because milk rather than blood was said to have flowed from her neck), whereupon angels carried her body to Mount Sinai, where later a church and monastery were founded in her name.

The popularity of Catherine and her wheel may have been assisted by its echo of ancient cults of the sun and fertility. The spikes of her wheel resemble the sun's rays, while in Europe a tradition of running burning wheels across fields or down hills, which had its origin as an encouragement to the fertility of the harvest, continued in many places until comparatively recently. The entanglement of the traditions of sun, wheel, and Catherine lives on in the revolving firework, the Catherine wheel.

St Christopher

Giant, carrying an infant on his shoulders; lantern, sprouting staff, river.

For centuries, the reputation of St Christopher has been caught in a tug-of-war between his immense popularity on the one hand and official disapproval on the other. His popularity derives from his being the patron saint of travellers, and from a very ancient superstition that should anyone look at an image of St Christopher, then they would not die that day. This is the reason

why, in old churches, he is sometimes painted opposite the entrance to the church, so that he is the first thing the visitor sees, and why his image is stamped onto medallions worn by vast numbers of people all over the world. The official disapproval is due to the mythological nature of the tales attached to him. During the Reformation he was seen as an example of the godless superstition that reformers believed was prevalent in the Roman Catholic Church, and images of him are far less common in churches of any denomination built after that time.

According to legend, Christopher was a man of huge size. He worshiped the Devil until, noticing that the Devil was afraid of the sight of a cross by the side of the road, he decided instead to join the winning team and converted to Christianity. As part of his Christian duties he was given the task of helping travellers to cross a swollen river, for which he used a lantern to help them see the way. One day, a child approached the river. Christopher carried him across on his shoulders, but found him immensely heavy. The child then told Christopher that he was Jesus, and that he had just carried the weight of the world on his shoulders, and the weight of the creator of the world ('Christopher' translates as 'carrier of Christ'). The child gave Christopher a staff, which flowered the next day as a proof that his words were true. Christopher went on to preach in Lycia, before being martyred by beheading.

The fairytale character of Christopher's story does not mean that he did not exist. At least one church had been dedicated to him by as early as the middle of the fifth century, which suggests that he may not have been a pure invention, and one can speculate as to which parts of his story might have some basis in fact. Does the reputation for Devil-worship show that he was a convert from some pagan faith? Was he a member of a church in Lycia? Was he a big man?

St Francis of Assisi

Brown Franciscan habit; birds and animals; stigmata.

St Francis of Assisi was the founder of the Franciscan order of friars. He was born the son of a wealthy cloth merchant in 1181, and grew up a spoilt young man, although he later turned his back on his privileged upbringing. When the young Francis was visiting the rundown Church of San Damiano in Assisi, he heard a voice say, 'Go, repair my church, which you see is collapsing.' Taking this injunction literally, he used first his inheritance and then goods begged from the local townspeople to regenerate the building. He then set off as a travelling preacher, supporting himself through begging. He gathered together a few followers, and together they lived communally in Assisi, tending a nearby leper colony, and going into the countryside to preach (they called themselves 'the Lord's Minstrels', since they sang with joy as they went on their way). The simple rule of the order emphasized obedience to the Church authorities (in particular the Pope), and a life of extreme poverty. Their huts and churches were simple, they had no furniture, and they slept on the floor. The order was officially recognized by Rome, and grew rapidly, although Francis' last years were difficult. He went blind and died aged forty-five, in 1226. More than for his works, St Francis is loved for the essence of his being, displayed in his empathy with the troubled, his joy, and his wisdom. As he would often say, 'What a man is in the sight of God, so much he is, and no more.'

Representations of Francis often include scars on his hands. In 1224, while on Mount La Verna, Francis is said to have had a vision of an angel and to have received stigmata (wounds that appear spontaneously in the hands, feet, and side, in imitation of the wounds of Jesus on the cross). The moment at which Francis received these wounds is often portrayed. Another scene that is

often depicted is Francis preaching to the birds and to the animals. Preaching to attentive fauna is an attribute that is attached to more than one great speaker, and a similar legend is told of St Anthony of Padua. As well as being a compliment to the preacher, it contrasts the receptiveness of simple animals with the mental resistance of the educated, and suggests God's care for the whole of his creation, and not only people.

St George

Cross on shield, in armour; dragon.

Patron saint of England since the fourteenth century, and greatly honoured by both Western and Eastern Churches, St George is a warrior saint.

George is best known for the legend of the dragon. A pagan town was terrorized by a dragon, which had eaten its way through the town's sheep and much of its people, before the townsfolk offered it their beautiful princess (an alternative story has it that the dragon's hunger could only be satiated with virgins, and that as the number of live virgins dried up, the townspeople were compelled to offer it the princess). George rode in, killed the dragon, and saved the day. The town was so grateful that it converted to Christianity en masse. Symbolically, the legend has been read with the dragon symbolizing Satan, the virgin princess symbolizing humanity, and George symbolizing Jesus, who saves humanity.

Little is known of the 'historical' St George, a figure to whom legends attached from a very early stage. The kernel of the stories is that George was Christian, and a senior officer in the army of the Emperor Diocletian (245–313). Diocletian was a persecutor of Christians, and the legend has it that George complained to him personally about his harsh anti-Christian decrees. George was

thrown into prison and tortured, but refused to recant his faith, and so was dragged through the streets and beheaded.

St Lawrence

Young man; iron grid; money bag.

St Lawrence (in Italian, San Lorenzo) was a deacon of the church in Rome (he is sometimes paired with St Stephen, who was a deacon in Jerusalem). He was known for his charity, which has led to his minor attribute, a bag of money. His major attribute is a heavy iron grille on which, according to legend, he was roasted alive by the Emperor Valerian. Whether or not this is true (and it probably isn't; Valerian preferred beheading), Lawrence died in around 258, in a persecution that also saw the deaths of his fellow deacons and the Pope, Sixtus VI. The church over his grave lies just outside the city walls of Rome.

Lawrence is popular as the playful saint, although some of his jokes are a little rough for today's tastes. As he lay on the iron grid, he is said to have joked to his torturers that they had better turn him over, because the side nearest the fire was well done. More poignantly, when the Emperor ordered him to hand over the treasures that the Church in Rome was reputed to possess, Lawrence is said to have gathered together the poor and the sick, and declared that they were the treasure of the Church.

St Martin of Tours

Coat cut in half; geese; burning globe.

St Martin of Tours is best known for one celebrated story. On meeting a half-naked beggar shivering in the cold outside the city of Amiens, he cut his cloak in two, and handed over one part. Later, he had a dream in which Jesus appeared, wearing the half of

the cloak that he had given away. The story is a vivid embodiment of Jesus' identification of himself with the poor: 'whatever you did for one of the least of these brothers of mine, you did for me' (Matthew 25:31–40).

Martin is sometimes shown in the dress of a Roman legionary. Born in Hungary, he followed his pagan father into the Roman army, but found his duties incompatible with his Christian beliefs. He refused to serve, and was thrown into prison, to be released only at the end of the war in 357. He became a monk, and the Benedictine Abbey of Liguge and the Monastery of Marmoutier near Tours both originate from groups that formed around him. In 372 he was made Bishop of Tours, through an act of trickery. On the death of the previous incumbent, Martin was the popular choice to replace him, but he preferred the monastic life. A rich citizen called Rusticius lured Martin into the town by claiming that his wife was close to death. When Martin rushed to Tours to comfort her, he was met with such acclaim that he found it impossible to refuse the bishop's role.

One day, while celebrating Mass, a burning globe of fire appeared over Martin's head, giving one of his attributes. His other, geese, is because of the migration of geese in France around the date of his death, 11 November. The date also lies behind the expression 'St Martin's summer', which describes a spell of settled weather in early November.

St Nicholas

Three golden purses or balls.
St Nicholas is the saint whose story gave rise to the figure of Father Christmas, or Santa Claus. Little is known about his life except that he was Bishop of Myra, in Turkey, in the fourth century.

What is known, though, is that he was honoured from a very early date, and that fantastic tales grew up around him.

Nicholas saved three young women from prostitution by hurling three bags of gold for their dowries through their father's window. These three bags became his symbol, and are also the origin of the three golden balls that hang outside pawnbrokers, since pawnbrokers have claimed Nicholas as their patron saint (although Nicholas never, as far as I am aware, lent, or charged interest, or required fixed-term redemption). He was active in saving those in peril, including sailors and condemned men, and he even raised the dead. Three boys who had been murdered by a butcher and stored in a tub of brine were restored to life by Nicholas, which led to his being named patron saint of children. This association with children, and his present-giving, led in turn to his association with Christmas.

St Sebastian

Young, beardless, tied and pierced with arrows.

The image of St Sebastian, semi-naked and riddled with arrows, is common in Christian art. Like St Agnes, Sebastian was a victim of the persecutions of the Emperor Diocletian in around 300. According to legend, he was a Roman soldier, and captain of the Praetorian Guard. Finding him comforting persecuted Christians, Diocletian ordered that he be executed by being shot to death with arrows (although he survived this inefficient method of execution, and had to be clubbed to death instead). Although the earliest known representation of him, a mosaic dating from 682, shows a bearded man and no arrows, it was the pleasure of artists from the Renaissance onwards to portray the saint as young, bound, and arrow-pierced.

St Theresa of Lisieux

Roses and other flowers; inflamed heart.

Theresa of Lisieux is remarkable by her difference. On the surface, she appears to have done nothing of importance. She did not found holy orders, write clever theology, or enjoy mystical visions. There are no fantastic stories connected with her life. She died of tuberculosis in 1897 aged just twenty-four, having spent all of her adult life within the confines of a nunnery. And yet she now is honoured so highly that images of her can be found in many Roman Catholic churches, in particular in France.

Theresa's message is one of simplicity, of paring Christianity back to its bare essentials. She entered a Carmelite nunnery at Lisieux, France, at the age of fifteen. She was a model of obedience to the rules of her order and, when she contracted her illness, endured it without complaint. She became known outside the walls of the nunnery through a work written as she lay dying, *L'Histoire d'un ame* ('The Story of a Soul') – a work that caused her to be named as a Doctor of the Church. She rejected the idea of self-punishment, saying instead that selflessness was the harder and more courageous goal. Images of her emphasize her artless sweetness, and have her standing in or spilling a shower of flowers. She said that she would send 'a shower of roses' of miracles, and became known as the 'Little Flower of Jesus'.

St Veronica

Cloth with the image of a face.

Veronica is most commonly shown in the sixth of the Stations of the Cross. According to legend (the story does not appear in the Bible), she wiped the sweat and blood from the face of Jesus as he carried his Cross to the place of Crucifixion, leaving a perfect image of his face on the cloth. According to one theory, Veronica's

name comes from the Latin *Vera Icon*, 'True Image' – that is, her cloth carried the true image of Jesus. A cloth claiming to be the one in question has been preserved in St Peter's, Rome, since the eighth century.

Some commentators have associated Veronica with women who appear in the Gospel stories, such as Martha, sister of St Mary Magdalene, or a woman who Jesus cured of a haemorrhage (Mark 5:25–34). Veronica's story first appears, though, a few hundred years after the Gospels, and it seems likely that it was invented. The real story behind the legend of Veronica may be the hunger of Christians to know more about Jesus than the Gospels reveal – in this case, what he looked like.

THE OLD TESTAMENT

T he term 'Old Testament' is an awkward one. The Old Testament is made up of books from the Jewish Holy Scriptures. The designation 'old' is intended to contrast the revelation of God recorded in those books with the 'new' revelation of Jesus, and the 'old' covenant between God and Israel with the 'new' covenant between God and humankind. But it is insulting to the living faith of millions of people who confess the Jewish faith to label their books with a title that implies redundancy. A better name, which is used in the title heading of some versions of the Bible, is 'the Hebrew Scriptures', or the Hebrew name for the whole body of traditional Jewish teaching, the Torah.

However, the Old Testament remains the title most widely used and recognized. More than that, the term is useful when considering images from the Torah in a Christian context, because those images are often used to make a New/Old Testament comparison. While images from the Old Testament are certainly used for 'stand-alone' revelations of God, they are also used in combination with images from the New Testament to convey a specifically Christian message. For example, some Christian

teachings depend on a state of affairs recorded in the Hebrew Scriptures being reversed in the New Testament. The most common example of this is the Fall of humankind in Genesis being reversed by the Redemption of humankind in the Gospels; of Adam contrasted with Jesus; and of the Tree of the Knowledge of Good and Evil contrasted with the Cross of the Crucifixion. In theological terms, Jesus is seen as the 'New Adam'. This meant that whereas it was Adam's sin (his disobedience to God in eating the fruit of the Tree of Knowledge) that caused the rift between God and humankind, it was Jesus' sacrifice on the cross that reconciled them. Images of the crucifixion may therefore be arranged and contrasted with images of Adam and Eve, in particular their expulsion from the Garden of Eden. Some artists portray Jesus crucified on a tree, the tree being the Tree of Knowledge.

This theological connection was bolstered by medieval legend, which made a direct 'historical' connection between Adam and the Cross. The legend has it that when he was expelled from Eden, Adam took with him a branch of the Tree of Knowledge. When Adam died, his son Seth planted the branch over his father's grave, where it took root and grew. This tree was cut down by King Solomon to build the Temple in Jerusalem but the wood from it did not fit, and so it was used to make a bridge across a stream. When the Queen of Sheba visited Solomon, she perceived that the bridge had miraculous properties, and she chose to walk through the stream rather than cross it. The Queen warned Solomon that the wood would one day destroy the nation of Israel, and so Solomon had it buried. However, a spring later bubbled up on the spot, and the wood rose to the surface. The spring took on the power of the wood, and became the Pool of Bethesda, with healing powers, where Jesus healed a paralytic. The recovered wood was used to make the cross on which Jesus was crucified.

Images from Old Testament stories are also used in combination with images from New Testament stories as 'types', with the earlier Hebrew story 'prefiguring' the Christian story. Types range from being fairly simple anticipations of the New Testament story, to making complex theological statements. For example, types for the Annunciation include the angels appearing to Abraham to announce the birth of Isaac, the Temptation of Eve, and Moses and the Burning Bush. The angels appearing to Abraham and the Annunciation form a simple reflection, since in both cases angels appeared to announce a birth. The temptation of Eve is more complex, since it makes a contrast between the two events. Eve gave in to temptation, which led to the separation of God and humankind, whereas Mary was obedient to God's will, which led to their reconciliation. The type of Moses and the Burning Bush is more complex still. In the Burning Bush and in the Annunciation, God was 'physically' present on earth – in the fire of the bush, and in Mary's womb – but did not destroy the material surroundings. God was present in the Burning Bush at the start of the Exodus story in which he would lead Israel out of slavery in Egypt; and he was present in the womb of Mary at the start of the story of Jesus when he would lead humankind out of the slavery of sin.

It is usual for figures in statues, paintings, or stained glass to be arranged in terms of the New and Old Testaments, for example on either side of a screen. New Testament characters usually appear on the south or east sides of the church (which have the greatest honour) while those of the Old Testament are more generally found on the north or west sides. One major theological arrangement of this sort is the sequence of the Apostles' Creed. The Apostles' Creed is a statement containing the key elements of Christian belief (creed means a set of beliefs or principles). The

Apostles' Creed developed as a unifying statement of Christian faith and it (or an expanded variant called the Nicene Creed) forms a core part of many acts of Christian worship, when the whole congregation recites it. In the Creed sequence, the Creed is broken into twelve units, each of which is written on an image of a scroll and given to a particular apostle. Against these are set prophecies that prefigured those units, which are written on scrolls held by the prophet that made them. So, for example, St Peter, the leader of the disciples, is given the opening words of the Creed, 'I believe in One God, Father Almighty, Maker of Heaven and Earth'; against this is set the Prophet Jeremiah, and his words 'Ah, Sovereign Lord, you have made the heavens and the earth by your great power'; or, 'You will call me "Father".' A table of the whole Creed sequence is set out in the Appendix (page 234).

We now turn to the Old Testament stories themselves, and the ways in which each is portrayed in churches. What follows is the order of stories as they appear in Bible, finishing with an account of the major prophets.

Creation
Six-pointed star.

In the beginning, the earth was a dark, formless void. On the first day, God created light, and separated night from day. On the second, he separated the sky from the waters. On the third, he separated the earth from the sea and covered it with vegetation and fruit trees. On the fourth, he created the sun, the moon, and the stars. The fifth day saw the creation of sea creatures and birds. On the sixth, God created the creatures of the earth. Finally, God created humankind, man and woman, in his own image, which is the scene most often depicted. On the seventh day, God rested (Genesis 1–2:3).

God is sometimes shown above the scenes of Creation, holding a pair of scales and/or a pair of compasses. The image comes from the Prophet Isaiah, who talked of God 'who has measured the waters in the hollow of his hand and marked off the heavens with a span, enclosed the dust of the earth in a measure, and weighed the mountains in scales and the hills in a balance' (Isaiah 40:12). If the image of God is given a cruciform halo (when he may have dark rather than white hair), it is a reference to Jesus as God the Son. The purpose is to make a theological point, which is made in the first verse of the Gospel of John, that God the Son ('the Word') was present at creation ('In the beginning was the Word ...' John 1:1). An ancient emblem of creation is a six-pointed star.

The Fall of Man/Adam and Eve

Tree with apple and serpent; Adam's symbol may be a spade, Eve's may be a spindle.

The Book of Genesis contains a second creation story, the story of Adam and Eve.

The Creation of Adam God formed Adam out of dust, breathed into his nostrils, and he became a living being. God planted a garden at Eden and put Adam there to till and keep it (Genesis 2:7). God can be shown breathing into Adam's nostrils, or giving Adam life by his touch, as on the ceiling of the Sistine Chapel in Rome.

The Creation of Eve God caused Adam to fall asleep, then took one of his ribs, and closed up its place with flesh. From Adam's rib, God created woman (meaning 'out of man') (Genesis 2:18–25). Eve is sometimes shown emerging from Adam's side as he sleeps. A vexed question comes into play here: should Adam

and Eve be portrayed as having navels? Since they were not born, they would have had no use for umbilical cords, and so the answer might be no. However, although Adam and Eve are occasionally portrayed with smooth stomachs, more often artists ignored the question, or ducked it through a judicious crease in the midriff to obscure the area.

The Temptation of Eve God had placed in the garden the Tree of the Knowledge of Good and Evil, and forbade Adam and Eve to touch it, on pain of death. However, the serpent, which was 'more crafty than any other wild animal', tempted Eve, who ate the fruit of the tree and also gave some to Adam. This was the moment of the Fall of Man, his first disobedience to God's wishes. On eating the fruit, Adam and Eve realized that they were naked, and so they made themselves loincloths from fig leaves (Genesis 3:1–7). Images in which Adam and Eve are naked (perhaps modestly obscured by a branch) are of the temptation before the Fall, whereas if they are dressed in leaves then it has

already happened. The serpent is sometimes shown with arms and legs, because these were only sloughed off by God's curse after the Fall (see below). The serpent is also sometimes given the face of a woman who resembles Eve, a detail which may originate in the medieval belief that there was an affinity between similar objects, such that Eve would have been more tempted by a creature that looked like her.

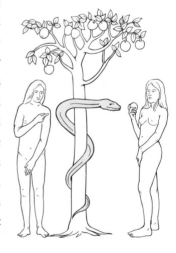

The Expulsion from the Garden *A fiery sword.*

Ashamed of their nakedness, Adam and Eve hid from God. Realizing that they had disobeyed his command, God cursed first the snake, and then Adam and Eve. The snake would crawl on its belly and there would be enmity between snakes and humans; Eve was given pain in childbirth; Adam was cursed to toil and sweat for his food until he died ('you are dust, and to dust you shall return'). God then clothed Adam and Eve in clothes of animal skins and expelled them from the garden. He placed an angel with a flaming sword to guard the return (Genesis 3:8–24). Adam and Eve are portrayed bowing their heads in misery as they are expelled from the garden; they should be wearing animal skins, although they are sometimes portrayed as naked, and covering their genitals with their hands.

Cain and Abel

Two altars, one with smoke rising, the other descending; jaw-bone of an ass.

The first and second sons of Adam and Eve were Cain and Abel. Cain became a farmer of the soil, while Abel became a shepherd. Each sacrificed to God from the fruits of their profession, crops from Cain and young sheep from Abel. God accepted Abel's offering but not that from Cain, a distinction that is sometimes represented by God's hand pointing to Abel's sacrifice, or by the smoke from Abel's altar rising straight upwards to heaven, while the smoke from Cain's altar dissipates, or shoots off at a right-angle. It is not clear why God rejected Cain's offering, but traditionally it was either because Cain did not offer the best of his goods, or because although he had made a material sacrifice, he did not give his heart to God. Whatever the reason, Cain became very angry. Although God tried to comfort and counsel him, Cain took Abel out into the field and killed him. As a consequence,

God cursed Cain to be a wanderer on the earth, and made a mark on him so that people would recognize him (Genesis 4:3–16). Cain's murder weapon may be a club, or the jaw-bone of an ass, a weapon later wielded by Samson. Abel's sacrifice of a lamb was taken to prefigure the Crucifixion, because God found the sacrifice of Jesus, the Lamb of God, similarly acceptable.

Noah/The Deluge

An ark, a rainbow, a dove with an olive branch.

Representations of the Deluge and Noah's ark are popular not just because it is a good story. The ark was seen as a symbol of the Church (see Abstracts, page 181), while the story as a whole was said (in the first Epistle of Peter) to prefigure the rite of baptism (3:20). Noah himself was thought to be a type of Jesus.

Noah was a descendant of Adam and Eve's third son, Seth. God saw humankind's wickedness on earth, and decided to destroy it. However, God saw that Noah was a righteous man, and so told him to build an ark to save himself, his family, and the animals and birds, which he took into the ark in male and female pairs. It rained for forty days and nights until the mountains were covered, and the flood then lasted for one hundred and fifty days. When God caused the waters to subside, the ark came to rest on Mount Ararat. Noah sent out a dove, which returned with a freshly plucked olive branch in its beak, a sign that the land was now dry (Genesis 6 & 7). The moment of the return to the ark – the dove is more often shown being welcomed back than being sent out – is the one most often portrayed. Noah, who was six hundred years old by this stage, is portrayed with a white beard.

The Drunkenness of Noah Noah was the first person to plant a vineyard. Drunk, he lay naked in his tent, where his son Ham saw

him. Furious that he had been seen naked, Noah cursed him (Genesis 9:20–27). The story may originate in the fact that Ham was considered the ancestor of the Canaanites, which became a competing tribe to the Israelites. This story is portrayed more often than one might expect, because it was thought to prefigure the mocking of Jesus in the Crowning with Thorns.

The Tower of Babel

A tower, built in diminishing stages.

The whole earth had a single language. In Shinar (the basin between the Rivers Tigris and Euphrates) people used bricks and bitumen to build a city with a tower that would have its top in the heavens. God saw the tower and took a dim view: 'this is only the beginning of what they will do; nothing that they propose to do will now be impossible for them'. He therefore confused their language, so that they could not understand one another's speech, and scattered them across the face of the earth (Genesis 11:1–9). The place became known as Babel, from the Hebrew '*balal*', meaning 'confuse'. A number of races may be portrayed around the Tower, to represent the different languages.

Abraham and Isaac

Abraham – White, flowing beard; sacrificial knife; a number of stars.

Isaac – A bundle of wood, in the shape of a cross.

Abraham is the first of the great patriarchs of the Old Testament. Originally called Abram, he was renamed Abraham (meaning 'ancestor of many nations') when God told him that he would father a people with whom he would make an everlasting covenant: the nation of Israel.

Melchizedek Abraham's nephew Lot, who lived in the City of Sodom, was captured in a raid on the City. When news of this reached Abraham, he set off in pursuit with 318 men (a mystical number – see IHS, page 219) and recaptured his nephew. As they returned, King Melchizedek, a priest, brought out bread and wine, and Abraham gave him one tenth of everything (Genesis 14:11–20).

This minor story is given weight by a reference to it in the New Testament Epistle to the Hebrews, which compares Melchizedek with Jesus (Hebrews 7), while the bread and wine that he brought out was thought to prefigure the Eucharist. It is also probable that the Church was keen for the story to be portrayed, since Abraham's gift supports the concept of 'tithing', or giving one tenth of one's earnings to the Church.

The Three Angels and the Birth of Isaac God appeared to Abraham as he sat at the entrance to his tent, in the form of three men, or angels. The three men announced that Abraham's wife Sarah, who was ninety years old, and with whom 'it had ceased to be after the manner of women' would bear Abraham a child. As promised, Sarah bore a son, who was named Isaac (Genesis 18:1–15 & 21:1–7). The appearance of God as three men was taken by Christian writers as supporting the doctrine of the Trinity.

The Sacrifice of Isaac God tested Abraham, by telling him to take his son Isaac and sacrifice him on a mountain. Abraham and Isaac reached the mountain with the help of a donkey and two young men. They then climbed the mountain alone, Isaac carrying the wood for the fire, and Abraham carrying the fire and the knife. In a touching exchange, Isaac, who did not know what Abraham intended to do, called out and asked him where the lamb for the

sacrifice was. Abraham told him that the Lord would provide. On the mountain, Abraham built an altar and laid the wood for the burnt offering. He then bound Isaac, laid him on the wood and took up a knife to kill him, whereupon an angel appeared (page 177), and told Abraham to stay his hand. Instead of Isaac, Abraham was told to sacrifice a ram that had its horns caught in a nearby thicket. In recognition of Abraham's faith, God promised Abraham to make his descendants numerous and mighty (Genesis 22:1–14). This famous story has been taken as prefiguring Jesus' sacrifice: like Abraham, Jesus was wholly obedient to God; like Isaac carrying the wood for the sacrifice, he carried his cross to the place of death; while the thicket that the ram had caught its head in mirrored the crown of thorns.

Lot

Lot and the pillar of salt Abraham's nephew Lot lived in the city of Sodom. Sodom and Gomorrah were wicked towns, and God decided to destroy them. A pair of angels warned Lot to flee the city, and not to look back. God then rained fire and sulphur on Sodom and Gomorrah, but as they made their escape Lot's wife could not resist a backward glance and was turned into a pillar of salt (which is sometimes portrayed as having a human head; Genesis 19:1–26). Later moralists saw Lot's wife as a metaphor for the sinner who turns back, or remains fascinated by sin, in spite of being offered salvation. In addition, the angel's warning to Lot was thought to prefigure the angel's warning to the Magi that they should not return to Herod (see the Massacre of the Innocents, page 61). In an interesting historical twist, at the time of writing a submerged town, which may be Sodom or Gomorrah, has been found beneath the salt of the Dead Sea.

Lot's daughters Lot and his daughters lived in a cave, he without a wife, and they without husbands. His daughters conspired to get him drunk on wine and then sleep with him, and they each bore him a son (Genesis 19:30–38). These sons founded the tribes of the Moabites and Ammonites, two of Israel's most despised enemies, and the tale may be intended by the Israelite author to cast aspersions on their enemies' parentage.

Jacob

A sun and full moon and twelve stars; a ladder.

Jacob is the third of the patriarchs. He was the younger of twin boys born to Isaac and his wife Rebekah, the elder being Esau (Jacob was said to have been born gripping his brother's heel, anticipating their later rivalry; his name means 'he takes by the heel', or 'he supplants'). He was seen as a type for Jesus, and his rivalry with Esau was a type of the conflict of Church and the Synagogue. The emblem of Jacob as a sun and full moon and twelve stars comes from one of the dreams of his son Joseph (below).

The stolen birthright Esau the hunter was his father's favourite, while Jacob the tent-dweller was more loved by his mother. When Isaac was old and considering his death, he sent Esau to kill some game for a meal, saying that he would bless him when he returned. Rebekah overheard, and told Jacob to pretend to be Esau, in order to win his father's blessing. The deception was possible because Isaac was blind, and because Jacob fooled his touch by donning goatskin to imitate his hairy brother. Esau was furious when he discovered that his brother had stolen the blessing that should have been his, and Jacob fled (Genesis 27).

Jacob's ladder Resting on his journey, Jacob dreamt of a ladder, reaching to heaven, on which angels ascended and descended. The same image is recorded in a famous verse of the Koran. In the dream, God promised the land that Jacob was lying in to him and his descendants. When he awoke, Jacob made a pillar with the rock on which he had been resting his head and poured oil on it, naming the place Bethel (which is around twelve miles north of Jerusalem) (Genesis 28:10–22). Jacob's ladder was thought to prefigure Jesus, who formed a link between earth and heaven.

Jacob wrestling with the angel Jacob went to try to reconcile himself to his brother. Having sent his caravan to ford a stream ahead of him, he was left alone, and wrestled with a man until daybreak. The man could not defeat Jacob and so struck him in the hip, which was put out of joint, or withered. The wrestler gave Jacob a new name, 'Israel', which can translate as either 'the one who strives with God', or 'God strives' (Genesis 32:22–32). The wrestler has been portrayed as God himself, or as an angel (page 177), while the struggle shows man's resistance to God and his absolute freedom to accept or reject God, since the wrestler could not overcome Jacob against his will. Sometimes, the wrestler is portrayed as a demon, when the scene becomes an allegory of the struggle between Vice and Virtue.

Joseph

Coat of many colours; thirteen sheaves of wheat bowing to a fourteenth that stands erect.

Joseph was the second youngest of the twelve sons of Jacob. Scenes from his life were popular, because so many elements in them were thought to prefigure the Gospel story.

Joseph and the coat of many colours Jacob loved Joseph over his brothers and gave him a coat of many colours (a less poetic translation is that the coat was a long robe with sleeves, which might mean that Joseph was excused from undertaking hard labour: see alb, page 225). Joseph's consequent unpopularity with his brothers was not helped when he told them of two dreams he had had, in which he appeared to reign over them. In the first, he and his brothers were binding sheaves when his sheaf grew large and his brothers' sheaves bowed down to it (which gives one of Joseph's symbols); in the second, the sun, moon, and eleven stars were bowing down to him (which gives another of Jacob's symbols). The jealous brothers threw Joseph into a pit (or well), and then sold him for twenty pieces of silver as a slave to a passing caravan that was heading towards Egypt (Genesis 37). This sale was taken by Christian writers to prefigure Judas' betrayal of Jesus, for thirty pieces of silver, while throwing Joseph into the well and drawing him out again was thought to prefigure the Entombment and the Resurrection.

Joseph and Potiphar's wife Enslaved in Egypt, Joseph became over time the trusted servant of Potiphar, captain of Pharaoh's guard. Potiphar's wife became consumed with desire for Joseph, but he escaped her advances by slipping out of his garment, leaving it in her hands. The act would probably have left him naked, and Potiphar's wife used the garment as evidence in claiming that Joseph had made improper advances to her. He was therefore thrown into jail (Genesis 39).

Joseph and the dreams In jail, Joseph correctly interpreted the dreams of two of his fellow-prisoners. Two years later, when Pharaoh was troubled by dreams, one of the prisoners, who had

been released, recommended Joseph as an interpreter. Pharaoh's dreams were of seven sleek, fat cows that came up out of the Nile, followed by seven ugly, thin cows that ate up the fat cows; and of a stalk with seven plump ears of grain, after which sprouted seven blighted ears that swallowed the fat ears. Joseph interpreted this as meaning that Egypt would enjoy seven years of good harvests, followed by seven years of famine, and that Egypt should provide for the famine by storing grain in the seven good years. Joseph's interpretation came true, and disaster was averted. In gratitude, Pharaoh made Joseph Governor of Egypt (Genesis 41). The event was thought to prefigure Jesus feeding the five thousand (see St Philip, page 114).

Joseph meets his brothers again The famine that afflicted Egypt also afflicted Israel, and Jacob sent his sons to buy corn from the Egyptians. They met with and bowed down before Joseph – fulfilling his dreams of years before – but did not recognize him. At Joseph's request they returned later with their youngest brother Benjamin who had been absent at the first visit (and who was Joseph's favourite). Joseph hid a silver cup in Benjamin's saddlebags and sent soldiers to arrest the brothers. Terrified, the brothers came back before him, only for Joseph to finally reveal himself to them. They were reconciled, and at his request Joseph's brothers and Jacob moved to Egypt with all of their flocks and herds (Genesis 42–45).

The Exodus and Moses

The Exodus is probably the most significant event in ancient Jewish history, and Moses one of history's most revered men. The Nation of Israel's long journey from slavery in Egypt, through the desert, to freedom in the Promised Land continues to resonate today in language, imagery, and popular symbolism.

Moses *Displaying two stone tablets; horned; carrying a staff, rod, or wand.*

Moses was considered by Christian writers to be the pre-eminent type of Jesus: both led people out of slavery (in the case of Jesus, out of the 'slavery of sin'), and whereas Moses brought the old law, Jesus brought the new. Moses, with white hair and long beard, is usually shown carrying two tablets bearing the Ten Commandments, rays of light streaming from his face, or with horns. The image of the horns comes from a mistranslation in the Vulgate Bible. When Moses received the Ten Commandments, it was said that his face 'was radiant'. This was translated in the Vulgate Bible as *cornuta* – 'made horned' (Exodus 34:29).

Aaron *Priest's clothes.*

Aaron, Moses' brother, was a priest and is always portrayed dressed in priestly robes. These were dictated in detail by God (Exodus 28), and included a gold breastplate set with four rows of precious stones, a blue robe with alternating bells and pomegranates around the hem, a turban with a gold rosette engraved 'Holy to the Lord', a chequered tunic, and an embroidered sash.

Background to the Exodus After his brothers joined Joseph in Egypt, the Israelites living there greatly increased in number. The first generation died away, as did the pharaoh who had been Joseph's patron. A new pharaoh came to power and he enslaved the Israelites.

Moses in the rushes Pharaoh was alarmed by the growing power of the Israelite slave-nation, and ordered that boys born to them should be thrown into the Nile. Moses' mother tried to save him

by placing him in a papyrus basket, which she hid among the reeds on its banks. When Pharaoh's daughter came to the river to bathe, she found the baby Moses and took him into her care. She named him 'Moses', meaning, 'I drew him out of the water' (Exodus 2:1–10).

Moses and the golden crown A Hebrew legend that does not appear in the Bible may preserve a memory that Moses had a speech defect. When Moses was a child in Pharaoh's court, Pharaoh one day playfully set his crown on Moses' head. Moses tore off the crown and threw it on the ground. Wise men in Pharaoh's court were called to interpret Moses' action: some said this was just a child's tantrum; others said that it was a sign that Moses would overthrow the Pharaoh. It was decided to put Moses to a test: he would be presented with a plate of cherries (in another tradition, rubies) and a plate of hot coals. If he picked one of the coals, he would be spared. Guided by God, Moses overcame the test, to the extent of taking a coal and thrusting it into his own mouth. From that moment on, he is said to have a speech defect. In the Book of Exodus, Moses describes himself as 'slow of speech and slow of tongue', and his bother Aaron speaks on his behalf, which may be a result of the same problem (Exodus 4:10–16).

Moses kills an Egyptian Moses came across an Egyptian beating an Israelite. He killed the Egyptian and hid his body in the sand. However, word of what he had done spread, and Moses was forced to flee to Midian, where he married. Some theologians cite Moses' violent response to the oppression that he witnessed as justification for an active resistance by Christians to oppressive regimes.

The Burning Bush *A bush with three flames of fire.*

Moses was tending his father-in-law Jethro's sheep when he saw a bush burning that was not consumed by the fire. God spoke to Moses from this Burning Bush, telling him to remove his sandals because he was standing on holy ground. He said that he had heard the cries of the Israelites, and would take them out of slavery to the Promised Land. Moses asked his name, to which God replied, 'I AM WHO I AM' (see Yahweh, page 221) (Exodus 3). So that Moses might be believed, God gave him signs to show the Israelites. One of these was that when Moses threw his staff on the ground it became a snake, and when he gripped the snake by the tail it became a staff again (Exodus 4). The encounter with God in the Burning Bush was thought to prefigure the Annunciation (see introduction to this section, page 134).

The plagues of Egypt Moses returned to Egypt and asked Pharaoh to release the Israelites. Pharaoh refused. God therefore sent a series of plagues to Egypt: water turning to blood, frogs, gnats, flies, illness among the Egyptians' livestock, boils, storms, locusts, and darkness (Exodus 7–10). The scene most often represented is the final plague, where God took the firstborn (Passover, below).

The Passover *A sword; a door with blood on the posts and lintel.*

After the plagues, God sent a final warning: if Pharaoh would not let his people go, he would kill the firstborn of every household. When Pharaoh continued to refuse to comply, God described a ritual to Moses that would become the important Jewish festival of Passover. Each Israelite family was to take an unblemished year-old male lamb, kill it at twilight and mark the door of their house with its blood, as a sign to God that he should pass over and not take the

firstborn in their houses. They should then roast the lamb whole, with unleavened bread (bread baked without yeast) and bitter herbs, and eat it that night, in a hurry, with a staff in the hand (so that they were ready to leave at once). That night, the first born to all in Egypt except the Israelites were killed. Pharaoh, in terror, finally relented and freed the Israelites (Exodus 11–12). A number of the elements from the Passover were thought to prefigure the Last Supper and the Crucifixion (for example, the sacrifice of the lamb).

The parting of the Red Sea God guided the Israelites towards the Red Sea in a pillar of cloud by day, and of fire by night. Meanwhile, Pharaoh had changed his mind about freeing them and set off in pursuit. When the Israelites reached the Red Sea, God told Moses to lift up his staff and stretch out his hand over the sea. A strong east wind blew all night, and the sea was parted to let the Israelites pass. The Egyptian army followed them. Safe on the opposite bank, Moses stretched out his hand and the sea reunited, destroying Pharaoh's army. The salvation of Israel by the obliteration of Pharaoh's army with water was thought to prefigure salvation with water in baptism.

Manna from heaven, and the water from the rock The Israelites continued their journey across the Sinai Desert. Each night, with the dew, fell manna, or bread, from heaven – a fine flaky substance, as fine as frost, that tasted like honey wafers. When the Israelites complained of thirst, God told Moses to strike the rock of Horeb with his staff, and water came out (Exodus 16:11–36, & 17:1–7; Numbers 11:7–9 & 20:1–13). These stories are examples of God's free provision for his people, and were thought to prefigure spiritual refreshment and provision, the feeding of the five thousand, and, more importantly, the Eucharist (the water from

the rock was also the wounded side of Jesus). The bemusement of the Israelites, though, is shown by its name: manna derives from '*man hu?*', meaning, 'What is it?'

The Ten Commandments On Mount Sinai, which was wreathed in thick cloud, God spoke to Moses and gave him ten commandments, written on two stone tablets with God's finger. The Ten Commandments are the pre-eminent orders from God to humankind. In summary, they are:

 I You shall have no other gods before me.

 II You shall not make for yourself an idol.

III You shall not misuse the name of God.

IV Remember the Sabbath day by keeping it holy.

 V Honour your father and your mother.

VI You shall not murder.

VII You shall not commit adultery.

VIII You shall not steal.

IX You shall not give false testimony against your neighbour.

 X You shall not covet anything that belongs to your neighbour.

(Exodus 20:2–17 and Deuteronomy 5:6–21)

Images of the Commandments are shown on two stone tablets, often identified only by their Roman numerals. There is sometimes a division between first four and the last six, since the first four are thought of as duties to God, the last six duties to other people. Often, though, the symmetrical division of five and five is used, the first five being thought of as 'duties of piety' and the last five 'duties of probity'.

After the Reformation, when some altarpieces (works of art displayed behind the altar) were swept away in the mood against imagery, some churches replaced them with two wooden or stone tablets inscribed with the Ten Commandments. This arrangement enabled a neat reference to the altar as representing the Ark of the Covenant, in which the tablets bearing the commandments were stored.

The Ten Commandments were affirmed by Jesus (Matthew 5 & 19), and are sometimes portrayed next to Jesus' 'Two Commandments'. When Jesus was asked which were the greatest Commandments, he replied, 'Love the Lord your God with all your heart and with all your soul and with all your mind', and 'Love your neighbour as yourself' (Matthew 22:37; the two Commandments are taken from Deuteronomy 6:5 and Leviticus 19:18).

The golden calf While Moses was on Mount Sinai the Israelites persuaded Aaron to build them an idol, a golden calf. They ate, drank, and danced before it. When Moses returned to find this scene, in a fury he threw the tablets bearing the Ten Commandments to the ground, breaking them, before destroying the golden calf, which he ground into fine dust (Exodus 32:1–20). The Israelites repented, and Moses returned to Mount Sinai for another copy of the Ten Commandments, although this time he, and not God, wrote them down. In Jewish legend, Moses identified those who had worshipped the golden calf by mixing the ground gold with water and then feeding it to the Israelite men. Where an Israelite was guilty of having worshipped the calf, the gold stuck to his beard. The scene is shown in a window at Malvern, where the beards of the guilty are yellow.

The Ark of the Covenant The Ark of the Covenant was made to house the Ten Commandments. It was made of acacia wood and overlaid with pure gold. Cherubs of hammered gold were placed on the top of the ark, one at each end facing inwards, with their wings spread over the Ark (Exodus 37:1–9). The Ark has become a key symbol in Christian art of God's covenant with humankind.

The bronze serpent As they continued on their journey, the Israelites fell to complaining about their miserable lot, and speaking against God and against Moses. God sent a plague of poisonous snakes among them as punishment. The Israelites speedily repented and asked Moses to ask God to take away the plague. God told Moses to make a bronze snake and raise it on a pole; if anyone was bitten then went out and looked at the bronze snake they would be healed (Numbers 21:1–8). The bronze serpent was used by Jesus himself as a metaphor for his Crucifixion and it can be portrayed juxtaposed with the Crucifixion, or with the serpent entwined around the Tree of Knowledge of Good and Evil (see the Fall, page 136).

The spies and the grapes As the Israelites approached the Promised Land, Moses sent spies ahead, and told them to bring back the fruit of the land. The spies cut down a single cluster of grapes, which they carried on a pole between two of them (Numbers 13:17–24), so demonstrating the wealth of the land that would soon be theirs. This image of a great single cluster of grapes hanging from a pole carried between two men is fairly common, not least outside English public houses. In Christian symbolism, the grapes represent the wine of the Eucharist, which

represented the 'Promised Land' of union with God. The man behind is the Christian, who can see this gift, while the man in front cannot.

The death of Moses God told Moses to climb Mount Nebo. God revealed to Moses that he himself would not cross the River Jordan to reach the Promised Land, but that he would be able to see it from a distance, from the mountain. Having seen the Promised Land, and blessed the Israelites, Moses died (Deuteronomy 34).

Joshua
A sword or a sceptre, and trumpet.
The Israelites marched over the River Jordan and into the Promised Land, with Joshua as their new leader. However, the land still had to be taken by force, and a series of battles ensued. Joshua's most famous battle was at Jericho. God told Joshua to circle the besieged city with all of his soldiers and the Ark of the Covenant, once a day for six days. On the seventh day, they should march around it seven times, with priests blowing on trumpets. When they gave a long blast on rams' horns, the people would give a great shout and the walls of the city would tumble before them (Joshua 6). The fall of Jericho was thought to prefigure the Last Judgement, or the return of the Messiah, which the Book of Revelation said would happen after seven angels had blown seven trumpets (11:15).

Samson
Lion, ass's jaw-bone, tumbling columns, gates, seven cords.
The Israelites successfully captured the Promised Land. But after the death of Joshua, they slipped back into disobedience to God,

and ultimately fell into the hands of the Philistines. God promised Israel a champion who would save them, and his birth was announced by an angel (traditionally, St Gabriel), in a prefiguring of the Annunciation. This was Samson, a man of legendary strength, but unlucky in love.

Samson and the lion The young Samson wanted to marry a woman who was not an Israelite. On the way to her home at Timnah he was attacked by a lion, which he tore apart with his bare hands. On his return journey, Samson found that a swarm of bees had made honey in the lion's carcass, which he scraped out and ate. At his marriage to the woman of Timnah, he bet his companions that they could not answer a riddle: 'Out of the eater came something to eat/Out of the strong came something sweet', a saying which, together with the dead lion and the bees, is now the emblem of the Tate & Lyle sugar company. Samson was betrayed by his new bride, who coaxed the answer out of him and passed it to his companions. Furious, Samson gave his new wife to his best man (Judges 14).

Carrying away the gates of Gaza Samson went to the city of Gaza to visit a prostitute. The Gazites were warned of his presence and lay in wait for him at the city gates. At midnight, Samson pulled up the city gates and their posts, and carried them to the top of a nearby hill (Judges 16:1–3). For all that Samson's motivation in visiting Gaza makes this an odd analogy, his ripping up of the gates was meant to prefigure Jesus breaking down the gates in the Harrowing of Hell (page 77).

Samson and Delilah Samson fell deeply in love with a Philistine woman called Delilah. The Philistine chiefs persuaded Delilah to

find out the secret of his great strength. After much nagging, and several false trails, he told her the secret: his hair had never been cut, and if his head were to be shaved he would become like anyone else. Delilah then let him fall asleep on her lap. She called a man to shave his head, and then summoned the Philistines, who captured him (Judges 16:1–21).

The death of Samson The Philistines gouged out Samson's eyes, bound him with bronze shackles, and threw him into prison in Gaza. They then put their defeated enemy on show at a feast to their god Dagon. Samson asked his attendant to put his hands on the pillars supporting the house where the feast was taking place. Samson's hair had been growing back in jail, and with it his strength: with a final cry to God, he pushed over the pillars and collapsed the house, killing thousands of Philistines as well as himself (Judges 16:21–30). The binding of Samson and the taunts at him were thought to prefigure the binding and mocking of Jesus.

King David

Lyre or harp; star of David; sling and five stones; lion; as a young man, in shepherd's clothes carrying a sling; as old man, in crown and royal robes.

King and prophet, David was born around 1085 BC, and reigned from 1055 to 1015. David's story appears in the two Books of Samuel and the first Book of Kings, which follow him from his youth as an unknown shepherd boy to his death as the elderly King of all Israel. To Israel, David gave a court, a capital, and a powerful military force; to the world he gave prophetic teaching, and the Psalms.

David's principal attribute is the lyre or harp. He was said to

play the instrument beautifully, and as a young man would play to King Saul to dispel an evil spirit that possessed him (1 Samuel 16:23). He is also traditionally attributed with authorship of the Psalms, which would have been sung accompanied by a lyre. Evidence for his authorship comes from the Book of Samuel, where he is recorded singing Psalm-like songs, and some of the Psalms seem to relate to his personal circumstances.

According to the genealogy at the start of Matthew's Gospel, David was Jesus' ancestor, and he was regarded as another prefigure of Jesus. They shared the birthplace of Bethlehem; David the shepherd is like Jesus the Good Shepherd; the five stones that David picked out to sling at Goliath suggest Jesus' five wounds; David and Jesus both had triumphal entries into Jerusalem (when Jesus was greeted as 'Son of David', Matthew 21:9); David was betrayed by Adonijah, his trusted son, just as Jesus was betrayed by his disciple, Judas Iscariot; David was a King on Earth, while Jesus is King of Heaven.

The life of King David can be considered and portrayed in three parts: his youthful life; his kingship; and his sin.

David chosen and anointed king Saul was the first King of Israel, anointed by the Prophet Samuel at God's direction, but his behaviour caused God to turn against him. Samuel was therefore told to anoint a different king, who would be one of the sons of Jesse. Seven of Jesse's sons passed before Samuel; finally, Jesse had to call in David, who was out tending the sheep, and had been overlooked because he was the youngest. God told Samuel that this was the one, and he anointed him (1 Samuel 16:1–13). The anointing was secret and it would be many years before David could take up his kingdom.

David and Goliath The Israelite and the Philistine armies were gathered on two mountains to do battle, with a valley in between them. The Philistine's champion was Goliath of Gath, a vast man dressed in bronze armour, and armed with a bronze javelin and sword. Morning and evening, Goliath would taunt the Israelites, challenging them to send someone to fight him. David, still a young shepherd, was visiting the Israelite camp with food for his elder brothers in the army. He persuaded Saul to let him challenge Goliath. Saul tried to dress David in his own armour, but David could not walk in it, and he chose to do without (although he is sometimes wrongly shown wearing it). He went into battle armed with just a staff, a sling, and five rounded stones that he had gathered from the stream. After an exchange of insults David slung a stone that sank into Goliath's forehead, and then cut off Goliath's head. The Philistine army took fright and was routed (1 Samuel 17). The event was thought to prefigure Jesus' defeat of Satan in the desert in the Temptation (Matthew 4:1-11). More simply, in Jewish and Christian thought, the story shows the success with God's help of right over wrong despite unequal odds.

David's victories David enjoyed many victories in his career, but there are three incidents connected to these victories that are most often represented. The first occured when David and Saul returned together from the victory over Goliath and the Philistines. They were met by Israelite women singing, 'Saul has killed thousands, but David has killed tens of thousands!' Infuriated by this comparison, Saul was set against David from that moment on (1 Samuel 18:6–9). The second occured after Saul died. David managed to defeat the Philistines a second time and to recover the Ark of the Covenant, which had been stolen by them. He declared Jerusalem his capital, and made a triumphal

entry into the city with the Ark, dancing in front of it (2 Samuel 6). The third was the death of David's son Absalom, who had revolted against his father. While riding in battle, Absalom caught his head in the branches of an oak tree. His mount walked on, leaving him dangling. He was killed by one of David's men, to David's great grief (2 Samuel 18; see oak, page 207).

David and Bathsheba Late one afternoon, David was walking on the roof of his home, when he saw a beautiful woman bathing. He was told that this was Bathsheba, wife of Uriah the Hittite. He sent for her, made love to her, and she became pregnant. David then contrived to have Uriah killed, sending him into the fiercest part of a siege and then drawing his other forces back. With Uriah dead, David married Bathsheba but, ominously, 'the thing that David had done displeased the Lord' (2 Samuel 11). The medieval Church saw the relationship between David and Bathsheba as a type of the relationship between Jesus and the Church – another twist of logic that is strange to modern eyes, given David's immoral behaviour.

David's suffering and repentance God sent the Prophet Nathan to rebuke David. David was repentant, but was told that the child to be born to him would die, and when Bathsheba gave birth the child fell ill and died within the week. However, David and Bathsheba had a second son, Solomon, who was to become king on David's death (2 Samuel 12).

King Solomon
Crown and royal clothes; the Temple.
The reign of King Solomon was calm, prosperous, and long. Solomon is remembered above all for the wealth that his kingdom

amassed, which enabled him to start the building of the Great Temple in Jerusalem, and for his wisdom (much of the Book of Proverbs is attributed to him). As if this were not enough, he is on record as having had seven hundred wives and three hundred concubines, and is attributed with the authorship of the Bible's great poem of love and erotic desire, the Song of Solomon.

The most famous example of Solomon's wisdom was a dispute between two prostitutes. They had given birth to sons within days of each other but one had died, and they were in dispute as to which was the mother of the living child. Solomon ordered that a sword be brought to him. He said that he would cut the child in two and give half to each. One of the women revealed herself to be the boy's true mother by insisting that the baby should be given to other woman, rather than be killed. Solomon restored her son to her (1 Kings 3).

Solomon's throne was made of ivory overlaid with gold, with six steps and a statue of a lion on either side of each step. When his mother Bathsheba visited, he placed her at his right hand (1 Kings 2:19). This scene was thought to prefigure the Coronation of the Virgin. Another scene often depicted is the visit of the Queen of Sheba. The Queen had heard of Solomon's wisdom and, accompanied by a magnificent retinue, came to test him with questions. She was impressed at his answers and lavished on him much of the wealth of gold, jewels, and spices that she had brought with her (1 Kings 10:1–13). The scene was thought to prefigure the visit of the Magi to the infant Jesus, and more generally God's revelation of himself to non-Jews. According to St Isidore of Seville (560–636), the Song of Solomon was addressed to the Queen of Sheba.

Solomon was led astray by certain of his wives, who persuaded him to build altars to foreign gods. God said that since

Solomon had been faithless, after his death he would split his kingdom in two. Where a scene of Solomon making an offering to foreign gods is depicted, the purpose of it is often a Protestant one, namely a protest against the practices of the Roman Catholic Church, which some Protestants regarded as akin to worshipping idols.

Jonah
A great fish, a ship, or a gourd.

The short story of the Prophet Jonah is one of the earliest to be used as a Christian type: Jesus himself referred to the three days that Jonah spent in the belly of the fish as being like the three days that would pass before his own resurrection (Matthew 12:40). Jonah was told by God to go to the city of Nineveh and speak out against its wickedness. However, Jonah tried to flee by sea from God's commission. A great storm blew up. Jonah admitted that his attempted escape was its cause and persuaded the sailors to throw him overboard, where a great fish swallowed him. He remained in its belly for three days and nights, praying to God, before the fish spewed him onto dry land, where he submitted to God's will and travelled to Nineveh. Nineveh heard his message, repented, and was spared (much to Jonah's disgust – but that is another story) (see also fish, page 188).

The Four Major Prophets

Amongst the stories of the Old Testament stand the words of prophets, men touched by and proclaiming the word of God. There are a number of Old Testament prophets, but those considered pre-eminent in Christian thought are Isaiah, Jeremiah, Ezekiel, and Daniel. You are more likely to encounter images of

them in churches than the other prophets, and the four are sometimes found grouped together – although, as we shall see, they are a wildly disparate group.

Isaiah

Saw, sack, tongs and burning coal, St Matthew at his shoulder, scroll with prophecy.

The Book of the Prophet Isaiah is one of the longest and most beautiful in the Bible. It is concerned with proclaiming God's holiness and power, with God's judgement and salvation, and with prophecies of the Messiah. Those vivid Messianic prophecies have two elements: the Messiah as king, and the Messiah as suffering servant. As a result of them, the Book of Isaiah is sometimes described as the fifth Gospel.

Isaiah's ministry took place in the second half of the eighth century BC. His name means 'God is salvation', and is essentially the same as the names Joshua, Hosea, and Jesus. Prophecy was in the family, since he was married to a prophetess, by whom he had at least two children. In an early vision of God, Isaiah exclaimed that he had unclean lips, whereupon a seraph (see angels, page 174) purified him by touching his lips with a live coal held in a pair of tongs, giving rise to one of his attributes (6:6–7).

Isaiah started his ministry by calling on King Ahaz to trust in God rather than his own plans. When he failed to do so, Isaiah withdrew from the political scene until Ahaz was succeed by King Hezekiah. Isaiah persuaded the new king to break Israel's old alliance with the pagan Assyrians – only for Hezekiah to form an alliance with Egypt that Isaiah also found offensive. For two years Isaiah went naked and barefoot, as a warning to Israel. But the King repented at a point of crisis when he fell very sick and was simultaneously threatened with destruction by the Assyrian

armies. Isaiah then correctly prophesied that God would save Jerusalem and prolong Hezekiah's life. Hezekiah was eventually succeeded by his son Manasseh, who returned to the worship of the Assyrian gods. The death of Isaiah is not reported in the Bible but there is a Jewish legend that he was martyred by being sawn in half on the orders of Manasseh (thus a saw is one of Isaiah's attributes).

Isaiah's prophecies of the Messiah are highly significant to Christians, since they are regarded as relating to Jesus. Two are particularly well known and may appear in representations of Isaiah: *Ecce virgo concipiet et pariet filium et vocabitis nomen eius Emmanuhel* (Latin: 'Behold, the Virgin will conceive and will give birth to a son, and will call him Immanuel'; 7:14; see the Virgin Mary, page 88); and *Egredietur virga de radice Jesse* ('A shoot will come up from the stem of Jesse'; 11:1; see Jesse tree, page 205).

Jeremiah

Cistern, stone, wand, St Luke at his shoulder, scroll with prophecy.

In addition to his eponymous book of prophecy, Jeremiah is traditionally the author of the Bible's

two Books of Kings, and of the Book of Lamentations. Jeremiah's ministry ran from the late seventh to the early sixth centuries BC and, on one view, it failed. He preached to Israel about God's love and the need to repent, but his message was not heard. Israel therefore became subject to puppet kings controlled first by the Egyptians, and later by the Babylonians. Since Israel had failed to repent, Jeremiah preached *against* it, and for submission to these outside forces. In 589 BC, King Zedekiah, who had been installed in Jerusalem by the Babylonians, led a revolt against his masters. Jeremiah urged Israel to surrender and when he tried to leave the

city was arrested and placed in an empty cistern (one of his attributes) to die, although Zedekiah later ordered his release. The Babylonians sacked Jerusalem, and Jeremiah was eventually taken to Egypt, where according to legend he was stoned to death.

Jeremiah was a suffering prophet. He was called to prophecy at a young age (Jeremiah 1:6), and God told him not to marry, or have children, or participate in communal feasts or mourning. His prophecies against Israel earned him few friends, especially among the unfaithful priests he condemned, who became his persecutors (he was barred from the Temple). His misery at his situation, the burden of his doom-filled message, and the failure of Israel to hear him and repent are recorded in the poetic laments contained in his book and in the Book of Lamentations.

Jeremiah can be portrayed holding one of his prophecies of the sufferings of Jesus. Most often, it is *Spiritus oris nostri christus dominus captus est in peccatis nostris* ('The Lord's anointed, our very life breath, was caught in their traps'; Lamentations 4:20), or *O vos omnes qui transitis per viam* ('[Is it nothing to you,] all you who pass by? [Look around and see. Is any suffering like my suffering … ?]' 1:12).

Ezekiel

Two wheels, gateway, plan of New Temple, St John at his shoulder, scroll with prophecy.

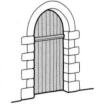

Ezekiel was prophet to a community in exile. In 597 BC, King Jehoachin surrendered Jerusalem to the Babylonians, and he and his court, including Ezekiel, were taken to Babylon. The Israelite community in Babylon was put in charge of regenerating the system of irrigation canals on which the city depended, and they seem to have enjoyed some autonomy. The book of his prophecies is characterized by vivid and colourful descriptions, and it is his

vision of the cherubim and the four mystical creatures (accompanied by wheels) that gave rise to the symbols of the Four Evangelists (Ezekiel 1 & 10). One of his symbols is wheels (the rims of which are filled with eyes) as in his vision. The number of wheels is usually reduced to two, to represent the importance of his vision to both Old and New Testaments, and to save on space.

Ezekiel's prophecies are optimistic, and follow a pattern of disaster followed by regeneration. One of his visions was of a New Temple in Jerusalem (40 & 41), which has become one of his attributes. Another is of a valley filled with dry bones. As Ezekiel watched, the bones in the valley rattled, came together and were covered with sinew, flesh, and skin, before the life was breathed back into them (37). The image is one of hope in the face of hopelessness, and is a metaphor for the regeneration that he prophesied was to come.

One of the prophecies that Ezekiel can be shown holding is associated with the Catholic doctrine of the perpetual virginity of Virgin Mary: *Porta haec clausa erit non aperietur* ('This gate is to remain shut. It must not be opened', 44:2; this is why a closed gate is another of his attributes). Another is a prophecy of the coming of the Holy Spirit at Pentecost: *Dabo vobis cor novum et spiritum novum* ('I will give you a new heart and put a new spirit in you'; 36:26).

Daniel

Lions, ram with four horns, St Mark at his shoulder, scroll with prophecy.
The Book of Daniel tells the story of a group of Israelites of royal blood, Daniel and his companions Shadrach, Meshach, and Abednego. The Babylonian King Nebuchadnezzar captured the four after he took Jerusalem, and they were taken to

the royal court in Babylon. The book follows the pattern of folklore, and Daniel's existence is not cited in any independent source. It may therefore be that, unlike the other major prophets, he never existed as a historical figure. The message of the author of his book is that not only is it possible to remain faithful to God in a foreign land, but doing so will help you. The men win respect and promotion each time they defy their new rulers in deference to God's laws.

The book also contains apocalyptic visions of the end of time, which are only matched in the Bible by the Book of Revelation. One of these is a vision of a ram with two horns (said to be the Kings of Media and Persia) that was defeated by a goat with one horn (said to be the King of Greece), only for four horns to mystically rise up (said to be four new kingdoms that would replace Greece; Daniel 8). A ram with four horns is one of Daniel's attributes.

The Israelites in the fire Nebuchadnezzar set up a huge golden statue and ordered that all people should bow before it. Faithful to God, Shadrach, Meshach, and Abednego refused. Furious, the King had the three men thrown into a furnace so hot that it killed the guards who threw them in. To their amazement, the onlookers then saw not three, but four unbound figures walking in the fire – an angel had joined the three men. The three emerged unscathed (Daniel 3). The scene is portrayed in the catacombs in Rome in one of the earliest images of Christian art, when the threat to Christians of being burnt alive was very real.

Belshazzar's feast and the writing on the wall Nebuchadnezzar's son Belshazzar became king. Drunk at a banquet, he ordered that the gold and silver vessels that had been plundered by his father

from the Temple in Jerusalem be brought out, so that his guests could drink from them. As a consequence of this blasphemy, a spectral hand appeared and wrote words on the wall. No one could interpret them until Belshazzar's wife called for Daniel. Daniel predicted Belshazzar's downfall for what he had done. The words were *Mene, Mene, Tekel* and *Parsin*, the less succinct English translation of which is 'God has numbered the days of your kingdom and brought it to an end, you have been weighed on the scales and found wanting, and the kingdom shall be divided and given to the Medes and Persians'. That night, Belshazzar died and Darius the Mede received the kingdom (Daniel 5).

Daniel in the lion's den Darius' courtiers were determined to trap Daniel. They persuaded Darius to sign a decree that anyone who worshipped anything other than the king would be thrown into a den of lions. When Daniel prayed and praised God as usual, he was thrown into the den by the reluctant Darius, which was then sealed with a stone (in a more colourful legend Daniel was thrown into the den because he had killed a sacred dragon by feeding it indigestible cakes). Happily for Daniel, an angel (traditionally, St Michael) stopped the mouths of the lions, and he emerged unscathed. The treacherous courtiers were thrown to the lions in Daniel's place (Daniel 6).

DOCTORS, ANGELS
AND ABSTRACTS

Having looked at the imagery of the New and Old Testaments, we now turn to some figures that are often portrayed in churches, but which are very diverse in character. First, we will look at some of the Church 'Doctors', people whose thought and writings have had a huge impact on Christian teaching; we will then consider the angels, the attendants or emissaries of God; and finally we will look at abstract figures, which personify parts of Christian teaching or Church life.

The Doctors

The 'Doctors of the Church' are writers and teachers whose work helped shape Christian thought and doctrine (the word 'doctor' here has the meaning of 'teacher'). To qualify for the description, Doctors must have displayed a high degree of learning and a high degree of sanctity, and their work must have been the subject of a proclamation from the Church. A Doctor's teachings are not thought to be infallible, and some of the views of individual Doctors, even of the great St Augustine, have later been considered to be wrong. The list of Doctors is by no means closed, and there

are now thirty-three recognized by the Roman Catholic Church.

In Western churches it is the group known as the Four Latin Doctors that is considered pre-eminent, and they are often portrayed together: St Augustine (354–430), St Jerome (341–420), St Ambrose (339–397), and St Gregory the Great (540–604). The Eastern Church chiefly honours St Basil the Great (329–379), St Gregory Naziansen (329–390), and John Chrysostom (344–407). All Doctors are routinely portrayed holding books, or engaged in study. When grouped as a foursome, the Four Latin Doctors are sometimes distinguished by their clothes: a monk's habit (Augustine), Cardinal's robes (Jerome), Bishop's robes (Ambrose) and Papal robes (Gregory).

St Augustine

Bearded; bishop's robes and staff, or a black monk's habit; a heart of fire, or pierced with three arrows; holding a city.

St Augustine is the most revered of the Latin Doctors. Born in 354, he had a Christian mother, but he all but renounced his Christianity, and lived with a mistress for some fifteen years. After a long internal struggle, and encouragement from St Ambrose, he was baptized a Christian in around 386. He led a quasi-monastic life in Africa before becoming a priest and finally Bishop of Hippo (later Bône, now Annaba, in Algeria).

His writings, which have an intellectual, mystical, and fiery style, helped develop Christian thought on Creation, grace, the Sacraments, and the Church. On the other hand, his teachings on predestination (which consigned predestined souls to damnation) and on sex (which he held to be sinful except for the direct purpose of procreation) have been much criticized. His work *The City of God*, which was a rebuttal to those who thought that the sack of Rome had come about because it had abandoned its pre-

Christian gods, led to his occasional portrayal holding a city. The passion of his work on the Trinity led some artists to portray him with a heart of fire, or a heart pierced with three arrows. Sometimes he is dressed in the black habit of the Augustine order of monks, at others, in his bishop's robes.

St Jerome

Cardinal's robes, or as a half-dressed ascetic; lion; holding a cave.

Jerome (341–420) was a well-educated man who studied in Rome before being baptized. After an early attempt at leading the monastic life he became a hermit in Syria for five years, where he studied Hebrew. Jerome is often portrayed as a hermit in the desert, dressed in rags and beating his breast with a stone, or holding his cave-home. After being ordained a priest, Jerome went to Constantinople before returning to Rome where he became secretary to the Pope, which has caused him sometimes to be portrayed as a cardinal. His most famous work is a standard Latin text of the Bible, known as the Vulgate.

Jerome was acerbic and sarcastic and had a tendency to make enemies, and he eventually left Rome to found a monastery in Bethlehem, where he carried on writing until his death. Legend has it that in Bethlehem he removed a thorn from a lion's paw. In spite of the discomfort of his fellow monks, the lion remained close to him ever after, and he is often portrayed with his lion in attendance.

St Ambrose

Bearded; bishop's robes, scourge, beehive.

St Ambrose (339–397) was a lawyer and a governor, based in Milan. When the Bishop of Milan died, Ambrose attended an assembly to choose a successor. Although he was not even

baptized, the crowd took up the chant 'Ambrose for Bishop', and in spite of his protests the bishopric of Milan was conferred on him (Ambrose is always portrayed in bishop's robes). His writings are best known for their work on the sacraments and the role of the clergy, and he wrote a famous commentary on St Luke's Gospel. Ambrose also took on and rebutted Arianism, a heretical view that denied the divinity of Jesus. He was fearless in his willingness to rebuke the powerful, and publicly condemned the Emperor Theodosius for a massacre by Roman soldiers at Thessalonica. As a consequence of Ambrose's condemnation, Theodosius undertook public penance. In memory of Theodosius' penance, or alternatively in memory of his having whipped the heresy of Arianism out of the Church, Ambrose is sometimes portrayed with a whip or scourge. Ambrose is also sometimes portrayed with a beehive, or a swarm of bees, following a legend that when he was a child a swarm of bees settled on his mouth, but did not sting him. The honey of the bees symbolizes his honeyed eloquence.

St Gregory the Great

Papal robes; a dove; a crucifix appearing before him at Mass.
Gregory (540–604) was the son of a wealthy Roman senator. After a spell in government he used his wealth to found a number of monasteries, and took up an austere monastic life himself. The Pope sent him to be his Ambassador to Byzantium, after which he returned to become abbot of his old monastery, and was then elected Pope when the previous incumbent died of the plague. Gregory's great passion was the conversion of the Anglo-Saxons, and he sponsored missions to Britain. Famously, he saw a group of English people in Rome, and was struck by their fair hair and beauty. When he asked what nationality they were, he was told that they were Angles (Anglo-Saxons). 'Not Angles,' he said, 'but angels!'

Gregory's most famous writings consist of explanations of the teachings of the Church that are designed for people with little or no knowledge of those teachings. He also has a long association with Church music, and the term 'Gregorian chant/plainsong' comes from him. His writings were said to have been directly inspired by God, and so he is sometimes shown with the white dove of God the Holy Spirit hovering over him. According to a legend that became popular as debate raged over the significance of the Eucharist, when Gregory was celebrating Mass he had a vision of Jesus over the altar, either on the cross or displaying his wounds, in confirmation of the real presence of Jesus in the Eucharist.

St Basil the Great
Long dark beard coming to a point, receding hairline.
Born in 329/330, Basil came from a remarkably pious family: his grandmother, mother, father, sister, and two brothers were all saints. He had an outstanding education, with St Gregory Naziansen and the future Roman Emperor Julian among his classmates. He went on to argue for a broad education that incorporated secular culture, since an understanding of pagan philosophers and writings could only help a deeper understanding of Christian truths. He created rules for monastic living that remain the standard for monks in the Eastern Church. Like St Ambrose, his main theological fight was with Arianism, but he also emphasized pastoral care, selling his inheritance to provide for the poor and serving in a soup kitchen. When he died in 379, Jews and pagans joined with Christians in mourning him.

Basil is sometimes joined in icons of the Eastern Church by St Gregory Naziansen/the Theologian (portrayed with a white square-cut beard and receding hair; he wrote on the Trinity, and

on the nature and duties of priesthood, having run away when first called to be a priest), and St John Chrysostom (short, dark beard; bald; *Chrysostoum* means golden-mouthed, and he was said to be such an inspired speaker that his congregations were warned to be careful of pickpockets, since they would stand so rapt in his words that they were easy prey for light-fingered thieves). Together, the three are known in the East as the Three Holy Hierarchs. To achieve symmetry with the four Latin Doctors, sometimes St Athanasius is added (white full beard, bald; he was the theologian of Jesus' Incarnation, saying 'the Son of God became man so that we might become God'), to make the group known in the West as the Four Greek Doctors.

Angels

Angels are mystical beings that act as instruments of God: as announcers (the angels before Abraham, the Annunciation), punishers of wrong-doers (Sodom and Gomorrah, Adam and Eve), givers of moral strength (the Agony in the Garden), and even mystical personifications of God himself (the Burning Bush). The word 'angel' comes from the Greek word for 'messenger'.

There are nine 'choirs' of angels, separated into three orders. The first and highest order is known as the Counsellors, and is made up of three choirs called Seraphim, Cherubim, and Thrones. The second order is the Governors (or Rulers), and its choirs are the Dominions, Powers, and Virtues. The third order, the Messengers, embraces Principalities, Archangels, and, at the bottom of the pile, the Angels. The orders and choirs are put together from the Old and New Testament sources. Angels and Archangels appear repeatedly throughout the Bible, Cherubim and Seraphim appear in the Old Testament, while St Paul was taken

to mention the other five choirs (Ephesians 1:21 and Colossians 1:16). Modern translations of the Bible cast doubt on whether that was quite what Paul meant, but the orders were codified in this way in around the beginning of the sixth century, and the arrangement is still with us.

The order of Counsellors is collected around the throne of God, and in accordance with their high, mystical status they can be shown by winged wheels and with bodies and wings full of eyes, after Ezekiel's vision (see the Four Prophets, pages 164–165). The Seraphim are portrayed in accordance with Isaiah's vision (Isaiah 6:2), with six wings, two covering their faces, two covering their feet, and two for flying. Isaiah saw the Seraphim singing 'Holy, holy, holy' (Latin: *Sanctus, sanctus, sanctus*), and they can be portrayed with these words. The traditional colour for Seraphim is red/crimson, while the colour for Cherubim is blue/sapphire. The grand status of the Cherubim eroded over time, until in much Renaissance and post-Renaissance art they became chubby children with tiny wings. The Thrones, who carry the Throne of God, escaped this undignified twist of fashion. They are the colour of fire, and hold towers or sit on golden thrones.

The Governors are portrayed as human beings with badges of great authority: golden crowns, golden sceptres, gold rings, long white garments, gold girdles, and green stoles. In the order of Governors, the Dominions represent the power of God. The more warlike Virtues are sometimes pictured with armour and weapons, or with lilies or red roses. The Powers are also in armour and carry flaming swords or chains with which to bind the Devil. The Powers are thought of as the guardian angels, the angels who watch over individuals.

The role of the order of the Messengers is to intercede directly and individually between God and humanity, and they

are portrayed as winged human beings. Within the order, the Principalities are charged with protecting rulers and are shown in armour, carrying a sceptre, cross, palms, or a lily. The Archangels and Angels act as divine messengers. Two of them are named in the Bible, and two more are commonly portrayed from apocryphal sources.

St Michael

Armour, sword or spear, scales.

Michael is the leader of the Archangels, and his name means in Hebrew 'Who is like God'. He was one of the guardians of the people of Israel (Daniel 10:13), and was therefore assumed also to be the protector of the Church. In the Book of Revelation, St John saw Michael in heaven leading a war against Satan, whom he cast down to earth (Revelation 12:7–9); church imagery most often portrays Michael after this episode, in armour and wielding a sword or spear, trampling a dragon (Satan) underfoot. Michael is also sometimes portrayed holding scales to weigh souls in images of the Last Judgement. This association may have come about because according to a second-century work entitled the 'Testament of Abraham', Michael's intercession was so powerful that it could even save people from hell. In keeping with his position in heaven, churches dedicated to Michael tend to be built in high places, for example the Mont St Michel, Tor Hill at Glastonbury, or in more recent times London's highest church, at the top of Highgate Hill.

St Gabriel

Lily, trumpet.

Gabriel (whose name in Hebrew means 'God is my Strength') appears in the Bible chiefly as an announcer and interpreter of

messages from God. He is best known for appearing to the Virgin Mary in the Annunciation, but he also announced the birth of St John the Baptist, and in the Old Testament he appeared to the Prophet Daniel to explain the meaning of his visions (Daniel 8:15). Through his association with the Virgin Mary, he is often portrayed with a lily (this being Mary's chief attribute). He is also traditionally the angel who will blow the horn of the Last Judgement (Revelation 8–9), giving another attribute of a trumpet. Appropriately enough, Gabriel is the patron saint of post office and telephone workers.

St Raphael

Pilgrim's staff, clothes and pouch; fish.

Raphael (Hebrew: 'God is my Health') is the leader of the Powers, the guardian angels. By reason of his healing name, Raphael was traditionally identified as the angel who stirred the healing waters of the Pool of Bethesda, where Jesus healed a paralytic (Matthew 9:1–8).

He appears in the popular Book of Tobit, a jewel of Jewish literature. Tobit, a faithful Jew living in a pagan land, loses his position and his sight. He sends his son Tobias to recover money that he has left in Media. Tobias locates a companion and guide for his journey, and they enjoy many adventures together, including one in which a monster springs out of a river to devour Tobit, who is saved by his companion. The two return home safely to cure Tobit's blindness – whereupon the guide reveals himself to be the Angel Raphael. By reason of these adventures, Raphael is usually shown in pilgrim clothes and with a pilgrim's staff and pouch, while the fish he holds is a diminution of the river monster he defeated.

St Uriel

Scroll or book.

Uriel appears in the First Book of Enoch, from the Jewish apocrypha. The Book of Enoch relates that a number of angels came to earth, bred with human women, and fathered a race of giants (the book causes much excitement amongst believers in extraterrestrial lifeforms). In the book, Uriel provided astrological data to Enoch, and also appeared to Noah to warn him of the coming floods that would destroy the giants. Uriel, whose name means in Hebrew 'God is my light', is traditionally the leader of the Seraphim, and the angel who was guarding the sepulchre of Jesus after the Resurrection.

Jophiel, Chamael, and Zadkiel

Christian art sometimes portrays three more Archangels, since seven angels were recorded in the Book of Revelation (Revelation 1:20). They have been named Jophiel (or Zophiel), reputed to have been the angel who guarded Eden after Adam and Eve were driven out, and so shown with a flaming sword; Chamael (or Chemuel), who carries a staff and cup since he was meant to have strengthened Jesus during the Agony in the Garden (he is also meant to have wrestled with Jacob); and finally, Zadkiel, who was meant to have appeared to Abraham to stop him sacrificing his son Isaac. He appears with Abraham's sacrificial knife.

Angels can also be used as symbols outside themselves. For example, Jophiel carrying the sword of the expulsion of Adam and Eve from the Garden of Eden can be portrayed with St Michael holding the scales of the Last Judgement. In this example, the angels are being shown not for their own sake, but to symbolize the early division and later reuniting of God and humankind.

Abstracts

The Seven Sacraments

A sacrament is an outward act with a prescribed form that confers a special grace on the person who participates in it. Put another way, it is a ceremony that expresses an inner spiritual development in the person, or persons, that are the subject of it. For example, Baptism is a sacrament in which the pouring on of water expresses the inner 'washing through' of the person; the marriage ceremony is a sacrament that expresses the inner joining together of two people. The external act is not regarded as 'causing' the inner change, but the internal and external acts are thought to be closely and mystically linked.

Protestant Churches recognize two sacraments, Baptism and the Eucharist. Catholic and Eastern Churches recognize a further five, Penance (repentance for sins), Confirmation (a ceremony when a person is 'confirmed' into the Church, through the laying on of hands by a bishop), Matrimony, Holy Orders (becoming a priest), and Extreme Unction (a ritual undertaken shortly before

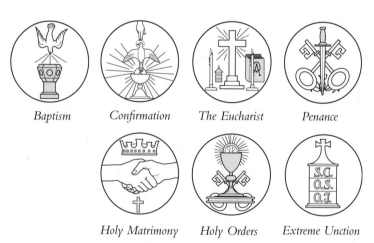

Baptism *Confirmation* *The Eucharist* *Penance*

Holy Matrimony *Holy Orders* *Extreme Unction*

a person's death; or, anointing the sick). Divisions during the Reformation over how many sacraments there were contributed to the popularity of portraying them in Catholic churches, particularly on fonts and behind altars, these being, respectively, the sites where the sacrament of Baptism and the sacrament of the Eucharist took place. There is, though, no set pattern as to how they are represented. It is often done with New Testament scenes, such as the Baptism of Jesus (for Baptism), the Last Supper (for the Eucharist), St Peter weeping over his Betrayal of Jesus or St Mary Magdalene weeping (for Penance), St Peter receiving the keys of heaven (for Holy Orders), and the Virgin Mary (or another saint) on her deathbed receiving the Eucharist (for Extreme Unction). In the form of emblems, the sacraments can be represented by a font (Baptism), a chalice or altar (the Eucharist), a whip or scourge (Penance), a dove (Confirmation; the dove is the Holy Spirit coming to the person confirmed), joined hands (Matrimony), clerical robes (Holy Orders), and an oil holder (Extreme Unction; oil is used to anoint the dying person).

Virtues and Vices

In the sixth century St Gregory the Great identified seven principal sins. In descending order of importance, they were: pride (Latin: *superbia*), anger (*ira*), lust (*luxuria*), greed (*avarita*), envy (*invidia*), gluttony (*gula*), and sadness (*tristia*). Sloth (*accidia*) later replaced sadness, and the group became known as the Seven Deadly Sins. Correspondingly, Seven Heavenly Virtues were acknowledged. These were broken down into the four cardinal virtues, fortitude, justice, prudence, and temperance, and the three theological virtues, faith, hope, and charity (identified by St Paul, 1 Corinthians 13:13).

Before Gregory, at the end of the fourth century, a Spanish

poet called Prudentius had published a long poem called *Psychomachia* ('Battle for the Soul'). *Psychomachia*, which influenced artists for many centuries, deals with a struggle of the soul, between virtues and vices pitted one against the other. When ranged against the seven deadly sins, later artists found seven corresponding virtues: humility versus pride, patience versus anger, chastity versus lust, liberality versus greed, kindness versus envy, abstinence versus gluttony, and diligence versus sloth.

Portrayals of the vices and their corresponding virtues became very popular, and artists had fun personifying them, particularly the vices. Greed could be a pot-bellied drunkard, anger a man twisted with rage, lust a lascivious woman, and so on. Although some animals became associated with the different vices and virtues, there is no strong codification, and different artists felt free to pick and pit different vices and virtues against one another in any number of ways.

Church and Synagogue

The perceived break with the old law through the resurrection of Jesus, and bringing in of a new covenant, led to the portrayal of the allegorical figures of Church and Synagogue. They are both women. The woman representing the Church is crowned and serene, and may be carrying a cross or chalice; the woman representing the Synagogue is blindfolded or veiled, her crown is falling from her head, and she carries a broken sceptre or spear, as a sign of her broken power. The blindfold or veil was intended to represent the veiled truth of the Old Testament, when compared with the clear vision of the Church. The two are most often seen in medieval images of the Crucifixion.

The Church

The Church itself is the subject of many symbols. These include an ark, since like the Church Noah's ark saved believers from the destruction of the world (Matthew 24:37–39; 1 Peter 3:20); a ship, afloat in the choppy waters of the world, with its mast shaped like a cross; the Ark of the Covenant, which was the Old Testament symbol of God's covenant with Israel; a vine; a rock, from Jesus' words to St Peter; and a 'gospel-mill', a hand-cranked mill into which grain is poured and flour emerges. This represents the grain of the Old Testament being transformed into the flour of the New.

ANIMALS, BIRDS AND FISH

W hen decorating churches, many artists borrowed images from the natural world to represent Christian ideas or teaching. In some cases the world of nature was used as it appears in the Bible, for example from the way sheep are described there. In other cases, aspects of the natural world appeared to be apt illustrations of Christian teaching, for example the transformation of a caterpillar into a butterfly illustrating resurrection. Particularly colourful analogies came from the medieval bestiaries. These were books that both described known animals and recorded fantastic legends: bear cubs born without shape, pelicans feeding their chicks with blood, or lions covering up their tracks with their tails. On top of all of these, artists used analogies with mythical creatures. All these gave birth to a colourful menagerie in church art.

Ape or Monkey A monkey or ape was thought to be an animal with human desires but without human restraint. Thus it became a symbol of immoral self-indulgence, greed, cunning, and lust. A monkey in chains symbolizes the defeat, or at least civilized restraint, of these tendencies. It is often shown in exotic settings, or with exotic persons, such as the Magi.

Ass or Donkey An ass or donkey is a humble working animal, and so is a symbol of humility. They almost always appear in images of the Nativity, and in many other stories including the sacrifice of Isaac, the Flight into (and Return from) Egypt, and the Entry into Jerusalem. The backs of donkeys have a clear cross of dark hair, stretching down the spine and crossed between the shoulders, which according to legend appeared to commemorate Jesus' ride into Jerusalem on a donkey's back.

The most notorious ass in the Bible is that belonging to Balaam, from the Old Testament Book of Numbers. Balaam is an enigmatic figure, a blend of occult magician and legitimate prophet. On the one hand, a foreign king felt able to try to hire him to place a professional curse on the Israelites and weaken them in battle. On the other, he is shown consulting with God and obeying his commands. In the scene usually shown, Balaam had responded to the foreign king's summons and was travelling to see him on the back of his ass. Three times God placed an angel in his path. Balaam could not see the angel, but the ass could and refused to take another step. When Balaam furiously beat the ass, God allowed it to speak and complain about his harsh treatment. The passage contains a rare biblical joke. The ass says, 'Am not I thine ass, upon which thou hast ridden ever since I was thine unto this day? Was I ever wont to do so unto thee?' Balaam's response is like an ass' cry: 'Nay!' (neigh) (Numbers 22:30, King James Version; when Balaam's response is translated as 'No!' the joke does not really work).

Basilisk The basilisk, also known as the cockatrice, was half serpent and half cockerel. It could be created through hatching a hen's egg under a snake or a toad. The basilisk was the king of serpents, and is portrayed with a high cockerel's comb, a serpent's

tail, and chicken's wings. They were deadly monsters, killing instantly with their breath or just with a look. Even if speared, the basilisk's deadly poison would shoot through the spear to kill the holder and any horse he might be riding on. All of this made the basilisk an obvious symbol for the Devil.

This connection was made explicit in one translation of Psalm 91:13: 'Thou shalt tread upon the adder and the basilisk and trample underfoot the lion and the dragon'. St Augustine interpreted the adder, the basilisk, the lion, and the dragon in this passage as representing aspects of the Devil: the adder is cunning; the lion is open rage; the dragon is hidden plotting; the basilisk is the king of serpents, as the Devil is the king of wicked spirits. In accordance with Psalm 91, the Church had the power to crush the basilisk, or the Devil, underfoot (St Augustine, *Expositions on the Psalms*).

In mythology, the basilisk's only natural enemy was the weasel, which was impervious to its deadliness. The weasel has never been taken up as a symbol in Christian art, but is a prime candidate.

Bear The bear is a symbol of evil power. The prophet Daniel had an apocalyptic vision of a bear with three tusks, one of four great beasts that symbolized four kingdoms that would arise and be defeated by God (Daniel 7; the bear has been taken to be the Kingdom of Persia). In one of the Bible's less attractive stories, a group of children shouted 'Clear off, baldy!' at the Prophet Elisha as he passed by their city. He cursed them, and two she-bears emerged from the woods, mauling forty-two of them (2 Kings 2:23–24). The scene is portrayed in the Chiesa della Ourita in Udine, Italy, an institution dedicated to the instruction of the (doubtless very respectful) young.

Bears also have an important symbolic meaning through the

medieval bestiaries. These taught that bear cubs were born as small eyeless lumps of flesh, which were licked into shape by their mothers (this being the origin of that phrase). Christians were correspondingly thought to be empowered to lick the world into shape.

Bee or Beehive The bee or beehive is a symbol of St Ambrose, page 171, who spoke with honeyed words and on whose mouth a swarm of bees was meant to have settled without harming him. The beehive can also be a symbol of the organized and industrious Church (with Christians as the bees), an analogy used by St Ambrose himself. See also Samson (page 155).

Birds Birds, as inhabitants of the air and the earth, were an ancient Egyptian symbol of the soul, a symbol that was adopted by the early Christians. Charming legends grew up around some species. During the Crucifixion, the robin was said to have fluttered around Jesus, desperately trying to staunch the flow of blood from his wounds with its own body. In honour of this, it has ever since been marked with a blood-red breast. The sparrow, on the other hand, hopped around the foot of the cross, jeering at Jesus. It was cursed to move forever on the earth in sharp, hopping jumps.

Bull When appearing with an eagle, a man, or a lion (most usually in a group of four), and especially when winged, the bull is an emblem of St Luke (see the Four Evangelists, pages 101–102).

Butterflies Butterflies can symbolize resurrection, transformation, and new life, because they have cast off their previous existence as creeping caterpillars. They sometimes appear in images of Jesus as a child.

Camels Since the camel can go many days without drinking, it became a symbol of temperance, one of the seven virtues (see page 179). As an exotic creature, it is also associated in church art with exotic persons, such as the Magi or the Queen of Sheba (see King Solomon, pages 159–160). St John the Baptist dressed in camel's skin (page 93); some artists took this literally, and he is shown draped with a one-piece camel skin, head and all.

Cockerel The cock, crying out at dawn, is a symbol of vigilance, especially against the wiles of the Devil. It is also an attribute of St Peter because of the cockcrow after his three denials of Christ.

Crane The crane is a symbol of vigilance. Cranes were said to gather in a circle to sleep, while one of their number stayed awake, on watch. The watcher's system for keeping awake was to stand on one foot, with the other raised in the air. If it dozed off, the raised foot would fall on the other, and it would wake itself up.

Dogs Dogs are a common symbol of faithfulness, and regularly appear as such in both religious and secular art. In churches they are particularly common on tomb monuments, in honour of the person's fidelity. Dominican friars are sometimes symbolized by a black and white dog, in a pun on their name (*Domini canes*, dogs of the Lord) and their black and white robes.

In biblical times (and therefore in the Bible) dogs had a poor image. They are associated with snarling violence, or are seen in a contemptuous light as 'lowly' creatures. Jezebel suffered the ignominious fate of being eaten by dogs (2 Kings 9:33–37), while in Jesus' parable of the rich man (Dives) and the poor man (Lazarus) 'even the dogs would come and lick his sores' (Luke 16: 21).

Doves In Christian art, a dove is most commonly a symbol of God the Holy Spirit, and appears in images of the Annunciation, the Baptism of Jesus, and of the Trinity. A dove is also prominent in the story of Noah. In the Old Testament a pair of doves (or pigeons) was declared an appropriate sacrifice for purification after the birth of a child (Leviticus 5:7), and Joseph took a pair of pigeons as a sacrifice when Jesus was presented at the Temple (Luke 2:22–24). As sacrificial objects, doves or pigeons also appear in scenes of the Expulsion of the Moneychangers, since the sellers of doves for sacrifice was one of the groups that Jesus drove out of the Temple precincts. Finally, doves are often used to represent the human soul. When there are twelve of them, they represent the twelve apostles, the twelve tribes of Israel, or all humankind.

Dragon Dragons, reptilian winged monsters, exist in the mythology of almost all cultures. In the Bible, the dragon symbolizes Satan, as it was the shape taken by him in the Book of Revelation. The Book of Revelation describes a war in heaven, between the angels of God, led by the Archangel Michael, and Satan and his rebel angels. The dragon ('an enormous red dragon with seven heads and ten horns and seven crowns on his heads') and the rebel angels are hurled to earth, whereupon they go to make war with Jesus' followers (Revelation 12 & 13). Where a dragon is portrayed being defeated by an angel – often run through with a spear and trampled underfoot – it is a depiction of Satan's defeat by Michael.

A dragon is also depicted in pictures of St George. These can be distinguished from depictions of St Michael because St Michael is winged, whereas St George is a knight on horseback, usually

with his badge of a red cross on a white background on his shield or breastplate.

Eagle As an ancient familiar of Jupiter, ruler of the gods, and a symbol of Rome, the eagle has had a long association with power and the divine. But its actual and legendary powers have also given rise to a number of specific symbolic meanings. It is most often used as a symbol of St John the Evangelist and of his Gospel. John's is the most mystical and spiritually revealing of the four Gospels, contemplating God in the same way that the eagle was meant to be able to look unflinchingly into the eye of the sun. It may appear along with a man, a lion, and a bull representing the other three evangelists. Church lecterns, which support the Bible for readings, are very often in the shape of an eagle with spread wings, because (for the same reason) the eagle was a symbol of divine inspiration.

Medieval bestiaries said that the eagle renewed its plumage each year by flying near the sun and then plunging into water. Like the phoenix, the eagle therefore came to be used as a symbol of the Resurrection, and so of Jesus. The same bestiaries also claimed that eagles always left half of their prey to the birds that followed them, no matter how hungry they were. They therefore became a symbol of generosity.

Fish The fish is a symbol for Jesus (see God the Son, page 52), while three fishes interwoven is a fairly common 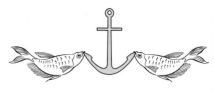 symbol of the Trinity. The fish also later became a symbol for the Eucharist, and if pictured near a chalice represents the bread, the body of Jesus.

Fishes feature most prominently in two New Testament stories.

Two fishes next to five loaves represents Jesus' miracle of the feeding of the five thousand, when Jesus took five loaves of bread and two fishes, blessed them, and was able to feed a crowd of five thousand with the multiplied food (see St Philip, page 114). At the start of his ministry Jesus promised to two of his fishermen disciples, the brothers St Peter and St Andrew, that if they left their nets and followed him then he would make them 'fishers of men'. After Jesus' resurrection the disciples were fishing in the early morning on the Sea of Galilee, but had caught nothing. Jesus appeared and told them to cast their net on the other side, when it was filled so full that they could not raise it and had to drag it back to shore (John 21:4–14). The story of the heavy net has been taken as a metaphor for the number of souls that the disciples were to save, with God's guidance, and fishes are sometimes used as a symbol of people's souls.

Like the image of the shepherd and the sheep, the image of the fish has a darker side, as a warning about the Last Judgement of God. Jesus said that the kingdom of heaven is like a net that was let down into the lake and caught all kinds of fish. When it was full, the fishermen pulled it up on the shore. Then they sat down and collected the good fish in baskets, but threw the bad away (Matthew 13:47–48).

See also Leviathan.

Flies Images of flies need to be treated with care. The fly has been used as a symbol of illness, evil, and sin (Beelzebub, the name of a powerful demon, or Satan himself, is a Hebrew word that translates as 'Lord of the Flies'). However, images of flies were also thought to have a practical purpose. It was believed that an image of a fly painted onto a sacred object repelled the real insects, and prevented them from profaning the images with their touch.

Foxes The fox is a traditional symbol of cunning, and may represent Satan. Samson destroyed the crops of the Philistines by tying burning torches to foxes' tails and releasing them into the harvest.

Frogs Frogs are a relatively rare symbol, of punishment and of demonic powers. One of the Plagues of Egypt was of frogs sent by God as a punishment (Exodus 8). Frogs appear in the Book of Revelation as the appearance adopted by certain evil spirits (Revelation 16:13) and demonic spirits are often portrayed in Christian art as being frog-like.

Goats *See* lamb.

Goldfinch For all of their vivid beauty and delicacy, goldfinches were thought to live on a diet of thistles and spiny plants, which symbolize the troubles of the world, or Jesus' crown of thorns. They sometimes appear in images of Jesus as a child, when they contrast his youthful innocence with the suffering he would endure as an adult. In a direct connection between the goldfinch and the Passion, a goldfinch was said to have tried to pull a thorn, from the crown of thorns, from Jesus' forehead. In the process it was splashed with a drop of Jesus' blood, which became the permanent red mark on its head.

Griffin (or Gryphon) The griffin was a monster with the head and wings of an eagle, and the body and legs of a lion. They were good at gold: different legends had them knowing instinctively where gold could be found, making their nests out of gold, or guarding gold mines.

The griffin was used as a symbol for Jesus, for a number of reasons. The two elements of the griffin were like the human

(lion on the earth) and divine (eagle in the sky) aspects of Jesus' nature; the lion and the eagle were respectively kings of the animals and of the birds; and it combined a lion's strength with an eagle's vigilance. It remained, though, a tricky image, suggesting at the same time ferocity, knowledge (particularly as regards money), and usury.

Horse The horse can also be a symbol of lust, after God's condemnation of the Israelites through the Prophet Jeremiah: 'They are well-fed, lusty stallions, each neighing for another man's wife' (Jeremiah 5:8). St George, as a warrior-saint, often rides a horse, while a man fallen from a horse may be St Paul on the road to Damascus.

Lamb, Sheep, Ram, Shepherd Jesus is often represented as a lamb (see pages 52-3), in which case the head of the lamb is usually surrounded by a cruciform halo. As St John the Baptist was the first to call Jesus 'the Lamb of God', he may be identified by holding or standing next to a lamb that represents Jesus in this way.

The image is reversed when Jesus is considered as the 'Good Shepherd', in which case the sheep are his people. The Bible is littered with sources for the image, which is an expression of the care that God has for humankind and the guidance he gives – but also the power he has over his flock. In the Old Testament, the images are of God as the gentle carer, particularly over the people of Israel ('The Lord is my shepherd, I shall not want', Psalm 23:1; 'He tends his flock like a shepherd: he gathers the lambs in his arms and carries them close to his heart; he gently leads those that have young', Isaiah 40:1). Jesus is seen as fulfilling Old Testament prophecies of a shepherd who would come to guide humankind, and he described himself as the Good Shepherd: 'I know my sheep

and my sheep know me, just as the Father knows me and I know the Father, and I lay down my life for the sheep' (John 10:14–15). Jesus was portrayed by the early Christians as a young shepherd carrying a lamb on his shoulder.

The image is used in a more frightening way in images of the Last Judgement. Then, Jesus is the shepherd who will separate the sheep from the goats, with the sheep being the souls of the saved and the goats the souls of the damned. Images of the final judgement in this way are recognizable by this division, and the flock of sheep should be on Jesus' right hand, the herd of goats on his left (in accordance with Matthew 25:33–34). In a final apocalyptic twist, the image of the shepherd and the sheep become mystically joined in St John's vision of the faithful in heaven: 'For the Lamb at the centre of the throne will be their shepherd; he will lead them to springs of living water. And God will wipe away every tear from their eyes' (Revelation 7:17).

Other images of lambs, sheep, and rams are: on Abel's altar in the story of Cain and Abel; the ram that was caught in a bush in the story of Abraham and Isaac; in the story of Joachim and Anna; and with the shepherds at the Nativity. Twelve sheep or lambs together represent the twelve Apostles, the twelve tribes of Israel, or all the faithful.

See also ram.

Leviathan Leviathan is a mythical beast which appears in the Old Testament, sometimes portrayed as a sea-serpent, sometimes as a fish, but important because of its great size. It is most often used as a metaphor to show the power of God, who can defeat this mighty animal (Psalm 74:14, Isaiah 27:1).

Leviathan is associated with (or taken to be the same as) Satan, and is connected with hell. Representation of the entrance to hell as a vast, fishy jaw comes from the vivid description of Leviathan in Job 41: 'From its mouth go flaming torches; sparks of fire leap out. Out of its nostrils comes smoke, as from a boiling pot and burning rushes.'

Lion When appearing with a bull, a man, or an eagle (usually in a group of four), and especially when winged, the lion is an emblem of St Mark (pages 101–102). Lions are also associated with Daniel (see Daniel in the lion's den, page 167), Samson (see Samson and the lion, page 155; Samson is often portrayed wearing the skin of the lion he killed) and St Jerome.

Lions can symbolize strength and majesty, and so Jesus. St John's vision refers to Jesus as a lion, standing victorious over evil: 'Then one of the elders said to me, "Do not weep! See, the Lion of the tribe of Judah, the Root of David, has triumphed"' (Revelation 5:4–5). Some translations of Psalm 22, which was seen by Christian writers as prophesying Jesus' suffering on the cross, include an image of a lion being pierced through hands and feet, like Jesus: 'Dogs have surrounded me; a band of evil men has encircled me, they have pierced like the lion, my hands and my feet' (Psalm 22:15–17). Powerful lions are defensive bulwarks in some Italian churches, where their statues support the porch columns. They catch in their claws small creatures, symbolizing sin, that have tried to slip in past them.

Some Christian writers pushed the analogy between Jesus and lions further, by reference to stories from the medieval bestiaries. Lion cubs were thought to be born dead, and to come to life after three days when their father breathed life into them, just as Jesus

died and rose again after three days; lions were meant to sleep with their eyes open, which made them a general symbol of vigilance, just as Jesus is vigilant of the well-being of humankind; finally (and by this stage the analogy was getting rather stretched), lions were thought to hide their tracks from hunters by brushing over them with their tails, just as Jesus was hidden from the world until the Incarnation.

More rarely, and depending on context, lions can symbolize evil, or the Devil. Jesus' defeat of evil was thought to be prophesied by Psalm 91:13, 'you will trample the great lion and the serpent', while St Peter says in his first epistle, 'Be self-controlled and alert. Your enemy the Devil prowls around like a roaring lion looking for someone to devour' (1 Peter 5:7–9). But when joined by other creatures, particularly a lamb, the lion's ferocity is transformed into an image of the peace and tranquillity that is expected when God's kingdom is finally established. The image is from the Prophet Isaiah: 'The wolf will live with the lamb, the leopard will lie down with the goat, the calf and the lion and the yearling together … ' (Isaiah 11:6–7).

Owl An owl was the traditional familiar of the Greek goddess of wisdom, Athene (as a Roman goddess, Minerva). This association caused it in turn to become an attribute of St Jerome, who was thought a fountain of wisdom. The owl is often also a symbol of the night, darkness, and evil. It is sometimes present at the Crucifixion, where it symbolizes the darkness into which Jesus gives light.

Ox Especially when winged, the ox is a symbol of St Luke (see the Four Evangelists, pages 101–102), and his Gospel. An ox is usually present at the Nativity.

Peacock Medieval bestiaries said that the peacock did not decay after it died, and so it became a symbol of immortality and the Resurrection. The peacock is particularly closely associated with the Virgin Mary: firstly, the bird was the

familiar of Juno, Roman queen of the gods, and so was already associated with the Queen of Heaven; secondly, Mary's body was thought to have been assumed, undecayed like the peacock's, into heaven (see the Death and Assumption of the Virgin, pages 90, 91).

Pelican The pelican was said in medieval bestiaries to peck at its breast in order to feed its young with its own blood. In a variation of the story, it could revive its young after death by sprinkling them with its blood. In both tales, the pelican gives its blood to feed,

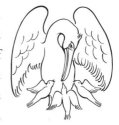

nurture, and save its offspring, which was seen as a direct analogy with Jesus' sacrifice. Christian commentators thought that this was confirmed by a prophecy about Jesus in Psalm 102, the King James Version of which reads 'I am like a pelican of the wilderness' (Psalm 102:6; in more modern translations the pelican is an owl). Images of the pelican feeding her young with her blood are known as the 'Pelican in Her Piety'.

Phoenix The phoenix resembles an eagle with brilliantly colourful plumage (often scarlet and gold), and is portrayed rising from a raging fire. The story of the phoenix was told, with variations, from Ancient Egypt and Greece through to Asia and China. There was only ever one phoenix at any one time, and it lived for a very long time – some stories say five hundred years,

some a thousand. When the time came for it to die, it would make itself a nest of spices, and sing a song so beautiful that the sun god would stop to listen. Sparks from the sun would set the nest alight, consuming the old phoenix. A rejuvenated phoenix would then rise up from the flames. The uniqueness and splendour of the phoenix, its dying and rising again, and its symbolism of hope in the face of death, caused it to be adopted as a symbol for Jesus and his Resurrection, and the Christian's triumph over death. The phoenix also appears on coinage of the late Roman Empire, since it came to be a symbol of the undying and eternal City of Rome.

Pig The pig is a symbol of lust, or greed, or sloth (see the Seven Deadly Sins, pages 179–180). It is also associated with St Anthony of Egypt (page 120).

Pigeon *See* dove.

Rabbit or Hare The rabbit and the hare are common symbols of lust. This was partly through the rabbit's proverbial capacity to breed, and partly through a Latin pun: the Latin for rabbit is *cuniculus*; for vagina, it is *cunnus* (the root of a word in the modern vernacular). A rabbit at the feet of the Virgin Mary symbolizes her victory over lust.

Ram The ram is a symbol of Jesus. He is the leader of the herd; rams were thought to be able to defeat wolves (which represent the Devil); most importantly, in the story of Abraham and Isaac, the ram substituted as a sacrifice for Isaac was thought to prefigure Jesus, who was a substitute sacrifice for the whole of humankind. See also lamb.

Raven Although in art and literature ravens tend to be birds of ill-omen, in the Bible they enjoy a happier reputation. In the story of Noah a raven was the first bird that Noah sent from the Ark to see if the floodwaters had receded, before sending out the more famous dove (Genesis 8). In Jewish legend, the raven was white as snow when Noah sent it out, and only turned black when it failed to return. Ravens are also honoured in the Bible as having been sent by God with food for the Prophet Elijah. Elijah had prophesied to the King that there would be no rain until he said so. Elijah then hid in a ravine, where he drank from a brook while ravens brought him bread and meat, morning and evening (1 Kings 17). There are a number of later stories of ravens feeding hermit saints in the desert, which may derive from the Elijah story.

Jesus also used ravens positively in one of his most famous sayings: 'Consider the ravens: They do not sow or reap, they have no storeroom or barn; yet God feeds them. And how much more valuable you are than birds!' (Luke 12:24).

Salamander In ancient mythology, salamanders were fireproof, and could even extinguish fire. They therefore came to symbolize the virtue of the righteous man, and his power to resist the fiery temptation of sin.

Scorpion The sudden sting of the scorpion gave it a reputation for evil, and is in particular associated with Judas Iscariot.

Sheep, Shepherd *See* lamb.

Snakes and Serpents Snakes usually symbolize the Devil, or sin. In the Garden of Eden, it was a serpent that persuaded the first-created woman, Eve, to eat the forbidden fruit of the Tree of the

Knowledge of Good and Evil, so allowing sin to enter and damage what had been until then a perfect world. When he discovered what the snake had done, God pronounced a curse on it: 'Cursed are you above all the livestock and all the wild animals! You will crawl on your belly and you will eat dust all the days of your life. And I will put enmity between you and the woman, and between your offspring and hers; he will crush your head, and you will strike his heel' (Genesis 3:14–15).

Snakes appearing grasped in a hand or squashed underfoot symbolize Jesus' (or the Christian's) triumph over sin. A snake at the foot of the cross in a crucifixion scene shows that sin has been defeated.

In contrast, when mounted on a staff, a snake is a symbol of Jesus. The image is derived from the story of the bronze serpent in Exodus, when the Israelites were saved from a plague of snakes by a bronze serpent that Moses had raised on a pole. Jesus made an explicit connection between the bronze serpent and his crucifixion ('Just as Moses lifted up the snake in the desert, so the Son of Man must be lifted up'; John 3:14). From the same story, the symbol of a snake entwined with a pole is a symbol of healing.

When hovering over a cup or chalice, a snake is associated with St John. The snake represents the poison in the chalice that John was challenged to drink as proof of his authority from God.

Finally, snakes can be used as an emblem of God's authority. God transformed Moses' staff into a snake and back into a staff, as a proof to the Israelites (and later to Pharaoh) that God had appeared to him and to Aaron (Exodus 4 & 7). When Pharaoh's sorcerers performed the same feat, the snake from Moses' staff swallowed up the snakes from the sorcerers' staffs.

Stag or Deer A famous passage from the Psalms reads, 'As a stag longs for flowing streams, so my soul longs for you, O God!' (Psalm 42:1; modern translations replace the stag with a deer). A stag on its own is therefore a symbol of spiritual longing, while if it is drinking it is spiritual fulfilment. A stag with a cross between its antlers is a reference to the story either of St Hubert or St Eustace, both of whom were supposed to have been converted to Christianity when, while out hunting, they encountered a stag wearing a cross. It is not known if there was a 'historical' St Eustace (although he was supposed to be a Roman general, and can be distinguished from St Hubert by his dress), but he gained popularity from the story of his conversion and from his lurid martyrdom, roasted alive inside a hollow bronze bull. More is known about St Hubert, who was Bishop of Maastricht in the eighth century. Both are patron saints of hunters.

Stork In the bestiaries the stork fed its parents in their old age, and so it became a symbol of filial duty. Since it migrated early in the year and announced the spring, it also became a symbol of the announcement of Jesus' birth at the Annunciation.

Unicorn The graceful unicorn, a small white horselike beast with a single spiralling horn on its forehead, was adopted by Christians as a symbol of God's incarnation in Jesus, and Jesus' sinless life. In Roman mythology the unicorn was powerful, wild, and impossible to catch by force. But it loved purity and could be tamed by a virgin, in whose lap it would lay its head and sleep. This combination of purity and strength made this a popular analogy, particularly as all-powerful God came to the womb of the Virgin Mary, just as the untameable unicorn would come to virgins. In addition, the horn of the unicorn was believed to be an antidote

to poison (for which purpose narwhal horns used to be sold as unicorn horns). Correspondingly, Jesus was an antidote to sin.

Whale A whale is most often associated with Jonah, and whales have an old association with devilry. Sailors believed that whales would pretend to be islands. When a ship anchored on them they would plunge into the depths, dragging the ship with them. Jonah's three days in the belly of the whale were thought to prefigure Jesus' three days in hell.

PLANTS

J ust as artists used images of animals, birds, and fish to illustrate Christian teaching, so too they used plants. Artists would portray plants in the way they are used in the Bible, or else would use characteristics of particular plants to make an analogy between them and parts of Christian teaching.

Acacia bush Traditionally, the Burning Bush was an acacia. When an acacia bush is topped with flames, it represents this event (or, to put it another way, the bush that you see burning should be an acacia). The bush was on fire but was not destroyed, and therefore acacia bushes also represent the immortality of the soul. See also brambles.

Almonds Almonds are a symbol of divine favour. In the Book of Numbers, God tells Moses that 'to rid myself of this constant grumbling against you [Moses] by the Israelites' he should get each of the leaders of the twelve tribes of Israel to bring a staff, and to write their name on it. God told Moses to place the staffs in a tent overnight; the staff belonging to the man he chose as leader would sprout (the leaders had each written their names on

their staffs, to avoid confusion). The next day the staff belonging to Aaron 'had not only sprouted but had budded, blossomed, and produced almonds' (Numbers 17:1–8). This symbolism may have come about because the almond was the first tree to flower after the Palestine winter. As the first sign of spring, its flowers showed that certain events were about to happen.

Almonds are also associated with the Virgin Mary, because of their symbolism of divine favour, the pure white of their blossom, and the womblike shape of the almond's nut. The Angel Gabriel's first words to Mary, when announcing that she was chosen to be the mother of the Son of God, were 'Greetings, you who are highly favoured! The Lord is with you' (Luke 1:27).

Anemone With its three large outer petals, the anemone is a symbol of the Trinity. The spots of red colour on the petals of some anemones were thought to represent drops of Jesus' blood at the Crucifixion. Anemones are sometimes shown growing at the foot of the cross in images of the scene, since according to legend they sprang up over Golgotha that evening. The image is probably borrowed from classical mythology, since the beautiful Adonis was said to have died on a bed of anemones, which were stained red with his blood.

Apple God told Adam and Eve that they could eat from any tree in the Garden of Eden, except the Tree of the Knowledge of Good and Evil. A serpent tempted Eve, who in turn tempted Adam, to eat this forbidden fruit, in humankind's first act of disobedience to God.

The Bible does not say what kind of fruit grew on the Tree of the Knowledge of Good and Evil, but the most common tradition is that it was an apple. This seems to be because the Latin word for

apple, *malum*, is also an adjective meaning 'evil'. In addition, the apple appears as a prize or reward in more than one Graeco-Roman myth. An alternative tradition, though, names the orange as the offending fruit, while the Eastern Church reasoned that, since Adam and Eve clothed themselves in fig-leaves, it must be a fig.

When held by Adam, an apple symbolizes sin. When held by Jesus or the Virgin Mary, it symbolizes salvation and triumph over sin (see introduction to 'The Old Testament' section, page 133). The idea of the apple in Jesus' hand being sweet after the bitterness of Adam's apple was thought to be predicted by the Song of Solomon: 'Like an apple tree among the trees of the forest is my lover among the young men. I delight to sit in his shade and his fruit is sweet to my taste' (2:3).

When three apples are shown, in a basket alone or with roses or other fruit, it is a symbol of St Dorothy (d. circa 304). No details are known about Dorothy's life, but the stories around her death made her a popular figure. On the way to her execution for refusing to renounce her Christian beliefs, she was jeered at by a young lawyer named Theophilus, who challenged her to send him fruit and flowers from paradise. An angel later brought Theophilus a basket containing three apples and three roses. He quickly converted to Christianity.

Aspen The small, delicate leaves of the aspen tree quiver at the slightest breeze, which has given rise to delightful legends. One is that it was aspen wood that was used for the cross of the Crucifixion (a role in which it competes with holly). When the aspen realized the terrible purpose to which it was to be put, it started trembling and has never stopped. Another legend is that alone among the trees it refused to bow to Jesus as he hung on the cross. As a result, it was cursed to tremble for eternity (there are a

number of legends that connect creatures with the Crucifixion: see birds, page 185).

Bramble An alternative tradition names the bramble, rather than the acacia, as the plant within the Burning Bush.

With thorns and thistles, brambles may symbolize earthly hardship, or desolation: 'Thorns will overrun her citadels, nettles and brambles her strongholds. She will become a haunt for jackals, a home for owls' (Isaiah 34:13).

Bulrush Bulrushes show God's power to nurture, sustain, and save. The symbol is taken from the Book of Job. God commented to Satan that Job was a truly good man. Satan responded that Job would curse God if he allowed Satan to afflict him. God allowed Satan to test Job in this way, and Job was tormented with boils. While Job was suffering, his splendidly named companion Bildad the Shuhite tried to comfort him: 'Can papyrus grow tall where there is no marsh? Can bulrushes thrive without water? While still growing and uncut, they wither more quickly than grass. Such is the destiny of all who forget God; so perishes the hope of the godless' (Job 8:11–13).

Christmas rose Unsurprisingly, the Christmas rose is a symbol of Christmas, or the Nativity.

Clover With its three leaves in a single plant, clover is a symbol of the Trinity.

Columbine Columbine is a symbol of the Holy Spirit, through its supposed resemblance to a dove. The plant's name comes from the Latin for dove, *columba*.

Holly The holly is a symbol of Jesus' suffering, because according to one legend it provided the wood for the cross of the Crucifixion. The trees of the forest splintered into fragments at the touch of the woodsman's axe, rather than be used to make the cross; only the holly did not. Its symbolism is explored exhaustively in the ancient hymn, 'The Holly and the Ivy'.

> The holly and the ivy
> When they are both full grown
> Of all the trees that are in the wood
> The holly bears the crown …

Iris Irises are also known as sword lilies. As such, they are occasionally, although rarely, used as a symbol of the Virgin Mary.

Ivy Ivy is such a useful decorative feature – it can be found wound around pillars, framing altars, or in any manner of positions – that it is dangerous to over-emphasize its symbolic purpose. However, as an evergreen it is a symbol of immortality; and as it grows by clinging to supports, it is a symbol of fidelity.

Jesse tree Chapter 11 of the Book of Isaiah contains a prophecy regarding the Messiah: 'A shoot will come up from the stump of Jesse; from his roots a branch will bear fruit. The Spirit of the Lord will rest on him – the Spirit of wisdom and of understanding, the Spirit of counsel and of power, the Spirit of knowledge and of the fear of the Lord – and he will delight in the fear of the Lord.'

Jesse was the father of King David. The prophecy was taken in Christian teaching to be of Jesus, because he was a direct descendant of Jesse. This is the origin of the 'Jesse tree', an image of a tree hung with symbols that traces the ancestry of Jesus. Often the tree is pictured springing up from a sleeping figure, which may

be Jesse, Abraham, or Adam (if it is Adam, then the tree may be growing out of his chest, in a reference to the creation of Eve from Adam's rib; if it is Jesse, the tree may be growing out of the poor man's loins). An alternative variety of Jesse tree is hung with the symbols of the story of God's revelation to humanity, from creation to Jesus' resurrection. For example, the hanging symbols might include an apple (Adam and Eve), rainbow (Noah), burning bush (Moses), harp (David), lily (Mary), and fish (Jesus). As well as a permanent image, some churches have a tradition of installing a tree at the start of the season of Advent (early December), and hanging different symbolic objects on it each day or each Sunday, to tell the story of God's revelation in the run-up to Christmas.

Laurel Laurel leaves woven into a crown are a pre-Christian symbol of victory, awarded to winners of ancient games and held above the triumphant victors of battles. They were therefore adopted as a symbol of Christian victory: Jesus' (and so the Christian's) victory over death, sin, and the world. Paul refers to the laurel obliquely in his Letter to the Corinthians, when he compares the prize to be awarded to followers of Jesus with the prize awarded to competitors in games: 'Everyone who competes in the games goes into strict training. They do it to get a crown that will not last; but we do it to get a crown that will last forever' (1 Corinthians 9:24–27).

As laurel leaves that have been cut do not wilt or change their colour, they are, like holly and ivy, symbolic of eternity and everlasting life. Laurel is also associated with chastity, since the laurel was the plant of the Vestal Virgins in Rome.

Lily In modern times, the lily has come to be associated with death, but in a church it is always associated in some way with the

Virgin Mary. Images of Mary often have her holding a lily, or one might stand in a vase beside her. Perhaps because of their close association with the Virgin Mary, lilies are also associated with the Archangel Gabriel and St Joseph.

In the Song of Solomon, the Bible's great love poem, the lily is also a symbol of great beauty: 'Like a lily among thorns is my darling among the maidens' (Song of Solomon 2:22). The Song of Solomon was interpreted by some Christian writers as representing Jesus' love for his Church, and the lily is associated with the beauty of the Church.

Narcissus In Christian imagery, the narcissus symbolizes divine love. The symbol derives from an ancient Greek myth, of a beautiful young man called Narcissus, who spent so long admiring his own reflection in a pool of water that he died there, and the flower that is now named after him sprang up on the spot. In a Christian context, the image has been turned around, from a symbol of self-love into a symbol of the triumph of divine love.

Oak The sturdy oak is a symbol of strength, durability, faith, and endurance. The symbol can also be reversed into one of pride, in God laying low the apparently strong: 'The Lord Almighty has a day in store for all the proud and lofty … for all the cedars of Lebanon, tall and lofty, and all the oaks of Bashan … the arrogance of man will be brought low and the pride of men humbled' (Isaiah 2; Amos 2:9).

The oak also appears in a dramatic Old Testament story. King David's third son Absalom organized a rebellion against him. David ranged his forces against Absalom, but ordered his commanders to be gentle with his son. The battle took place in a forest, and while riding his mule, Absalom's head became caught

in the branches of a thick oak tree. Absalom's mule kept walking, and Absalom was left suspended, to be found by King David's commander Joab. Joab ignored David's order, and plunged three javelins into Absalom's heart as he hung, alive but helpless in the oak. When David heard of Absalom's death, in spite of his son's rebellion he gave out a father's cry of immense sorrow and pain: 'O my son Absalom! My son, my son Absalom! If only I had died instead of you – O Absalom, my son, my son!' (2 Samuel 18). The story gives rise to the word 'Absalomism' – a son's rebellion against his father.

Olive branch and leaf The olive branch is a symbol of peace and prosperity. The symbol is now a universal one, visually when clasped in the beak of a dove, or verbally when we talk of the olive branch of peace.

The image comes from two sources. The olive was one of the seven foods that God promised to the Israelites in the Promised Land (the others being wheat, barley, vines, fig trees, pomegranates, and honey, Deuteronomy 8:7). As a vital crop in Palestine, olives appear repeatedly in the Bible when representing wealth, or the destruction of wealth. In the story of the Deluge, when the ark was floating above the flooded earth, Noah sent out a dove, and it returned with an olive leaf in its beak, showing that the waters were receding from the face of the earth, and that God's punishment was over.

Palm leaf The palm leaf has been associated with victory since pre-Christian times. It was therefore a logical step for it to become a symbol of Jesus' victory over death, and of the Christian's victory over sin, the world,

and the Devil. The most common use of the symbol is of martyrdom, and it is often referred to in Christian literature as the martyr's palm. The martyr's palm held or near to a figure will indicate that that person was a martyr.

Pomegranate Fruits bursting with seeds, pomegranates are symbols of fertility and bounty. A single pomegranate may also symbolize the Church, as it has many segments and seeds within the one fruit.

The pomegranate also took on symbolism from classical mythology. Persephone (in Roman mythology, Proserpina) was the daughter of Zeus (Jove), the king of the gods, and Demeter (Ceres), the goddess of the harvest. She was so beautiful that Hades (Pluto), god of the underworld, took her to be his queen. When Demeter discovered this, she went to reclaim her. But Persephone had eaten four pomegranate seeds while in the underworld, which gave Hades a claim on her. She was therefore to live in the underworld for one month each year for each seed she had eaten, during which time winter would reign, because Demeter would not let anything grow. Persephone would then emerge to spend the rest of the year with her mother, whereupon spring would bloom. In the hands of Christian artists, the legend of the pomegranate was developed to become a symbol of new life and resurrection.

Rose The rose symbolizes purity, and the Virgin Mary. St Ambrose related a legend of the rose. Before the Fall, he said, the rose had no thorns. When it developed them after the Fall, it was as a poignant reminder of the disaster that had taken place: the beauty and scent of the rose was to remind humankind of the paradise that it had lost, while the thorns were a reminder of the

barrier that had been created and the suffering humankind had now to endure. Roses therefore show heavenly joy, when they are worn by angels or persons who are in heaven. Derived from the same legend, Mary is sometimes called the 'rose without thorns', because she was thought to have been without sin. If you look carefully at images of the Virgin Mary that also show roses growing, you should see that the stems are smooth. Mary also took the rose as an attribute since it was the flower of Venus, Roman goddess of love, and because of a verse from the Song of Solomon that was thought to relate to her: 'I am a rose of Sharon, the lily of the valleys' (2:1).

The blood-red rose is a symbol of martyrdom, the white a symbol of purity and perfect beauty.

Thistles Thistles are a symbol for earthly hardship and sin. The source of the image is God's curse on Adam, when he had broken God's prohibition from eating from the Tree of the Knowledge of Good and Evil: 'Cursed is the ground because of you; through painful toil you will eat of it all the days of your life. It will produce thorns and thistles for you, and you will eat the plants of the field' (Genesis 3:17–18). The thistle is also used in the Old Testament as a symbol of earthly desolation ('Thorns and thistles will grow up and cover their altars', Hosea 8).

Thorns After he was condemned to death, Roman soldiers placed a crown of thorns on Jesus' head, in mockery of his claim to be the King of Jews (see page 73). The crown of thorns was a parody of the crown of roses that the Roman Emperor wore at festivals. The crown is traditionally portrayed as a circular woven ring, because the soldiers are recorded as having twisted thorns into a crown. When it is placed with other instruments of Jesus'

suffering such as the cross, nails, or whip, the crown of thorns is also a symbol of Good Friday.

A flowering thorn bush may represent the Glastonbury thorn, which in England is a symbol of the Nativity. The reference is to an ancient English tradition. Joseph of Arimathea (see the Descent from the Cross, the Pietà, and the Entombment, pages 76–77) was said to have returned to England after Jesus' resurrection to spread the Gospel. Tired from his journey, he rested on Glastonbury Hill and stuck his staff in the ground. When he awoke, the staff had taken root and blossomed. It blossomed every year around Christmas time, and so an association with Christmas and the Nativity arose. There is still a thorn bush at Glastonbury Abbey which, it is claimed, is descended from that planted by Joseph of Arimathea.

With thistles and brambles, thorns can be a symbol of the hardship of life, derived from the reference in Genesis. Jesus in his parable of the sower took the image further. He used the thistle to symbolize life's worries, riches, and pleasures, which can choke the word of God. Jesus told the story of a farmer who went out to sow his seed. Some of the seed fell on hard ground where it was eaten by the birds; some on rock, where it died for no moisture; some fell among thorns, which grew up and choked it; some fell on fertile ground, where it yielded a huge crop. Jesus explained the parable to his disciples. The seed was the word of God. Some people would hear the word of God, and then the Devil (the birds) would come and take away the word from their hearts; some are like the rock, who receive the word with joy, but have no root and fall away; the seed that fell among thorns stands for those who hear, but are ultimately choked by life's worries, riches, and pleasures, and they do not mature; the seed on good soil stands for those who hear the word and by persevering produce a crop (Luke 8).

Vines and grapes Like ivy, vines are an extremely useful decorative feature, curling around stonework and the edges of pictures. But their association with the wine of the Eucharist gives them a vital symbolic purpose. When seen with wheat, grapes symbolize the wine used in the Eucharist.

As an important crop in ancient Palestine, the vine is an Old Testament symbol of abundance. For example, Jacob blesses Judah by saying that the land will be so wealthy that he would tether his donkey to a vine, and wash his clothes in wine (Genesis 49:11). In the New Testament, the vine symbolizes Jesus, who described himself in these terms: 'I am the vine; you are the branches. If a man remains in me and I in him, he will bear much fruit; apart from me you can do nothing' (John 15:5). Since Jesus also describes his followers in these terms, a vineyard can symbolize the Church.

Violets Violets are a symbol of humility, because they grow low and have small flowers. Violets are particularly associated with the Virgin Mary, through her humility in accepting the motherhood of God, and with Christ, in accepting humanity.

Wheat Wheat, whether in single stalks or bound in a sheaf, has a number of interlocking meanings. It is a symbol of the bread used in the Eucharist, and this will be its meaning when it is placed together with grapes, which symbolize the wine of the Eucharist. Wheat is a symbol of the word of God, from the parable of the sower (see thorns). It is also a regular biblical emblem of God's bountifulness. In a sheaf it is therefore a symbol of the Harvest

Festival and of thanksgiving (expressed in a great American hymn, which begins 'Bringing in the sheaves, bringing in the sheaves, we shall come rejoicing, bringing in the sheaves').

Wheat was also used to show Jesus' human nature, and to convey a message of hope. Jesus predicted his death, and the hope of his Resurrection, through an analogy with wheat dying: 'The hour has come for the Son of Man to be glorified. I tell you the truth, unless a kernel of wheat falls to the ground and dies, it remains only a single seed. But if it dies, it produces many seeds' (John 12:24). It can also be incorporated into images of the Last Judgement, as a symbol of the good soul – '[God's] winnowing fork is in his hand to clear his threshing floor and to gather the wheat into his barn, but he will burn up the chaff with unquenchable fire' (Matthew 3:12; Luke 3:17).

LETTERS AND
WORDS

I f they are not in the national language, letters and words carved
or painted in churches are almost always in or derived from
Hebrew, Latin, or Ancient Greek. Hebrew is the holy language of
the Old Testament, and words such as *Adonai* and *Amen* connect
the church with its Old Testament roots. Latin and Ancient Greek
were the 'civilized' languages of the world at the time of Jesus.
Although in later centuries they ceased to be used by the general
population, they continued to be used by scholars. As the
Christian Church spread to different nations, Latin in particular
became the medium of communication used by Churchmen. The
use of Latin and Greek words in church buildings therefore shows
three things: it is a link to the earliest Christians; it is a mark of
intellectual understanding; and it is an expression of the
communication of God's word to all the nations.

These words can appear on their own, or phrases can be
abbreviated to their initial letters. It is by no means always used,
but if a short horizontal line, with one end slightly lowered and
one end slightly raised, appears near or over certain letters, then it
is intended to indicate that the letters are an abbreviation.

We will see that some of these words are straightforward

translations of key passages from the Bible. Others, such as IHC, IHS, and the Chi Rho (which, since they all indicate Jesus in some way, are known together as the Sacred Monograms), have taken on a symbolic life of their own. The more that a combination of letters has taken on this separate symbolic existence, the more likely it is to appear in combination with other symbols, such as a crown over the letters (which with the Sacred Monograms would show Jesus' kingship), or giving off rays of light (showing Jesus' glory).

Adonai *Adonai* is Hebrew for 'The Lord'. This was a way of referring to God while avoiding the use of his true name, which it was considered wrong to write or speak (see Yahweh).

Agnus Dei Latin for 'The Lamb of God' (see St John the Baptist, and God the Son, pages 95 and 52).

AMDG AMDG stands for the Latin words *Ad Maiorem Dei Gloriam*, 'To the greater glory of God'. When the letters appear on an object, such as an item of church furniture or stained glass, it often indicates that it was donated to the church, and that the donor wished that the gift would work to God's greater glory.

Amen *Amen* is the Hebrew word for expressing confirmation and agreement. It means 'certainly', or 'truly', and is used in the New and Old Testaments to confirm prayers, as a statement that the preceding words are true and good. The word can also be translated as 'so be it', or 'let it be so' (Numbers 5:22), as a final plea that the prayer will be heard. The word has been used continuously and unchanged from its Hebrew root, through Greek and Roman speech, to the present day.

In a darker twist, the word can also be used to confirm curses. Moses commanded that *Amen* should be used by the congregation as a response to a series of curses led by the priests ('"Cursed is the man who sleeps with his mother-in-law!", then all the people shall say "Amen!" '; Deuteronomy 27:23).

AMGPD AMGPD stands for the Latin words *Ave Maria, Gratia Plena, Dominus tecum*, 'Hail Mary, full of grace, the Lord is with you' (see the Virgin Mary, page 87).

AMR AMR stands for the Latin words *Ave Maria Regina*, 'Hail Mary, the Queen [of Heaven]'.

AΩ AΩ – *Alpha* and *Omega* – are the first and last letters of the

· A ꙍ · A Ω ·

Greek alphabet. They therefore indicate the beginning and the end of all things and so symbolize God, and in particular God's infinite and eternal nature. In the first chapter of the Book of Revelation, St John had a vision of God making this analogy himself ('I am the Alpha and the Omega,' says the Lord God, 'who is, and who was, and who is to come, the Almighty'; Revelation 1:8). Later on in the vision, John saw Jesus adopting the same description to himself ('I am the Alpha and the Omega, the First and the Last, the Beginning and the End'; Revelation 22:13).

The use of the alphabet's first and last letters as a symbol of God was inherited from Judaism, and the Hebrew letters gave this an additional significance. The first and last letters of the Hebrew alphabet are *Aleph* and *Thaw*. The Hebrew word for truth is *Emeth*, a word that begins and ends with these letters. The word *Emeth* was therefore considered sacred, and to have a mystical meaning: truth was fully and infinitely in God, and there was

nothing outside of him, before him, or after him, that was truth.

The Greek letters will often appear high up on stained glass, when they might represent God the Father as part of the Trinity (with God the Spirit in the form of a dove positioned below, and God the Son below that), or simply emphasize the infinity of God. The letters may appear in Jesus' halo, over the crossbar, particularly in Eastern icons. If the letters are standing alone, they often appear with other symbols, such as a cross (to emphasize the divinity of Jesus, or the sufferings of God) or a crown (God is King of All), or the Chi Rho. Sometimes the position of the Alpha and the Omega is reversed, with the Alpha on the right and the Omega on the left. In this order, the letters show that in Jesus the beginning and the end became one.

Ave [Maria], gratia plena, Dominus tecum Latin for 'Hail [Mary], full of grace, the Lord is with you' (Luke 1:28). See the Virgin Mary and the Annunciation (page 87).

BMV/Beata Maria Virgo 'Blessed Virgin Mary'. See the Virgin Mary (page 83).

Chi Rho *See* under XP, below.

DD/DDD DD stands for the Latin words *Donum dedit*, 'he/she gave as a gift'. A third D stands for *Deo*, meaning 'he/she gave as a gift to God'. It may be seen on objects that have been donated to a church.

DNJC DNJC stands for the Latin words *Dominus Noster Jesus Christus*, 'Our Lord Jesus Christ'.

DOM DOM stands for the Latin words *Deo Optimo Maximo*, 'The highest and the greatest God'. Jupiter, the king of the Roman gods, was addressed with these words, and they appear on the ruined temple of Jupiter on the Capitol Hill in Rome. The words were naturally transferred by Christians from Jupiter to God, and were placed on monuments and over church entrance doors.

Ecce Agnus Dei, qui tollit peccatum mundi Latin: 'Behold the Lamb of God, who takes away the sin of the world' (John 1:29). See God the Son (page 52).

Ecce Ancilla Domini Latin: 'Behold the handmaiden of the Lord' (Luke 1:38). See the Virgin Mary and the Annunciation (page 87).

Ecce Homo Latin: 'Behold the man' (John 9:5). These were the words that Pilate used of Jesus when he presented him to the crowd (John 19:5).

Ecce Virgo Concipiet Latin: 'Behold, the Virgin will conceive'. See the Virgin Mary and Isaiah (pages 88 and 163).

Eloi, eloi, lama sabachthani? 'My God, my God, why have you forsaken me?' (Mark 15:34, from Psalm 22:1). These are the words that Jesus cried out as he hung on the cross, shortly before his death. The words are Aramaic, the day-to-day language of Jesus and the disciples. They have caused difficulties for some theologians, since they seem to show Jesus the Son of God in complete despair, believing at the point of death that he had been abandoned by the very God who is meant to have been manifested in him. One explanation of the words is that at this

point it was the wholly human part of Jesus that was expressing itself. But an overly theological examination of the words may be missing the point. It is precisely because it would have been more convenient for the Gospel-writers to omit to mention these words, included in the Gospels in spite of the fact that they are in a foreign language, that it is likely that they are the actual words of Jesus. They are a point of contact with Jesus that cuts like a knife through the tangle of centuries of biblical translation and exposition. This cry of pure pain, in Jesus' ordinary language, is one of the most deeply moving moments in the Bible.

Emmanuel *See* Immanuel.

Hosanna *Hosanna* is a Hebrew word meaning 'save', which developed into an exclamation of praise. It was shouted by the crowds on Jesus' Entry into Jerusalem (page 67).

IHS and IHC IHS and IHC are symbols of Jesus. 'IHC' is derived from the Greek spelling of Jesus (<u>IH</u>COY<u>C</u>). The Greeks also used the letters IH, IC or ICXC (Jesus Christ), while some of a more mystical bent used the letters IET. The letters IE were the first letters of Jesus' name, while the T formed the shape of the cross; moreover, when turned into numerals, in Greek the letters IET come to 318, a number which was thought to have a mystical significance and was the number of trained fighting men who followed Abraham, Israel's founding father (Genesis 14:14). The letters IHC were later 'translated' into the Latin form 'IHS'. Purists tend to prefer the Greek lettering because of its earlier origins (IHC appears on a third-century Roman monument, whereas IHS was only popularized in the fifteenth century). However, IHS has taken on

other meanings over the years, having been mistranslated as the first letters of three separate words, variously *Iesus, Hominum Salvator* ('Jesus, Saviour of Humankind'), *Iesus Habemus Socium* ('we have Jesus as our companion'; this was the interpretation of the Jesuits, who adopted IHS as the symbol of their order), and *In Hoc Signio* ('by this sign [you shall conquer]', these being the words spoken in Constantine's vision – see XP). These misinterpretations, if that is what they were, have given IHS a solid defence to preference over its older relative. IHS and IHC are together known as the 'Chismon'.

Immanuel/Emmanuel *Immanuel*, or *Emmanuel*, means 'God with us'. It is first used in the Bible by the Prophet Isaiah, who wanted to give a sign from God to stiffen the resolve of the King of Judah, King Azar, against invading armies: 'Therefore the Lord himself will give you a sign: the virgin will be with child and will give birth to a son, and will call him *Immanuel*' (Isaiah 7:14). This prophecy was applied by St Matthew to Jesus (Matthew 1:22–23). The paramount importance of the words lies in applying this word *Immanuel*, God with us, to Jesus. The meaning for Christians is that, in Jesus, God came into the world.

INRI INRI are letters that almost always appear on a scroll or plaque, nailed to the top of the Cross in scenes of the Crucifixion. The letters stand for '*Iesus Nazarenus Rex Iudaeorum*', Latin for 'Jesus of Nazareth, King of the Jews'. This was the inscription, in Aramaic, Greek, and Latin, that Pontius Pilate, the Roman Governor who condemned Jesus to death, had prepared and fastened to the Cross. It was usual to have a placard, called the 'titulus', attached to the cross, bearing the condemned man's name and his crime. In a striking exchange, the Chief Priests complained to Pilate that he should not

have written 'the King of the Jews', but instead 'This man *claimed* to be the King of the Jews'. Pilate refused to back down, and growled back that what he had written, he had written (John 19:19–22).

JHVH (Jehovah)/YHWH (Yahweh) When God appeared to Moses in the Burning Bush, Moses asked him what he should tell the Israelites was God's name. God replied, 'I AM WHO I AM. This is what you are to say to the Israelites: "I AM has sent me to you"' (Exodus 3:14). This was an expression that God is complete and self-existent, and the word in Hebrew is *Yahweh*. In Jewish tradition the name of God was too sacred to speak or write, and so it was substituted in speaking by the word *Adonai* ('Lord') and in writing by the consonants YHWH.

In later transcriptions of the Bible, YHWH became JHVH, as I's and J's, V's and W's were commonly muddled. In the Middle Ages, the vowels from *Adonai* were added to JHVH, to give the name of God as *Jehovah*.

M/MR/Mater Dei (ma di/MP OY) The letter 'M' is likely to refer to the Virgin Mary. This can appear with an 'R' (for MaRia, or *Maria Regina*, 'Mary, Queen [of Heaven]'). When the two letters are joined, with the loop of the 'R' piercing the right-hand arch of the 'M', the arrangement is known as the Monogram of the Blessed Virgin.

The Virgin Mary is also identified by the words 'Mater Dei', often abbreviated to 'ma di' (or in Greek, *MP OY*), meaning 'Mother [of] God'.

As with the sacred monograms, these letters can be combined with other symbols to give particular meanings, such as a crown to show that Mary is Queen of Heaven.

MHP.OY This is an abbreviation of *Meter Theou*, Greek for 'Mother of God'. It is found on Orthodox icons of the Virgin Mary.

N/Nika The Greek word *nika* means 'victor', or 'conqueror'. It is sometimes combined with the Chi Rho or the letters IC or IC XC to represent the phrase 'Jesus, Victor' or 'Christ, Conqueror', a reference to Jesus' victory over death and sin. Sometimes only the 'N' is used, superimposed over a Sacred Monogram or a cross. A single N used in this way may also have a more tender meaning, as it can stand for *Noster*, 'Our', for example 'Our Jesus'.

Noli Me Tangere Latin: 'Do not touch me' (John 20:14). See St Mary Magdalene (page 98).

Quo Vadis?/Domine Quo Vadis? Latin: 'Where are you going? Lord, where are you going?' See St Peter (page 106).

RIP The letters RIP, familiar from gravestones and funeral monuments, stand for the Latin *Requiescat In Pace*, or equally nowadays its English translation, 'Rest In Peace'. It expresses the hope and wishes of the living for the dead person's peace, and acts as a prayer for them.

Sanctus Sanctus Sanctus 'Holy, Holy, Holy'. These were the words sung endlessly by the mystical creatures around the throne of God, in St John's vision (Revelation 4:7–8). They may also be sung by the congregation during the Eucharist. See the Four Evangelists (page 102).

Sta. Sta. is an abbreviation of *Santa*, meaning 'saint'.

VDMA / Verbum Dei Manet in Aeternum Latin: 'The Word of
God endures for ever' (1 Peter 1:25). The letters or words are most
usually found on or around places where the Bible is read out in
church, such as lecterns or pulpits. They are sometimes portrayed
in imagery as printed in a book, in which case the book is meant
to be the Bible.

Vox clamantis in deserto Latin: 'A voice crying out in the
wilderness' (Mark 1:3). See St John the Baptist (page 94).

XP – the Chi Rho The Chi Rho is, with the letters
'IHS' or 'IHC', one of the Sacred Monograms. 'XP'
stands for 'Christ', from the Greek word for Christ,
XPICTOC. The symbol is known as the Chi Rho, after the names
for the Greek letters. In signifying the word 'Christ' rather than
'Jesus', the emphasis in the symbol is on Jesus' position as the Son
of God, the Messiah. The 'X' in the Chi Rho can be used
artistically as a reminder of the cross, and so the letters are often
interlinked to make a single whole – for example, the X
superimposed over the vertical of the P, or indicated by a diagonal
through the vertical of the P, or the P indicated by a half-circle at
the top of one of the bars of the X.

Like so much Christian symbolism, the Chi Rho has a
meaning that predates Christianity. The Ancient Greek word for
gold (*chrysoun*) starts with the same two letters, and the Chi Rho
was stamped onto coins to show that they were made of gold. This
meaning pleased Greek Christians, as the symbol represented their
golden Christ.

The popularity of the symbol soared after it was adopted by
the Emperor Constantine, the first Christian Roman Emperor. In
312 Constantine invaded Italy, having declared war on the

Emperor Maxentius. He had a vision of the Chi Rho, together with the words *En toutoi nika*, 'By this sign, you will conquer'. That night, he dreamed of the Chi Rho, and Jesus appeared and told him to place it on his military standards. He did so, and went on to defeat Maxentius in spite of overwhelming odds. Constantine declared Christianity the state religion, and in the course of the fourth century the sign was stamped onto everything from tombs to household utensils.

Images of the adoration of the name of Jesus – a person or group venerating the sacred monograms, which hover before them shining in the night – were popular in medieval and Renaissance art.

YHWH *See* JHVH.

HOW TO READ
A PRIEST

So far, we have been looking at the objects and images that can be found as part of the fabric or furniture of a church. In this last chapter, we will look at the history and symbolism of clerical dress, the ceremonial clothes of the priesthood.

The more traditional the Church, the more traditional is the dress of its clergy. Most of what follows will be found in Churches in the Catholic tradition. Protestant Churches may have retained some elements of the dress, although some have forgone traditional costume altogether.

Traditional clerical dress is ultimately all derived from the clothes of the well-dressed Roman. As fashions changed, the tendency of religious orders towards conservatism, or perhaps nostalgia, caused them to retain the old styles of dress. These have not necessarily stayed fixed, and over time elements of Roman costume have contracted (as in the pallium) or expanded (as in the surplice). Symbolic meanings have grown up around the clothing, but they were not the reason for adapting the clothing in the first place.

Alb When celebrating the Eucharist, the priest should wear an alb, a long-sleeved tunic reaching to the ankle. It is a one-piece,

VESTMENTS

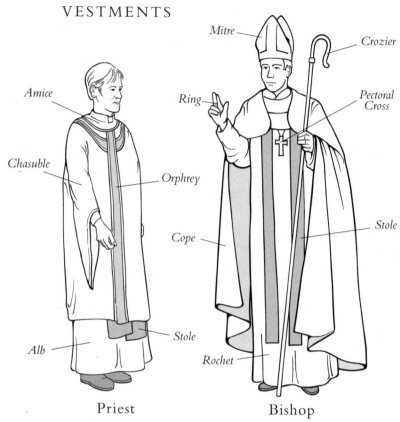

Priest

Bishop

seamless garment like the one that was taken from Jesus before the crucifixion, and for which the Roman soldiers gambled (John 19:23–25). There may be embroidery on the sleeves, hem, and chest to symbolize the five wounds of Jesus.

The Roman tunic that is the ancestor of the alb would have had short (or no) arms and would barely have reached the knees (the Romans disliked arm or leg coverings, which they associated with barbarian dress). The Emperor Aurelian introduced long sleeves in 270. As over time the tunic extended in length, it became impossible to undertake labour in it, and so it began to be

HOW TO READ A CHURCH

worn by upper-class and intellectual men, who considered it a sign of special standing. Priests who wore it were taking on this status, but it became associated with the Eucharist because of the simple need to wear something clean. Clerics tended to wear official dress as they went about their day-to-day work, and so it was felt necessary to have a clean over-garment for religious ceremonies. In the words of St Jerome, 'we ought not to enter the holy of holies in soiled everyday clothes, but with a clean conscience and clean clothes to administer the mysteries of the Lord'.

The clean white alb became a symbol of priestly purity. Moreover, with the reference to it in the story of the Crucifixion, it is a reminder of what Jesus endured.

Amice The amice (pronounced *a-miss*) is a piece of stiff linen, bearing a cross and often much embroidered, worn around the neck when celebrating the Eucharist. The name comes from the Latin *amictus*, meaning 'outer garment', and it is derived from a Roman neckerchief, which was worn like a small shawl. For a period it came to be worn by priests over the head (presumably for additional warmth), before it fell back to being a neck dress. Its symbolic function is to commemorate the blindfold tied around the face of Jesus before his trial. In mockery of his reputation as a prophet, Jesus' captors tied a cloth around his eyes and then beat him, all the while demanding, 'Prophesy, who is it that struck you?' (Luke 22:64).

Archiepiscopal cross Archbishops often have their own 'archiepiscopal' cross, a crucifix mounted on a staff, which is carried before them in procession. Unlike the processional cross, the figure of Jesus is turned towards the archbishop, as the function of the cross is to remind the archbishop, the highest priest, of Jesus'

sacrifice and leadership, an interpretation that enables them to be symbols of humility rather than (perish the thought) of status. When they give a blessing, archbishops remove their mitres in deference to this cross; ordinary bishops, who do not have the right to have a cross carried before them, keep their mitres on when blessing.

Bishop's crook The bishop's crook refers to the shepherd's crook, and is symbolic of the bishop's position as shepherd of the people, just as Jesus was the Good Shepherd (see lamb, page 191). There is an express command in the Book of Acts that the elders of the Church at Ephesus should 'be shepherds of the church of God' (Acts 20:28).

Cassock The cassock is the 'ordinary' dress of priests. It has long arms to the wrists and is ankle-length, with a short, raised collar parted at the front to display the dog collar. Buttoned at the front, it should ideally have thirty-three buttons, in memory of the thirty-three years of Jesus' human life on earth, or, in the Church of England, thirty-nine for the thirty-nine Articles of Religion. For ordinary clergy the colour is black; for bishops, purple or black; for cardinals, red; for the Pope, white.

The cassock is derived from a warm, long-armed garment worn by the pre-Christian French (Gauls), known as a *caracalla*. At first it was regarded as vulgar barbarian dress by all good Romans, but it came into fashion when the Emperor Marcus Aurelius Antonius (211–17) wore one in an attempt to increase his standing with his troops. Its chief function for the Romans, as it would have been for the French, was to keep them warm, and they were frequently lined with fur (sheepskins for the lower clergy, fur for the higher). *Caracalla* was anglicized over time to cassock.

Chasuble The chasuble is worn over the top of the other clothes during Communion. It is often very richly decorated, and chasubles with different colours and decorations can be worn at different times, depending on the stage in the Church year (see the section colours, page 15). It should be seamless, again in memory of the garment that was taken from Jesus before the Crucifixion. The name comes from the Latin *casula*, meaning 'little house'. As the outermost garment, it represents Christian protection (as it is like an outer wall) and love (because love is the foremost Christian virtue).

Cope The cope can outdo even the chasuble for rich ornamentation. It is a cloak, roughly the shape of a half-circle, usually with ornate bands running down each seam and with a clasp (known as the morse) below the throat. Its ancestor from the early church was a hooded black bell-shaped cloak used for outdoor activities and for warmth in cold churches. Like its ancestor, the cope is worn in processions and on particularly important occasions. As an outdoor garment it was named after its hood – the word 'cope' is derived from *caput* meaning 'head', the same root as 'cape' and 'cap'.

Like the chasuble, the colour and decoration of the cope worn may depend on the stage in the Church year. Although it has been interpreted as symbolizing priestly dignity and purity, most copes are so laden with symbolic decoration that they need to be interpreted individually.

Cord or Cincture Tied around the waist of the alb is a cord of wool or silk, known as the cincture, or simply the cord. It has been said to be a reminder of the rope with which Jesus was tied to the pillar during the Flagellation.

Dog Collar The dog collar, shrunken through the centuries, derived from a white cravat. It has become the priest's central symbol, its whiteness symbolizing priestly purity.

Maniple A strip of material worn wrapped over the left wrist of the priest performing the Eucharist is known as the maniple. It is rarely used nowadays (its tendency to knock over the communion wine played a part in its downfall) but may appear in images of priests or bishops. It has been interpreted as a memorial of the cloth that Jesus used to clean the feet of the disciples (see Jesus Washes the Feet of the Disciples, page 70), or as the rope used to drag Jesus to crucifixion (see the Road to Calvary, page 73).

Mitre Bishops, archbishops, cardinals, and some abbots wear mitres. They are tall hats, arching front and back to two points, split sideways, with two flaps at the rear and usually highly decorated.

The ancestor of the mitre was a conical hat, shaped like a narrowing fez, although the name itself comes from the Greek *mitra*, meaning 'band' (or in this case, headband – the two flaps at the back of the mitre, known as fanons, are descendants of the loose pieces of string left from tying the headband at the back). In early pictures of bishops, the mitre is more rounded and shorter than we see in use today, and they reared upwards over time.

The two points of the mitre, which rise above a fairly flat surface front and back, give the headdress a number of meanings. They are the two points of light that traditionally shone from Moses' radiant face when he received the Ten Commandments. They also signify the Old and the New Testaments. The two fanons are meant to symbolize the letter and the spirit of God's promises to humankind.

Pallium The pallium is a strip of white wool that runs over the far extent of the shoulders to join at a hanging pendant at the front. It has six black crosses worked into the material.

The pallium is derived from an ancient garment called a '*himation*', which was a single piece of material worn draped round the body, often without any other item of clothing. At the start of the Christian era, it was the universal dress of philosophers and teachers, and may in fact have been the item of clothing 'without seam' that was worn by Jesus (John 19:23–25; see alb). Later, the pallium was worn over other clothes and by the fourth century it ceased to be worn at all, except as an official garment of high officers of the Roman Empire. As it developed into a badge of office, its width was reduced for convenience, and in the Western Church it eventually became the purely ornamental band that is still with us today. In the Eastern Church, the pallium continues to be a narrow scarf draped around the shoulders. In images of prophets draped with an 'old-style' pallium, the pallium should be enveloping the left arm and even covering the left hand. The Romans considered it improper to cover the right arm.

Palliums are made of wool and are draped over the shoulders the same way a lamb is carried by a shepherd. Therefore the pallium is like a sheep, and the wearer is representing Jesus as the Good Shepherd (see lamb, page 191). The Y-shape is also an emblem of the Cross.

Rings Rings have a long history of religious significance. When a nun makes her final vows to join her order, she becomes 'married' to Jesus, and so wears a ring on the third finger of her left hand, her wedding finger. Some wear the ring on the equivalent finger of the right hand, in order to show that this is not an ordinary marriage. Rings worn by bishops and abbots are

similarly worn on the third finger of the right hand: they too are 'married', in the meaning of 'joined', to God.

The Pope wears a gold ring known as the 'fisherman's ring', because it contains an image of St Peter fishing (St Peter, the first Bishop of Rome, was a fisherman, and was told by Jesus that he would make him a 'fisher of men'). Each Pope's fisherman's ring is unique to him and carries his name. It is broken on his death.

Stole The stole is a long band of material worn draped over the neck and with each end hanging to below the waist. It is now an important mark of priesthood, although its origins are less noble, since it is derived from the *sudarium*, the ancient equivalent of a handkerchief, which was used for wiping the nose.

The stole is worn around the neck or over one arm. It is usually embroidered with three crosses, one in the middle (which rests behind the neck) and one at each end. When celebrating the Eucharist, the stole should be crossed over the priest's chest; otherwise, it hangs straight down. The stole is a symbol of humility for the priest. Its position around the neck is a reference to the yoke of a beast of burden, and so to submission to faithful service. It also represents the bar of the cross that Jesus carried, and is a reminder to the priest that he is standing in the place of Jesus.

Surplice The surplice is a knee-length, one-piece white overgarment with a hole for the head. It is a late modification of the alb, and the name is derived from *superpellicium*, meaning 'over-cassock' (cassocks when lined with fur were known as *pellicea*, from *pellis*, 'skin'). The surplice is generally worn by assistants in church services, rather than the priest, who wears an alb.

Like the alb, the surplice was used as a respectably clean item of clothing for wearing for worship over the often grubby cassock.

The effect of the surplice is 'angelic', as the garment flows like wings with movements of the arms, and when worn by the choir is a reminder of the choirs of angels described as eternally singing praises to God in the Book of Revelation (Revelation 5:11–12). Like the alb, the symbolic purpose of the pure white surplice is to express purity and holiness.

Appendix

The Creed Sequence

Apostle	Apostles' creed – Latin	Apostles' creed – English
Peter	*Credo in Deum Patrem omnipotentem, Creatorem coeli et terrae*	I believe in One God, Father Almighty, Maker of Heaven and Earth
Andrew	*Et in Jesum Christum Filium eius unicum Dominum nostrum*	And in Jesus Christ His only son our Lord
James the Great	*Qui conceptus est de Spiritu Sancto natus ex Maria virgine*	who was conceived of the Holy Spirit, born of the Virgin Mary
John	*passus sub Pontio Pilato crucifixus mortuus et sepultus*	suffered under Pontius Pilate, was crucified, died and was buried
Thomas	*descendit ad inferna tertia die resurrexit a mortuis*	He descended into hell; on the third day he rose again from the dead
James the Less	*ascendit ad coelos sedet ad dexteram Dei Patris omnipotentis*	he ascended into heaven and he sits at the right hand of God the Father Almighty
Philip	*inde venturus (est) judicare vivos et mortuos*	From thence he shall come to Judge the Living and the dead
Bartholomew	*Credo in Spiritum Sanctum*	I believe in the Holy Spirit
Matthew	*sanctam ecclesiam catholicam sanctorum communionem*	The Holy Catholic Church, the communion of saints
Simon	*remissionem peccatorum*	the forgiveness of sins
Jude	*carnis resurrectionem*	the resurrection of the body
Matthias	*vitam oeternam. Amen*	and the life everlasting. Amen

I have listed here the most common examples of the prophets and prophecies that are used to correspond to the Apostles and the part of the Apostles' Creed associated with them. However, this is not a fixed list, and readers may well find local variations.

Prophet	Prophecy – Latin	Prophecy – English
Jeremiah	Heu Domine Deus ecce tu fecisti caelum et terram in fortitudine tua magna; or patrem vocabis me	Ah, Sovereign Lord, behold, you have made the heavens and the earth by your great power (32:17); or, Father, you will call me 'Father' (3:19)
David	Dominus dixit ad me filius meus es tu ego hodie genui te	The Lord said to me, 'You are my Son; today I have become your Father' (Psalm 2:7)
Isaiah	ecce virgo concipiet et pariet filium et vocabitis nomen eius Emmanuhel	Behold, the Virgin will conceive and will give birth to a son, and will call him Immanuel (7:14)
Zechariah	aspicient ad me quem confixerunt	They will look on me, the one they have pierced (12:10)
Hosea	ero mors tua o mors ero morsus tuus inferne	Where, O death, are your plagues? Where, O grave, is your destruction? (13:14)
Amos	qui aedificat in caelo ascensionem suam	He who builds his lofty palace in the heavens (9:6)
Zephaniah/ Malachi	et accedam ad vos in iudicio et ero testis velox	So I will come near to you for judgement. I will be quick to testify (Malachi 3:5)
Joel	effundam spiritum meum super omnem carnem	I will pour out my Spirit on all people (2:28)
Micah/ Zephaniah	vocent omnes in nomine Domini et serviant	They will all call in the name of the Lord and serve him (Zephaniah 3:9)
Malachi	cum odio habueris dimitte dicit Dominus Deus Israhel	I hate divorce, says the Lord God of Israel (2:16)
Daniel/ Ezekiel	ecce ego aperiam tumulos vestros et educam vos de sepulchris vestris	Behold, I am going to open your graves and bring you up from them (Ezekiel 37:12)
Obadiah	No Vulgate translation	The kingdom will be the Lord's (Obadiah 21)

Selected further reading

Anderson, M.D. 1971 *History and Imagery in British Churches.* London, John Murray

Cunnington, Pamela 1993 *How Old Is That Church?* Yeovil, Marston House

Farmer, David 1997 *The Oxford Dictionary of Saints.* Fourth Edition. Oxford, Oxford University Press

Ferguson, George 1977 *Signs and Symbols in Christian Art.* New York, Oxford University Press

Hall, James 1974 (revised 1996) *Hall's Dictionary of Subjects and Symbols in Art.* London, John Murray

Jenkins, Simon 1999 *England's Thousand Best Churches.* Harmondsworth, Penguin

Meakin, Tony 2001 *A Basic Church Dictionary.* Fourth Edition. Norwich, Canterbury Press

McGrath, Alister E. *Christian Theology. An Introduction.* Third Edition. Oxford, Blackwell

Murray, Peter & Linda 1996 *Oxford Companion to Christian Art and Architecture.* Oxford, Oxford University Press

Norris, Herbert 1949 *Church Vestments.* London, J. M. Dent & Sons Ltd

Post, W. Ellwood 1974 *Saints, Signs & Symbols.* Second Edition. London, SPCK

Speake, Jennifer 1994 *The Dent Dictionary of Symbols in Christian Art* London, Dent

Sutton, Ian 1999 *Western Architecture: A Survey.* London, Thames & Hudson

Visser, Margaret 2000 *The Geometry of Love. Space, Time, Mystery and Meaning in an Ordinary Church.* London, Penguin

Shire Book booklets available from Shire Publications
http://www.shirebooks.co.uk
Church Fonts (Pounds, Norman)
Church Memorial Brasses & Brass Rubbing (Chapman, Leigh)

Church Monuments (Kemp, Brian)
Discovering Cathedrals (Peppin, David)
Discovering Church Architecture (Child, Mark)
Discovering Saints in Britain (Vince John)
Discovering Stained Glass (Harries, John & Hicks, Carola)

Further Bibilography

Child, Heather & Colles, Dorothy 1971 *Christian Symbols Ancient & Modern. A Handbook for Students*. London, G. Bell & Sons

Clark, Kenneth 1969 *Civilisation*. London, John Murray

Cox, J. Charles & Harvey, Alfred 1907 *English Church Furniture*. London, Methuen

Curl, James Stevens 1992 *Classical Architecture*. London, B. T. Batsford Ltd

Didron, Adolphe Napoleon (trans. Stokes, Margaret) 1891 *Christian Iconography; the History of Christian Art in the Middle Ages*. 2 volumes. London, George Bell & Sons

Grant, Alexander H. 1869 *The Church Seasons. Historically and Poetically Illustrated*. London, James Hogg & Son

Jameson, Mrs 1848 *Sacred and Legendary Art*. 2 volumes. London, Longman, Brown, Green & Longmans

Mills, Watson E. (general editor) 1990 *The Lutterworth Dictionary of the Bible*. Cambridge, Lutterworth Press

Murray, Peter & Linda 2001 *Oxford Dictionary of Christian Art*. Oxford, Oxford University Press

O'Connell, J. 1955 *Church Building and Furnishing: The Church's Way*. London, Burns & Oats

Webber, Frederick R. 1938 *Church Symbolism*. Second Edition. Cleveland, Ohio, J.H. Jansen.

Index